# THE WORK OF ANDY WARHOL

Dia Art Foundation
Discussions in Contemporary Culture
Number 3

# THE WORK OF ANDY WARHOL

Edited by Gary Garrels

BAY PRESS       SEATTLE       1989

Printed in the United States of America
First Printing 1989
Second Printing 1996
Bay Press
115 West Denny Way
Seattle, Washington 98119

Design by Bethany Johns
Typesetting by The Sarabande Press, New York
Printing by Edwards Brothers, Ann Arbor
Set in Perpetua

**Library of Congress Cataloging-in-Publication Data**
(Revised for no. 3)

Discussions in Contemporary Culture

Nos. 1-2 edited by Hal Foster. No. 3 edited by Gary Garrels.
Contents: no. 1 [without special title]. —no. 2. Vision and visuality.
— no. 3. The work of Andy Warhol.
1. Art and society.   2. Aesthetics, Modern—20th century.   3. Andy
Warhol.
I. Garrels, Gary.   II. Dia Art Foundation.
N72.S6D57 1987        700'.1'03        87-71579
ISBN: 978-1-565845-01-5

# CONTENTS

In 1987, the Dia Art Foundation initiated a commitment to critical discussion and debate through a program of lectures and symposia, with related publications in some instances, called "Discussions in Contemporary Culture."

Events in the series are organized usually by artists, scholars, and critics from outside the Dia Foundation. The first major project in this program was a series of six weekly public discussions organized by Hal Foster on diverse cultural topics, edited transcripts of which, together with prepared texts by the participants, formed the core of the first volume in the "Discussions in Contemporary Culture" publication series. The second volume followed from a day-long symposium on recently developed theories of vision (biological, social, cultural), also organized by Hal Foster. We look forward to the continuation of this series as a chronicle for topics of concern to cultural communities in downtown Manhattan and, through our publications, to broader national communities.

This is the third volume in the series, documenting presentations and discussion at a day-long symposium, organized by Gary Garrels, Director of Programs here at Dia, around the topic "The Work of Andy Warhol." We are very grateful to the contributors to this publication for their research and thought on Warhol's work and for their participation in the symposium as presenters and respondents to questions. We also thank Phil Mariani, who organized the production of this publication, Bethany Johns, our designer, and Thatcher Bailey, our publisher at Bay Press. This is an opportunity to thank once again the lenders to the three exhibitions of the work of Warhol organized by Dia which led up to this symposium and publication (exhibitions documented at the end of this volume). Others without whose assistance the symposium and this publication would not

have been possible include Fred Hughes, Steven Bluttal, and Margery King at the Andy Warhol Foundation, Daniel Schulman at the Museum of Modern Art, and the many individuals and organizations who assisted with providing photographs. Finally, Dia owes its deep thanks to Gary Garrels for his thoughtful organization of the symposium, his editing of contributions of the authors, and his guidance of this project from beginning to end. The Dia staff worked under pressure both in the planning of the symposium and in the production of the publication, and are largely responsible for the achievement of both undertakings.

As always, the continued support of our programming of the Board of Directors of the Dia Foundation has made this project possible.

**Charles Wright**
Executive Director
Dia Art Foundation

**Gary Garrels**

This book is based on a symposium of the same name, "The Work of Andy Warhol," held at the Dia Art Foundation in New York on April 23, 1988. Planning for this symposium began in the summer of 1987, a few months after Warhol's unexpected death and in the midst of mounting attention to Warhol the personality. The symposium itself coincided with the opening day of sales of Warhol's collections and estate at Sotheby's, an event which again amplified the fascination with the biography and persona of Warhol. While the phenomenon of Warhol cannot be disengaged from the works he made—paintings, drawings, prints, objects, films, photographs, and books—it is the works themselves which prompt the interest in the life of Warhol and which in his absence will continue to sustain our attention. The focus then of this symposium was determined at the outset to be on the work of Warhol but knowing that no such inquiry could be disengaged from his persona.

The Dia Art Foundation under Heiner Friedrich, its first director from 1974-84, acquired an exceptional collection of the works of Warhol. However, aside from the "Shadow" series (shown at 393 West Broadway from January 27-March 10, 1979), this collection was largely unknown to the public. In early 1986 Charles Wright, the new Executive Director of Dia, initiated a series of three exhibitions at 77 Wooster Street of the works of Warhol based in large part on works from the Dia collection. The first exhibition, *Disaster Paintings 1963,* was shown from March 15 through June 14, 1986; the second, *Hand-Painted Images 1960-62,* was shown November 5, 1986 through June 13,

1987; and the third, *Skulls 1976,* was presented from October 14, 1987 through June 18, 1988. In presenting these focused exhibitions over the last three years, important parts of Warhol's work known largely from reproductions (or in the case of the "Skulls," almost completely unknown in any form), were again allowed a firsthand appraisal. The final section of this volume documents these exhibitions.

The symposium was planned to mark the completion of this series of exhibitions and to advance the critical and scholarly discourse about the work of Warhol subsequent to his death. Because the Dia exhibitions were drawn mainly from Warhol's paintings, the symposium focused also primarily on his paintings, recognizing the enormity of that subject alone. Warhol's films, graphic work, photographs, and books are of immense importance in understanding his work but would have required a much more ambitious undertaking than this single-day symposium allowed.

Within this framework, then, the symposium was organized to reflect a diverse range of approaches and attitudes, theoretical positions and methodologies. The papers included here are slightly edited and revised versions of the oral presentations, without substantive changes or stylistic shifts. In keeping with the series "Discussions in Contemporary Culture," of which this is part, the intent has been to present serious and sustained inquiries rather than closed summations. The papers have been published here in the same order in which they were presented at the symposium. Because of scheduling conflicts, Simon Watney could not participate in the symposium itself. His paper is presented as the last one here, prior to the closing discussion among the symposium participants.

Charles Stuckey has drawn on traditional approaches of art history to examine Warhol's work—the importance of original settings and environments to understand intent and meaning which are lost subsequent to the removal and dispersal of works;

the role of patronage and sponsorship to the final form that works take; formal precedents and works by peers that influenced the artist's work, and relative to this, issues of dating and biography. Nan Rosenthal also has used the tools of art history to examine the influence of education and training on the artist's work, particularly during what could be called his "apprenticeship" period as a commercial designer, and like Stuckey, the relationship to immediate formal antecedents and the influence of peers. She also has shown that single paintings are capable of intensive formal and iconographic analysis, which, in turn, can inform our understanding of the artist's work as a whole. While for many historians, critics, and curators, Warhol's work of the seventies and eighties remains problematic, Trevor Fairbrother has established in his analysis of a single series, the "Skulls" produced in 1976, the extraordinary complexity and accomplishment of Warhol's later work. Fairbrother examines this series for its formal sophistication and the significance of subject, grounding this single series within a broad range of Warhol's later work, particularly the self-portraits. Both Rainer Crone and Benjamin Buchloh analyze Warhol's work from cultural and ideological perspectives with attention to issues of technique and production, noting the importance of drawing for understanding Warhol's work. Crone sets up a detailed developmental typology for Warhol's work from the 1940s to the 1960s, arguing for consistency and continuity of his development and for a consideration of Warhol's work in a long tradition of twentieth-century theory and practice. Benjamin Buchloh analyzes Warhol's work in relation to issues of modernism and mass culture, while not disengaging this abstract, analytical inquiry from the objects themselves. He concludes by suggesting ideological and political implications of Warhol's work for current and potential art practices. Simon Watney tackles the complex, charged, and more speculative inquiry around the fusion of the artist as persona with the objects he created. Like Fairbrother, he introduces is-

sues of psychology and personality as inextricable from the artifacts of Warhol's production, particularly in relation to portraits, but finally emphasizes the importance of cultural and critical context for shaping an understanding of these relations.

As will be apparent from a comparison of the differing theoretical and methodological approaches of these authors and their conclusions, which are both reinforced and contradicted between papers, the discussion around the work of Warhol is complex and only beginning to be articulated. My hope with these papers is to establish the value and validity of a wide range of analyses, and to underline the need to examine Warhol's work throughout its entire span of production, linking any such inquiry firmly to the objects he produced.

# THE WORK OF ANDY WARHOL

Charles F. Stuckey

# WARHOL IN CONTEXT

"Mr. Warhol, do you mean to be funny?" Mr. Warhol
said, "No."
— "The Contemporary Art Scene—Soup's On," *Arts
Magazine* (May-June 1965), remarks made by Warhol at a
Society of Illustrators luncheon, February 19, 1965

I used to think that everything was just being funny but
now I don't know. I mean, how can you tell?
— Warhol, quoted by John Perreault in *Vogue*,
March 1, 1970

Basically he's a liar when he's interviewed.
— Gerard Malanga, in John Wilcock, *The Autobiography &
Sex Life of Andy Warhol* (1971)

Where Warhol is concerned, most of the crucial issues for
American museums today are raised by a conceptual art piece
that William Anastasi made in 1977. It consists of a black rec-
tangle inscribed: "A painting of a soup can used to hang here"
(fig. 1). The "Campbell's Soup Cans" have become so famous,
that mentioning Warhol's name is unnecessary. But as a com-
mentary on the temporary nature of most art displays, Anastasi's
use of the past tense draws attention to the unfortunate fact
that, beginning in the 1960s, most of Warhol's works quickly left
this country for collections in Europe.[1] Future generations will
have no choice but to judge Warhol's art in the context where it
was first collected, rather than in the context where it was
produced.

The singular noun in Anastasi's inscription raises a second
contextual issue: since Warhol generally conceived and presented

new works as ensembles, a single work removed from its original
setting operates at a loss.[2] For example, Warhol's large-format
*Mao* painting (fig. 2), acquired by the Art Institute of Chicago in
1974, is fundamentally a fragment from an important installation
piece. When first presented at the Musée Galliera in Paris in
early 1974, the Art Institute piece was among 1,951 similar im-
ages in a variety of sizes, including those comprising the *Mao
Wallpaper* manufactured as background for this occasion (fig. 3).
Seen in that orchestrated context, the unique qualities of each of
the "Mao" paintings both stood out from and blended into the
sort of decorative redundancy essential to Warhol's vision. The
problem is that few institutions or individuals have the financial
resources to acquire all of the components of one of Warhol's
environments or sufficient available gallery space to exhibit such
a work on a permanent basis.[3] To alleviate it, at least for the
works that Warhol presented against wallpaper backgrounds, the
Warhol Foundation should probably license posthumous editions,
permitting owners of the paintings to display them in the proper
spirit as an abridged installation. Moreover, responsible museums
should try to acquire or borrow multiple works from any given
series, in different-sized formats when appropriate.

The first to face up to this problem was dealer Irving
Blum, who gave Warhol his debut exhibition as a painter at the
Ferus Gallery in Los Angeles during July and August 1962 (fig.
4). Although the artist was indifferent to whether the exhibi-
tion's contents—thirty-two paintings of different varieties of
Campbell's soup cans—were dispersed through sales, for Blum
the only way to preserve Warhol's essential concept was to keep
these paintings together, so he acquired them all for himself.[4]
The concept at stake was a parodistic extension of the famous
Impressionist series exhibitions, some of which had been par-
tially reconstructed for the *Claude Monet, Seasons and Moments*
show at the Museum of Modern Art in 1960.[5] Whether or not
Warhol fully appreciated the concept's implications at first,

Blum's patronage can only have encouraged his development as above all an installation artist. Seldom preserved, or even well documented, however, the original physical contexts for most of Warhol's subsequent works have been disregarded in the literature devoted to the artist.[6]

The historical context out of which Warhol's work evolved has been similarly ignored, discouraged by Warhol's own tendency to rest his case on luck, flair, and publicity rather than on aesthetic issues. Only recently, thanks above all to Patrick Smith's publications,[7] have the basic antiquarian tools of art history been applied to gathering essential data about Warhol, making it possible to understand many of his works "in context." Most of all, Smith has revealed how most of the characteristic tendencies of Warhol's celebrated 1960s career as a gallery artist were carry-overs from his 1940s and 1950s career as a commercial designer — among them his tendencies to appropriate photographs from magazines as the basis for images, to rely upon the collaboration of assistants to execute his ideas, and to favor themes of celebrity and disaster.

It seems clear now, thanks to Smith's research, that Warhol was temperamentally inclined, from the time he was a teenager in school, to trade upon the shock value of his art. "Usually being the right thing in the wrong space and the wrong thing in the right space is worth it," Warhol wrote as a sort of credo of his philosophy of context in 1975, "because something funny always happens. Believe me, because I've made a career out of being the right thing in the wrong space and the wrong thing in the right space. That's one thing I really do know about."[8] As early as 1948-49, Warhol had sought out and created controversy when he submitted a painting entitled *The Broad Gave Me My Face, But I Can Pick My Own Nose* to the Associated Artists annual exhibition in Pittsburgh.[9] Given the opportunity to have an exhibition of his drawings five or six years later in New York, Warhol surprised his friends with a sort of proto-installation

piece, covering the walls and floor of the Loft Gallery with folded sheets of marbleized paper.[10]

This undocumented exhibition aside, Warhol's career as an installation artist began with one of his window dressings, on view for a week during April 1961 at Bonwit Teller's on Fifty-sixth Street in New York (fig. 5), where Jasper Johns had first exhibited two of his "Flag" paintings around 1957-58.[11] Understood as Warhol's first painting exhibition, it fulfills his "right thing in the wrong space" approach. To suggest that the fashion mannequins are visiting an avant-garde studio, Warhol included five of his own recent paintings, in appearance rather unlike any art that might be on view at the time. Certainly in the early sixties no paintings would be installed as these were here, unframed, unaligned, overlapping one another, one of them with a table for a pedestal.

Although the imagery of the paintings included at Bonwit's, appropriated from the works of comic book and advertising artists, prefigures the art-about-commercial-art theme of Warhol's first bonafide exhibition of "Campbell's Soup Cans" in Los Angeles the following year, the concept for his Ferus Gallery installation was apparently most indebted to abstract painter Frank Stella, whose serial "Aluminum Paintings" exhibition led off the fall 1960 season at the Leo Castelli Gallery. Taken to his studio by filmmaker Emile De Antonio, Warhol commissioned a set of six small-format versions of Stella's 1961 "Benjamin Moore" paintings, the color of each in effect representing a different variety of brand-name canned goods.[12] Poet Charles Henri Ford, who accompanied him to other artists' studios around this same time, asked Warhol why he bothered with these visits. "That's the way I get my ideas," was Warhol's reply.[13]

Whereas Warhol may have gotten his idea for a series of painted cans from Stella's series of canned paint colors, he chose Campbell's Soup out of longstanding consumer loyalty to the product.[14] However, Warhol's decision in 1961 to begin to paint

cans (rather than bowls) of the soup, as well as cans of Del
Monte peaches and Martinson coffee, amounts to an "anything-
you-can-do-I-can-do-too" art joke, aimed at Johns's highly pub-
licized 1960 sculpture of cans of Ballantine ale (fig. 6).[15] But
given Warhol's unrequited admiration for Johns and Robert
Rauschenberg in the early 1960s, this joke is somewhat ear-
nest.[16] Johns himself owned Rauschenberg's small combine box
sculpture, *Paint Cans,* 1954, and this work too may have been a
starting off point for Warhol, if not for his can paintings, then
for the "Boxes" sculptures of 1963-64.[17] Rauschenberg acquired
Warhol's *Popeye,* 1961, a related subject in a far-fetched way con-
sidering how this comic book hero gains superhuman strength
from canned spinach.

It was Rauschenberg's solvent transfer technique, however,
that interested Warhol most of all at this time, and one of
Rauschenberg's transfer drawings, *Pewter Drawer,* 1961, actually
includes the image of a can of Campbell's soup as a color accent.
Warhol's admiration for his colleague is made explicit in the
title—*Let Us Now Praise Famous Men*—that Warhol chose for one
of his six 1962-63 silkscreen paintings of Rauschenberg and his
family (fig. 52). It was in 1962 that both Warhol and Rauschen-
berg, trading information, began to use silkscreens to transfer
photographic images onto their canvases. On different occasions
Warhol credited himself both with introducing the technique
and with copying it from Rauschenberg.[18]

Johns, Rauschenberg, and Warhol all found a mentor in
Marcel Duchamp, the first champion for the appropriation of
everyday consumer goods as readymade art.[19] The great majority
of Warhol's paintings, beginning in 1962, including the "Camp-
bell's Soup Cans" (figs. 4 and 49), are absolutely literal represen-
tations of banal objects in the tradition of Duchamp's famous
readymades, and several specific works and gestures were con-
ceived as art jokes alluding to Duchamp. Warhol's large *Handle
With Care—Glass—Thank You,* 1962 (fig. 7), for example, is a fa-

cetious homage to Duchamp's legendary *Large Glass,* since the labels repeated over Warhol's painting suggest in trompe l'oeil fashion that the hidden support is glass, when it is in fact canvas.[20] The "Oxidation" paintings of 1978 (fig. 8), which appear to mimic the gestural brushwork of such modern masters as Jackson Pollock or Sam Francis, are also homages to Duchamp, this time to his famous urinal readymade, *The Fountain,* 1917, since Warhol achieved his gestural effect by urinating on these canvases.[21]

Nevertheless, whereas Duchamp claimed to have a horror of repeating himself, Warhol's grid composition paintings, such as *Handle With Care — Glass — Thank You* and *100 Campbell's Soup Cans* (fig. 87), are attempts to make a decorative virtue out of repetition.[22] What seems clear is that Warhol based the composition of his decorative grid paintings on the regular grids of Johns's "Alphabet" and "Numbers" paintings (fig. 9), the first of which date to 1955.[23] Moreover, Johns's "Numbers" paintings, as well as other works with numbers as subject matter by Rauschenberg and Cy Twombly, among others, were also a frame of reference for Warhol's "Do-It-Yourself" paintings (fig. 44). These represent partially completed paint-by-number pictures of the sort first marketed for children and amateurs in 1952 by the Palmer Paint Company in Detroit.[24] They playfully reiterated the then pervasive Greenbergian theoretical issue of depicted versus literal flatness used to interpret Johns's works. One of these was included in a group show entitled *The New Realists* at the Sidney Janis Gallery from October 31 through December 1, 1962.

Warhol's "Dance Diagram" paintings, one of which was also included in *The New Realists* show, likewise refer to the widespread numeral imagery in 1950s art.[25] In general, the subject of dance has especially Johnsian/Rauschenbergian overtones, given these artists' long collaborative association with the Merce Cunningham troupe, and Warhol's *Dance Diagram — Tango* (fig.

10) is specifically an allusion to Johns's painting, *Tango,* 1955.[26] Although they were painted on his studio wall,[27] Warhol's "Dance Diagram" paintings of stylized footprints appropriated from a teach-yourself book were exhibited on the floor, with deadpan logic.[28] Warhol had evidently begun to experiment with paintings in the spirit of rugs even earlier. As he told an interviewer in 1976, "Then there were the canvases that I used to leave on the street and people used to walk on them; in the end I thought they were all diseased so I rolled them up and put them away."[29] Abandoning these works with their image-by-proxy concept, Warhol, in his "Dance Diagram" pictures exhibited on the floor, nevertheless invites spectator participation. Addressed to would-be dance students, Warhol's paintings act as potential pedestals for performers in a way analogous to Rauschenberg's use of a collage painting as a base for the tire-girded goat in his 1959 combine sculpture, *Monogram.*

Just one week after the opening of *The New Realists,* with three of Warhol's unique, hand-produced paintings on view, the Stable Gallery opened Warhol's first one-artist exhibition in New York. In addition to versions of the works at the Janis group show, including a *Do-It-Yourself* painting and a *Dance Diagram* on the floor, this sell-out exhibition included some of Warhol's earliest silkscreen paintings[30] based on photographs from current periodicals of celebrities, such as Elizabeth Taylor, Marilyn Monroe, and Elvis Presley. The four "Marilyn" paintings in different decorator colors, evidently installed together in the gallery's hallway, were an important prologue to the expanded decorative installations of series silkscreen paintings that would shortly become Warhol's hallmark.[31]

Heralded as one of the pioneer Pop artists in *Time* magazine in May 1963, Warhol made a startling statement: "Paintings are too hard. The things I want to show are mechanical. Machines have less problems. I'd like to be a machine, wouldn't you?"[32] To take full advantage of the mass-production potential

of the silkscreen technique, Warhol rented an old firehouse for a larger studio space and in June he hired Gerard Malanga as an assistant to make series of paintings, comparable to editions of prints, executed in acrylic paint on canvas. Malanga's first assignment was to help with a group of "Liz" paintings on silver backgrounds.[33] These were evidently in production for a show scheduled to open at the Ferus Gallery in September, as were the "Elvis" paintings, also with silver backgrounds, that were the next to be executed in the firehouse (fig. 11).[34] "I think somebody should be able to do all my paintings for me," Warhol explained to Gene Swenson.[35] Appropriately enough, the still larger loft studio space on East Forty-seventh Street, where Warhol installed himself in November 1963, came to be known as the Factory. The silver-foil interior decor, for which Billy "Name" Linich was responsible,[36] provided a "silver screen" background, like those in Warhol's recent paintings, for all of his helpers and visitors.[37]

Commenting on the Guggenheim Museum's March-June 1963 exhibition, *Six Painters and the Object,* one of many group shows of Pop art organized in this country and Europe throughout 1963 to include some of Warhol's silkscreen paintings, Aline Saarinen compared his repeated images to a sequence of frames in a filmstrip.[38] While not included in the Guggenheim show, several of Warhol's silkscreen paintings are literally images of stills from famous films, including one entitled *The Kiss (Bela Lugosi)* (fig. 12), based on the 1931 production of *Dracula.* Although Donald Judd's review[39] of *Six Painters and the Object* insinuates that, unlike his co-exhibitors Johns and Rauschenberg, Warhol could "only paint," he had evidently already begun to make his box sculptures[40] and around June he began to make underground movies.

Warhol emerged publicly as a filmmaker in September, when some of his "Kiss" films[41] were presented at the Grammercy Arts Theater (fig. 13).[42] Only one hundred feet long,

Warhol's "Kiss" films hardly demanded more extended viewing than one of the still photographs upon which he based his paintings.[43] At first Warhol took special pride in his perverse decision to innovate as a filmmaker by keeping his camera static,[44] thus eliminating motion from motion pictures, even in his longer films, from *Sleep* (July 1963, fig. 14) to *Empire* (June 1964, fig. 75). These films in effect extend the concept addressed by Duchamp in his 1918 glass "painting" entitled *To Be Looked At With One Eye Close To, For Almost an Hour*. And although Warhol may not have been aware of the fact, *Sleep* echoes a project already suggested in 1942 by Duchamp's associate, André Breton:

*Nothing has charmed me more than that series of photographs published recently in an American magazine, reproducing some of the successive attitudes taken by a man during the course of one night's sleep. I should have preferred for the sleeper's movements to be filmed without interruption and run off on a screen in fast motion.*[45]

It was also in September 1963 that Warhol drove to Los Angeles with friends for the opening of his second one-artist show at the Ferus Gallery. This consisted of twelve "Liz" paintings in one room[46] and in another room a group of nearly life-sized silkscreen paintings of Elvis that Warhol had previously shipped to the gallery (fig. 11). To gallery director Blum's astonishment, Warhol had sent a roll of canvas printed like a Chinese scroll with variants of a single publicity image of Presley as a cowboy for his 1960 movie, *Flaming Star*.[47] Warhol left it to Blum to cut the roll into conventional-format paintings to be mounted on various sizes of stretchers. His instructions were remarkably limited: "The only thing I really want is that they should be hung edge to edge, densely—around the gallery. So long as you can manage that, do the best you can."[48] Thus, Warhol relinquished control of his remaining artist's perogatives, as he had already relinquished control over the selection and rendition of his images to friends and assistants. Unsolicited as it may have been,

Blum's role in the September 1963 exhibition was crucial to
Warhol's concept for his subsequent wallpaperlike installation
pieces executed with the help of collaborators.

The cinematic qualities of the "Elvis" paintings were car-
ried still further in the "Jackie" series (fig. 15). Explaining these
grid paintings composed from a variety of related newspaper im-
ages, Warhol pointed out ". . . it was just to show the passage of
time from the time the bullet struck John Kennedy to the time
she buried him."[49] The assassination of Kennedy on November
22, 1963, must have been especially shocking to Warhol,[50] who
had worked on pictures of death and disaster from the summer
of 1962 until the summer of 1963.[51]

Although Warhol included a few of these works rendered
in decorator colors in museum group shows, evidently no dealer
was interested in such unsaleable pictures at first. By the time of
Warhol's interview with Swenson in the summer of 1963, how-
ever, Ileana Sonnabend had decided to do a show devoted to
them: "My show in Paris is going to be called 'Death in Amer-
ica.' I'll show the electric chair pictures and the dogs in Bir-
mingham and car wrecks and some suicide pictures."[52] As it
turned out, the "Jackie" paintings, executed with the help of
Malanga in December,[53] would be incorporated into this exhibi-
tion, which opened in January 1964. Even Warhol's grim pic-
tures for the Sonnabend show seem on one level to be art jokes.
The "Tunafish Disasters" (fig. 16) allude to Warhol's own
"Campbell's Soup Cans," of course, and in the context of the
early 1960s art scene the "Car Crashes" (fig. 17) recall Jim
Dine's 1960 happening, Car Crash, but even more they recall
John Chamberlain's sculptures made of crushed automobile body
parts painted in factory colors. These were first exhibited in
1960, and Warhol acquired one entitled Jackpot (fig. 18) the fol-
lowing year to place on the staircase landing of his home.[54]

At once a beguiling and upsetting mixture of naive
sincerity and shrewd publicity baiting, Warhol's anticommer-

cialism was building to a peak during the last half of 1963. In response to the explicit sexuality of some of George Segal's plaster sculptures, Warhol was at work on what he described as a pornographic picture visible only under ultraviolet light for the *First International Girlie Exhibition* at the Pace Gallery in 1964.[55] And for the "Boxes" exhibition organized by John Weber for the Dwan Gallery in Los Angeles, which opened in February 1964, Warhol unveiled his sculptures for the first time, trompe l'oeil versions of the wholesalers' shipping cartons for brand-name groceries. Extending the commercial art theme of his can paintings to its next logical dimension, Warhol exhibited four such sculptures, three "Brillo Boxes" (fig. 19) and one *Heinz Box,* at Dwan.[56] Challenging taste by attempting to shame collectors into a reexamination of their commitment to advanced art, Warhol's "Boxes" were a slap in the face to the conventional art prerequisite of saleability. Anyone who might agree to litter a home or museum with packaged-goods cartons could acquire the real things for next to nothing, and thus turn the tables on Warhol's visual joke.[57] Nathan Gluck, who helped Warhol with the "Boxes," recalls his determination to appropriate only the least visually interesting carton designs, in line with his conviction to make "Commonist" (meaning common) art.[58]

Whether by way of coincidence, intuition, or premeditated parody, the formal component of Warhol's first sculptures followed close on the heels of a brand new trend in American art: the presentation of regular, or nearly regular, rectangular structures directly on the floor.[59] Works of this sort by Tony Smith, Robert Morris, Anne Truitt, and James Byars were prominently displayed in Sam Wagstaff's *Black, White, and Gray* exhibition at the Wadsworth Atheneum in Hartford from January 9 through February 9, 1964, which also contained some of Warhol's silkscreen paintings. The historical genesis of boxlike sculpture on the floor around 1960, by artists as diverse as Louise Nevelson, Mark di Suvero, Walter de Maria, Donald Judd, and Carl Andre,

is too complicated to reconstruct here in detail, but Warhol's boxes call the bluff of this theoretically charged issue with *faux-naïve* humor. Out of all the sculptors involved with this genre, Marisol and Larry Bell would probably have been the most familiar to Warhol. The former began exhibiting her witty carved and/or painted stacked box figural sculptures in 1962 at the Stable Gallery, with which Warhol was associated, and she used Andy as the subject for one of these in 1963 (fig. 20).[60] Bell's exhibition of his early box sculptures at the Ferus Gallery immediately followed Warhol's show there in 1963.

Around January 1964, Warhol threw himself into high gear to make approximately three hundred boxes for his April-May Stable Gallery show, according to its owner, Eleanor Ward, who helped him with the installation (fig. 21).[61] Gregory Battcock and Billy Linich were among the Factory assistants enlisted to silkscreen the boxes' rectangular plywood sides, transforming them into impersonations of Mott's boxes, Del Monte boxes, and Campbell's boxes, as well as Brillo boxes in two sizes, and Kellogg's Cornflakes boxes.[62] Realizing that the Stable exhibition was fundamentally an environment or installation piece, the critic Sidney Tillim worried that individual boxes removed from context would be dubious relics.

*The place looked like a very neat warehouse. The boxes were sold — and they did sell — singly and in groups. One wondered, of course, if a single box, or a few boxes, would reproduce the effect of the ensemble in a gallery where they could so successfully repudiate any art quality whatsoever. . . . Another environment, particularly a collection, would at least be a contradiction, unless the collector enjoyed being laughed at.* [63]

Accounts published later suggest, on the contrary, that sales were few.[64]

Judging from photographs, the warehouse-style installation, with "Boxes" stacked all over the floor, even on the window sill, some reaching up to the ceiling, was something like a set for a

happening waiting to happen as gallery spectators entered to be-
come the unwitting performers.[65] This was the first chance for a
New York audience to experience Warhol's obsession with repe-
tition as a strategy for installation art, which had already been
demonstrated, albeit more conventionally, at his painting exhibi-
tions in Los Angeles in 1962 and 1963. Although journalists did
not immediately draw attention to the obvious superficial rela-
tionship, it is hard to imagine that anyone interested in contem-
porary art failed to notice that the "Boxes" show was a parody
of the happenings and installation exhibitions that had been or-
ganized by artists associated with the Hansa, Judson, Reuben,
and Martha Jackson galleries, including Jim Dine and Claes
Oldenburg.[66] The latter's celebrated *Store,* consisting of painted
plaster, papier-mâché, and cardboard cartoon sculptures of
everyday consumer goods, presented in May and again in Sep-
tember 1961, was surely the foremost butt of Warhol's latest art
joke. Ted Carey, who accompanied Warhol to the *Store,* recalls
that "it was so overwhelming and so fabulous that Andy was so
depressed. He said, 'I'm so depressed.'"[67]

Oldenburg, himself an avid proponent of art jokes, helped
to pioneer the genre of floor sculpture in the early 1960s, and
Warhol's decision to begin making underground films in 1963
must have been in part a response to Oldenburg's 1962 "Ray
Gun Theater" performances, the sets for which had been in-
spired by filmmaker Jack Smith.[68] Considering this ongoing
dialogue with Oldenburg's work, the April 1964 "Boxes"
installation amounted to a slightly late entry into the *Four En-
vironments by Four New Realists* exhibition at the Janis Gallery in
January of the same year, which excluded anything by Warhol,
but included works by Dine, Rosenquist, Segal, and Oldenburg,
whose fabricated *Bedroom Ensemble* marked a Warholian shift in
his work away from his prior hand-made aesthetic.

Although Warhol *was* among the Pop artists from whom
works were commissioned for the World's Fair in Flushing

Meadows, his silkscreen murals, installed by April 17, were censored by Governor Rockefeller because of their subject matter and covered over with whitewash (figs. 22 and 23).[69] Dropping his original idea to use the Heinz pickle as a theme to allude to a souvenir pickle distributed at the 1939 World's Fair, Warhol had decided instead to realize an idea related to his disaster series and executed murals based on police photographs of wanted criminals with their identification numbers.[70] A Dada gesture at billboard scale, the "Thirteen Most Wanted Men" paintings alluded to *WANTED/$2,000 REWARD* (fig. 24), a 1923 work which Duchamp had reproduced as a poster for a retrospective exhibition, the opening of which Warhol had attended during his trip to Los Angeles in 1963. Given Warhol's yen for publicity, the lack of press coverage of the murals' censorship seems astounding.[71]

By the time that Warhol's first show at the prestigious Leo Castelli Gallery in New York opened on November 21, 1964, Warhol's foremost preoccupation was filmmaking. The summer 1964 issue of *Film Culture* bestowed its sixth Independent Film Award on Warhol, and his films were included at the New York Film Festival in September. Perhaps the demands that filmmaking made on his time were a factor in his decision to enlist assistance to produce yet another environment for the Castelli exhibition, this time a room covered with, for the most part, square "Flowers" paintings (fig. 25). All of these works were made from silkscreens based on blow-ups of a photograph, five versions of which were published as part of an article about variations in color printing in the June 1964 issue of *Modern Photography*.[72] Henry Geldzahler, who takes credit for suggesting that Warhol undertake a series of "death" paintings two years earlier, also claims to have suggested the source for the "Flowers" as a sort of antidote.[73] Although Geldzahler chose the image at random, it seems significant that this photograph bore striking graphic similarities to Warhol's own wrapping paper design

watercolors made in the late 1950s (fig. 26),[74] as well as to the recent flower paintings by Martial Raysse.[75]

During an interview, Warhol implied that he had painted the "Flowers" in a relatively short period just before the opening:

*I was going to show all Goldwater [silkscreen paintings] if he won [the presidential election held on November 3], because then everything would go, art would go . . . But no it's going to be all flowers — they're the fashion this year. They look like a cheap awning.*[76]

Besides suggesting how quickly he could determine and fulfill the concept for a major show with the help of silkscreens and assistants, this remark is an astounding revelation about a different installation idea that Warhol would not realize until eight years later when he began to address political issues in his installations with the "Mao" paintings and later with the "Hammer and Sickle" paintings. Warhol's reference to "a cheap awning" is no less significant. With twenty-eight of the small-format versions arranged in rows to completely cover a large partition wall, the "Flowers" resembled not only oversized swatches of a repeat-pattern printed fabric in different colors, but wallpaper. Complaining that Warhol's exhibition smacked of Salvador Dali style commercialism, Thomas Hess quipped: "It is as if Warhol got hung up on the cliché that attacks 'modern art' for being like 'wallpaper' and decided that wallpaper was a pretty good idea."[77] If the idea had not already occurred to Warhol, who would begin to produce real wallpaper as art by 1966, Hess's remark apparently brought it to his attention.[78] In any event, the "Flowers" are too somber to function successfully as wallpaper. The green grass and bright artificially colored petals in Warhol's paintings seem out of key with the tragic black backgrounds upon which he printed the image.[79]

The references to politics, fashion, and "flower children" notwithstanding, these ostensibly upbeat paintings had funereal

associations for Warhol.[80] He told one critic that the large for-
mat *Flowers* in white was dedicated to his dancer friend Fred
Herko, who had recently committed suicide.[81] In this regard, it
should be stressed that the Castelli exhibition contained a single
*Jackie* painting in a back room.[82] "Maybe I should have made the
whole show just Jackie," the artist confided.[83]

In retrospect, the Castelli show can be understood to have
marked the end of the first phase of Warhol's career. Instead of
conceiving a new work for his exhibition in May 1965 at the
Galerie Ileana Sonnabend in Paris, Warhol decided once again to
show the "Flowers" (fig. 27),[84] repeating the earlier installation
as he had previously repeated the same image in one work and
then repeated single works like impressions in a print edition.
Even if components of any given installation piece were sold to
collectors, Warhol's Factory could easily make others as replace-
ments for recreations of his decorative ensembles. For the Paris
show Warhol printed up scores of new "Flowers" paintings in
tiny formats.[85]

It was at this show in Paris that Warhol announced his re-
tirement (only partial and temporary, as it turned out) from
painting in order to devote himself more to filmmaking.[86] Of
course, this announcement was a sort of gesture in the spirit of
Duchamp, who decided in 1918 to give up painting. Moreover,
Warhol's "Flowers" installation now addressed its most impor-
tant historical precedent. The gallery in Paris was located only
a short distance across the Seine from the Orangerie where
Claude Monet's ultimate *Water-Lilies* murals, 1918-26, images
observed from above like Warhol's, are permanently installed.
"In France they weren't interested in new art," Warhol wrote
later. "They'd gone back to liking the Impressionists mostly.
That's what made me decide to send them the Flowers."[87] War-
hol may have been unaware that Monet had referred to his own
large works as "decorations." Yet, when in 1966 an interviewer
asked whether homes made better settings for his paintings than

art galleries, Warhol replied, "It makes no difference — it's just decoration."[88] By then, he also conceived of his movies as decor not requiring special attention from the viewer.[89]

For the most part, Warhol kept to his word about not making any new paintings, although when the situation called for it (he had not retired from sending paintings to exhibitions) he would make new versions of works already conceived before his retirement. For example, photographs of the Factory taken by Stephen Shore in early 1965, when Warhol was producing the "Flowers" for his Paris show, record his earliest "Cows" and a new group of self-portraits.[90] Ivan Karp's recollections about the genesis of Warhol's last early images suggest that Warhol had by then already become dissatisfied with his painter's persona.

*In 1965, Warhol said that he was using up images so fast that he was feeling exhausted of imagination. . . . He asked, "What shall I paint? What's the subject?" I couldn't think of anything. I said, "The only thing that no one deals with now these days is pastorals." I said, "My favorite subject is cows." He said, "Cows!" He said, "Of course! Cows!" He said, "New cows! Fresh cows!"[91]*

When Karp shortly afterwards suggested the possibility of self-portraiture, Warhol returned to this theme with which he had already experimented in 1964 (fig. 28).[92]

For his films Warhol needed to earn money rather than the sort of notoriety that came from gallery exhibitions of art conceived to be unsaleable. To this end, Warhol placed an advertisement in the *Village Voice* (the exact date of publication needs to be reestablished), offering to make endorsements for any sort of commercial product, and that despite his retirement he was willing to paint on commission. Holly Solomon asked Warhol to make three silkscreen painting portraits of her in 1966 (fig. 29) and to produce a wallpaper with the same image that would serve as a decorative background. She recalls that the price quoted for the paintings was reasonable enough ($1,000 apiece),

but that Warhol wanted $6,000 to have the wallpaper fabricated. In the end she opted against the expensive wallpaper but purchased all eight paintings that the enterprising Warhol made from one of a vast number of photographs that he had instructed her to make in a do-it-yourself photomat.[93]

The exact connection, if any, between the unrealized commission for this portrait wallpaper and Warhol's decision to have his cow image fabricated as wallpaper for one room of his two-part exhibition at the Leo Castelli Gallery in April-May 1966, is open to debate (fig. 30). Whatever the case, the idea for the *Cow Wallpaper* would seem to have been the logical, literal extension of the commercial art implications of the previous year's "Flowers" installations. Of course, ever since Édouard Vuillard's pioneering efforts to make decorative paintings in which the background takes a dominant role, wallpaper had begun to play a prominent part in the paintings and collages of such artists as Matisse, Picasso, and Braque. Playing off this tradition in the spirit of Raoul Dufy, Warhol's installation of *Cow Wallpaper* was an all-background art, a sort of stage set against which visitors to the gallery could watch one another "perform." No matter how perverse (in the sense of "the wrong thing in the right space") Warhol's concept to exhibit wallpaper as art, the realistic photo-based image of a cow's head, printed in artificial colors (pink on a yellow background), is totally unsuitable for a wallpaper design. Its left side does not interlock graphically with its right side as repeat patterns must. Instead, Warhol's *Cow Wallpaper* is like a printed film strip of a close-up shot for one of his motionless movies.

Warhol's helium inflated "Silver Pillows," about fifty of which floated about in an adjoining room in the same exhibition (fig. 31), are in every way (except for the repetitive use of a module) the antithesis of the *Cow Wallpaper:* sculptural rather than pictorial, foreground rather than background, nonfunctional as opposed to utilitarian, colorless as opposed to garish.

Warhol explained to Alan Solomon:

*Since I didn't want to paint any more, I thought . . . that I could give that up and do the movies. And then I thought that there must be a way that I have to finish it off, and I thought the only way is to make a painting that floats. And I asked Billy Klüver to help me make a painting that floats, and he thought about it and he came up with the . . . the silver—since he knew I liked silver he thought of the silver things that I'm working on now and the idea is to fill them with helium and let them out of your window and they'll float away and that's one less object . . . to move around. And, it's the . . . well, it's the way of finishing up painting.*[94]

According to Billy Klüver,[95] however, Warhol's first idea was to make inflatable vinyl light bulbs, an allusion to Johns's lead-colored 1958 sculpture, a drawing of which Warhol had purchased from the Castelli Gallery in 1961.[96] But, since such a form would not float properly, the pillow idea, apparently an allusion to one of Rauschenberg's favorite motifs, if not to Warhol's own 1963 film, *Sleep,* was developed instead. Since the silver material for Warhol's "Silver Pillows" could be understood as an emblem for his famous tin-foil decorated Factory studio, it is worth mentioning that Johns had recently completed a large, mostly gray painting based on impressions of the doors and windows in his own studio.

At the Castelli Gallery, the "Silver Pillows" reflected everything, the doors as well as visitors, who could observe their reflections as, literally, moving pictures. Considered as paintings, the "Silver Pillows" were a rejoinder to the recent vogue for shaped canvases chronicled in an exhibition at the Guggenheim Museum in December 1964, especially Frank Stella's "metallic" paintings. Considered as sculptures, they mimic the surfaces of David Smith's *Cubi,* 1962, and sheet-metal sided works by Minimal sculptors, no less than the antics of Jean Tinguely's kinetic machine creatures. Whereas Warhol had dispensed with conven-

tional bases for his "Boxes" sculptures exhibited on the floor, now he addressed the pedestal issue with the help of levitation. In this theoretical sense, Warhol's "Silver Pillows" should perhaps be understood as an art joke version of hanging sculptures, such as Oldenburg's *Ice Cream Cone,* 1962, or Robert Morris's suspended *Cloud,* 1964.

Warhol, whose contemporaneous *Self-Portrait,* 1966-67 (fig. 28), shows him covering his mouth with his hand, had little to say about their meaning, although at the opening he opened a window and let one of the floating sculptures drift away.[97] Only later did he explain this gesture: "I felt my art career floating away out the window."[98]

That career had already been documented in a retrospective exhibition at the end of 1965 in Philadelphia at the Institute of Contemporary Art, and another retrospective was scheduled at the Institute of Contemporary Art in Boston for the end of 1966. When art galleries or museums requested Warhol's participation in shows now, he would comply by circulating single works or installations no differently than he distributed prints of his films for screenings in different cities. The "Thirteen Most Wanted Men" paintings went to Paris and Cologne in 1967 and to London in 1968. The "Flowers" reappeared in Stockholm in 1968, in Milan in 1971, and again that same year in Los Angeles as part of a rain machine contraption that Warhol made for Maurice Tuchman's *Art and Technology* exhibition.[99]

As for the *Cow Wallpaper* and "Silver Pillows," there were showings in Los Angeles in 1966,[100] in Cologne in 1967, and in Stockholm (for a retrospective at the Moderna Museet) and Bern (for a group show of installation artists at the Kunsthalle) in 1968. In Stockholm, the *Cow Wallpaper* was applied in Christo fashion to the *outside* of the museum building.[101] Invited to create a set for Merce Cunningham's *Rainforest,* performed in Buffalo in 1968, Warhol again used the "Silver Pillows" idea.

When Mario Amayo approached him about the possibility

of a retrospective at the Institute of Contemporary Art in London in 1968, Warhol suggested that he borrow the thirty-two "Campbell's Soup Cans" paintings that Irving Blum had acquired in 1962 and space them at intervals throughout the museum. Amayo and Warhol were shot by Valerie Solanis during their discussion.[102] Two years later, when a touring retrospective of his works was organized by the Pasadena Museum, Warhol, his tongue probably in his cheek à la Duchamp, complained: "I wanted them to let me do something new, but they said that it was a retrospective and a retrospective means you have to show all those old things, so I guess it's O.K. But I would rather have done something new and up-to-date."[103] As a special gesture for his New York audience, Warhol considered several possibilities for the Manhattan venue of this retrospective in the spring of 1971. Leo Castelli heard that Warhol wanted to do the "Flowers" there.[104] And, according to reports in the press, Warhol suggested that he cover the Whitney Museum galleries with *Cow Wallpaper,* applied backwards.[105] In the end, his *Cow Wallpaper* was used in conventional fashion as a most unconventional background for his paintings in the exhibition.

It was only in 1972 that Warhol came out of retirement with a new show of ten screenprints in different colors of the same image of Mao, based on the frontispiece photograph to *Quotations from Chairman Mao Tsetung,* first published in English in 1966. In 1974 he showed drawings based on the same image at a gallery in London, while he realized his largest installation yet, Mao drawings, paintings, and wallpaper, at the Musée Galliera in Paris.[106] As already mentioned, the basic concept for this installation evolved in 1964 during the Goldwater-Johnson election campaign. As for the image of Mao, Warhol apparently recalled, or wanted to allude to, works by his old friends Marisol and Dali. She had done a paper sculpture head of the Chinese leader in 1967. He had produced a composite photograph of the faces of Mao and Marilyn Monroe for the 1971 Christmas issue

of the French edition of *Vogue.* In a similar art-about-art spirit, Sigmar Polke's large *Mao* painting, now in the Museum of Modern Art, New York, was apparently a response to the publication of Warhol's prints.

Awareness of the historical antecedents and precedents for any of Warhol's images, awareness that is of the historical context in which his art developed, will eventually make it clear how he was always guided by a wry sense of conceptual contextual gesture. Under the circumstances, it seems particularly fitting that so-called appropriation artists, from the pioneer Elaine Sturtevant to Mike Bidlo, have so often copied works by Warhol. More than anyone, he opened wide the door to this postmodern conceit.

Although the limited scope of this essay precludes detailed examination of Warhol's works after 1974, it seems appropriate to mention in conclusion the possibility that the most remarkable of his late exhibitions, the *Shadows* installation, presented in New York at the Lone Star Foundation, formerly the Heiner Friedrich Gallery, in early 1979 (fig. 32), was an homage to Rauschenberg's *White Paintings,* executed beginning around 1949. Several of these were included in the retrospective of Rauschenberg's art organized by the National Collection of Fine Arts, Smithsonian Institution, to tour American museums from 1976 to 1978. Whereas Rauschenberg designed these proto-installation paintings as blanks to register the play of shadows in the space where they are exhibited, Warhol literally depicted a shadow, repeating it on eighty-three canvases installed edge to edge around the gallery space. Like Rauschenberg, Warhol had evidently now reached the stage of his career where he felt willing to reflect backwards on the evolution of his art. At least, the series entitled "Reversals" (fig. 33) that Warhol presented in the spring of 1980, consisting of a group of paintings based on his own earlier motifs, amounts to his own retrospective in which his old images are presented in a new, now self-appropriating context.

## Notes

I am especially indebted to Carole Tormollan, an art history student at the
School of the Art Institute of Chicago, who gathered the documentation for this
paper.

1. Phyllis Tuchman, "American Art in Germany: The History of a Phenome-
non," *Artforum* 9, no. 3 (November 1970): 58-69.

2. Warhol himself indicated that examples of his art should be regarded as sou-
venirs of his exhibitions, according to John Perreault, "Expensive Wallpaper,"
*Village Voice*, May 13, 1971, p. 27; later he explained, "Like the *Flowers* were one
big painting that was cut up in small pieces. So I guess you could put them all
together." See Phyllis Tuchman, "Pop!" *Art News* 73, no. 5 (May 1974): 26.

3. An exception is Warhol's "Shadow" installation, which he referred to as
"one painting with eighty-three parts" when it was first exhibited at the Heiner
Friedrich Gallery in New York from January 27-March 10, 1979; see *Warhol
Shadows* (Houston: The Menil Collection, 1987).

4. Patrick S. Smith, *Andy Warhol's Art and Films* (Ann Arbor, Mich.: U.M.I. Re-
search Press, 1986), pp. 219-220. It was Blum, not Warhol, who conceived of
installing the "Campbell's Soup Cans" paintings on little shelves in 1962; au-
thor's conversation with Irving Blum, January 25, 1980.

5. See John Coplans, *Serial Imagery* (Pasadena: Pasadena Art Museum, 1968).

6. The importance of the installation context was, however, stressed by Stephen
Koch, "Warhol," *The New Republic,* April 26, 1969, pp. 24-25, and John Coplans,
"Andy Warhol and Elvis Presley," *Studio International* 181, no. 930 (February
1971): 49.

7. Patrick S. Smith, *Art and Films,* and *Warhol: Conversations About the Artist* (Ann
Arbor, Mich.: U.M.I. Research Press, 1988), which repeats some of the same
material.

8. Andy Warhol, *The Philosophy of Andy Warhol: From A to B & Back Again* (New
York: Harcourt Brace Jovanovich, 1975), p. 158.

9. Smith, *Art and Films,* p. 16; Smith, *Conversations,* pp. 16 and 32.

10. Smith, *Art and Films,* pp. 329 and 332; Smith, *Conversations,* p. 50.

11. Rauschenberg and Rosenquist also incorporated their early works into com-
mercial art displays for Bonwit's. See Smith, *Art and Films,* pp. 98 and 167;
Smith, *Conversations,* p. 111. Artists such as Salvador Dali and John Graham had
done this already in the 1930s and 1940s.

12. Andy Warhol and Pat Hackett, *POPism: The Warhol '60s* (New York: Harcourt
Brace Jovanovich, 1980), p. 9. Warhol gave the set to the Brooklyn Museum.

13. Charles Henri Ford, in John Wilcock, *The Autobiography & Sex Life of Andy
Warhol* (New York: Other Scenes, Inc., 1971), unpag.

14. Gene Swenson, "What is Pop Art?" *Art News* 62, no. 7 (November 1963): 26;
for friends' corroboration of his claim, see Smith, *Art and Films,* pp. 377 and 401.

15. Ford in Wilcock, *Autobiography & Sex Life*, unpag.; Hugh Kenner, *The Counterfeiters: An Historical Comedy* (Bloomington: Indiana University Press, 1968), pp. 72-73.

16. Warhol and Hackett, *POPism*, p. 11; see also Smith, *Art and Films*, p. 245. John Cage, *Silence: Lectures and Writings* (Middletown, Conn.: Wesleyan University Press, 1961), p. 100, pointed out how Rauschenberg was willing to incorporate his friends' contributions into his works.

17. The earliest published reference to Warhol's sculpture is the reference to "enormous boxes of detergent" in the account of a visit to his studio by Aline B. Saarinen, "Explosion of Pop Art," *Vogue*, April 15, 1963, p. 134. The objects in the foreground of Tom Wesselman's *Still Life #17*, 1962, apparently a parody of recent works by Warhol, among others, includes a Brillo box, and thus may indicate a slightly earlier date for their conception. Both Wesselman's *Still Life #17* and *Still Life #19*, which includes a box of Lipton's Soup Mix and a Del Monte can, were included in *The New Realists* exhibition at the Sidney Janis Gallery, October 31-December 1, 1962.

18. See John Coplans, "Early Warhol," *Artforum* 8, no. 7 (March 1970): 54-55; Ford and Sam Green, in Wilcock, *Autobiography & Sex Life*, unpag.; *Andy Warhol: Transcript of David Bailey's ATV Documentary* (London: Bailey Litchfield and Mathews Miller Dunbar, 1972), unpag.; Warhol and Hackett, *POPism*, pp. 22-23; Calvin Tomkins, *Off the Wall: Robert Rauschenberg and the Art World of Our Times* (New York: Doubleday & Company, 1980), p. 200; and Barbara Rose, *Rauschenberg: An Interview with Barbara Rose* (New York: Vintage Books, 1987), p. 78. Rauschenberg's interest in the silkscreen technique was partially predicated on his earlier use of newspaper photographs of collage and assemblage elements, and these details in early works such as *Gloria* (1956) exerted a significant influence on Warhol's ideas for paintings.

19. Warhol, whose familiarity with Duchamp's pioneering work from 1913 to 1921 was heightened by the multiple edition of fourteen of these early readymades that was issued in 1964 to celebrate the fiftieth anniversary of the art form, was aware of Duchamp as early as 1949; see Smith, *Art and Films*, pp. 14, 92ff, 322, and 454.

20. Ibid., p. 93, and see also p. 104 for Johns's subsequent quotation of Warhol's allusion here.

21. According to *The Unmuzzled Ox* 4, no. 2 (1976): 44, the idea for these paintings went back to the early 1960s, but this early dating is disavowed in Andy Warhol and Bob Colacello, *Andy Warhol Exposures* (New York: Grosset & Dunlap, 1979), p. 129.

22. Warhol could have heard Duchamp explain this attitude in the talk he delivered at the Museum of Modern Art on October 19, 1961. Duchamp would come to understand Warhol's heresy in conceptual art terms: "If a man takes

fifty Campbell's Soup Cans and paints them on a canvas, it is not the retinal image which concerns us. What interests us is the concept that wants to put fifty Campbell's Soup Cans on a canvas." Quoted in Samuel Adams Green, "Andy Warhol," in *The New Art*, ed. Gregory Battcock (New York: E. P. Dutton & Co., Inc., 1966), pp. 229-230.

23. Ellen H. Johnson, "The Image Duplicators: Lichtenstein, Rauschenberg, and Warhol," *Canadian Art*, no. 100 (January 1966): 17. Of course, Rauschenberg's incorporation of rows of Coca-Cola bottles into works like *Coca-Cola Plan* and *Curfew*, both 1958, provided the precedent for Warhol's Coca-Cola bottles grid paintings.

24. Warhol applied the numbers in these paintings mechanically; see Smith, *Art and Films*, p. 315. Harold Rosenberg, "The Game of Illusion," *The New Yorker*, November 24, 1962, pp. 161-167, categorized the works in *The New Realists* exhibition as "art comically talking about contemporary art."

25. Smith, *Art and Films*, p. 133, discusses them with reference to Warhol's personal interests in dance.

26. Robert Hughes, "The Rise of Andy Warhol," *New York Review of Books*, February 18, 1982, p. 7, suggested a reference to Piet Mondrian's "Fox Trot" paintings. Of course, Sidney Janis is famous for his ballroom dancing. Werner Spiess, "Critique of Emotionlessness," in *Andy Warhol: Cars* (New York: Solomon R. Guggenheim Museum, 1988), p. 22, interprets Warhol's "Dance Diagram" paintings as allusions to photographs and film strips of Jackson Pollock at work "dancing" around a canvas on his studio floor.

27. Smith, *Art and Films*, p. 314.

28. See Leo Steinberg, "Other Criteria," in *Other Criteria: Confrontations with Twentieth-Century Art* (New York: Oxford University Press, 1972); originally published as "Reflections on the State of Criticism" in *Artforum* 10, no. 7 (March 1972): 37-49. Steinberg commented on what he called the "flatbed" nature of strictly horizontal images, such as Rauschenberg's *Automobile Tire Print*, 1951, or *Bed*, 1955, conceived to be installed vertically on the wall.

29. *The Unmuzzled Ox*, p. 44; Smith, *Art and Films*, pp. 200 and 287.

30. According to Nathan Gluck, Warhol first made use of a prepared silkscreen to make his "Dollar Bill" paintings; see Smith, *Art and Films*, p. 315. For Warhol's account of his first silkscreens, see Gerard Malanga, "A Conversation with Andy Warhol," *Print Collector's Newsletter* 1, no. 6 (January-February 1971): 126.

31. A similar group of four "Marilyn" paintings was included in *The Popular Image* exhibition staged at the Washington Gallery of Modern Art from April through June 1963. For an account of the Marilyn theme in context, see Lawrence Alloway, "Marilyn as Subject Matter," *Arts Magazine* 42, no. 3 (December 1967–January 1968): 27-30. De Kooning's 1954 painting of Marilyn was included in the Museum of Modern Art's 1959 *New Images of Man* exhibition, the

catalogue to which discusses his use of magazine photographs for inspiration. Thomas Crow, "Saturday Disasters: Trace and Reference in Early Warhol," *Art in America* 75, no. 5 (May 1987): 13, misattributes to Warhol comments about De Kooning taken from an interview with Wesselman that was added by mistake at the end of Swenson's 1963 *Art News* interview with Warhol when it was reprinted in John Russell and Suzi Gablik, *Pop Art Redefined* (New York and Washington, D.C.: Praeger Publishers, 1969), pp. 118-119.

32. "Pop Art—Cult of the Commonplace," *Time,* May 3, 1963, p. 72.

33. Malanga, "Conversation," p. 125.

34. *Andy Warhol: Transcript of David Bailey's ATV Documentary.*

35. Swenson, "What is Pop Art?," p. 26.

36. Warhol and Hackett, *POPism,* p. 64.

37. The Factory probably reminded Rauschenberg of the all-silver decor that he had fashioned for his own home/studio around 1950; see Rose, *Rauschenberg,* p. 45. According to Alan Solomon, "Introduction," *Andy Warhol* (Boston: Institute of Contemporary Art, 1966), unpag., Warhol claimed to like silver because it makes things disappear.

38. Saarinen, "Explosion of Pop Art," p. 134.

39. *Arts Magazine* 37, no. 9 (May-June 1963).

40. Saarinen, "Explosion of Pop Art," p. 134.

41. Warhol's subject here spoofs the obligatory close-up in Hollywood romances, as well as such art "kiss" images as those by Brancusi and Duchamp.

42. Jonas Mekas, "The Filmography of Andy Warhol," in *Andy Warhol,* by John Coplans (London: Weidenfeld & Nicolson, 1970), p. 146.

43. Howard Junker, "Andy Warhol, Film Maker," *The Nation,* February 22, 1965, p. 207, described Warhol's project to make *Living Portrait Boxes* with 8mm film loops that "would be just like photographic portraits except that they would move a little."

44. Ronnie Tavel, in Wilcock, *Autobiography & Sex Life,* unpag.; Smith, *Art and Films,* pp. 151 and 510; Smith, *Conversations,* p. 120.

45. "Genesis and Perspective of Surrealism," in *Art of This Century,* ed. Peggy Guggenheim (New York: Art of This Century Gallery, 1942), p. 16. Spiess, "Critique of Emotionlessness," p. 30, suggests that John Cage's "Lecture on Nothing," published in 1959, may be a source for Warhol's films.

46. An installation shot of the "Liz" room was published in *Das Kunstwerk* 17, no. 10 (April 1964): 7.

47. Coplans, "Andy Warhol and Elvis Presley," p. 49. Gerard Malanga claims that he executed the ones with the overlapping images that seem the most cinematic; see Smith, *Art and Films,* p. 395. In *Andy Warhol: Transcript of David Bailey's ATV Documentary,* Warhol explained that most of the "Elvis" paintings were destroyed.

48. Smith, *Art and Films,* pp. 221-222. Of course, some of Warhol's "Marilyn" paintings with the image repeated in rows could conceivably be cut into dozens of individual pictures that had all been printed for convenience on the same section of an unstretched roll of canvas in assembly-line fashion, and these resemble repeat pattern wallpaper.

49. Gretchen Berg, "Nothing to Lose—Interview with Andy Warhol," *Cahiers du Cinéma in English* 10 (May 1967): 42.

50. For Warhol's initial nonchalant reaction to the news of the assassination, see Warhol and Hackett, *POPism,* p. 60. In subsequent years, however, the event became the subject of a portfolio of prints, "Flash—November 22, 1963," and a movie; see Smith, *Art and Films,* pp. 275 and 394.

51. Malanga, in Wilcock, *Autobiography & Sex Life,* unpag., claims that Warhol's "Disasters" series was completed when he began to work for him in June 1963. The first "Disaster" painting, its subject suggested by Ivan Karp, was based on the front page of the *New York Mirror* for June 4, 1962. See Neil Printz, "Painting Death in America," in *Andy Warhol: Death and Disasters* (Houston: The Menil Collection, Houston Fine Art Press, 1988), pp. 12 and 44.

52. Swenson, "What is Pop Art?," p. 60.

53. Smith, *Art and Films,* p. 394.

54. David Bourdon, in Wilcock, *Autobiography & Sex Life,* unpag. Warhol gave this sculpture to the Whitney Museum of American Art in 1975. Spiess, "Critique of Emotionlessness," p. 9, associates Warhol's "Car Crash" paintings with Jackson Pollock's death in an automobile accident.

55. Swenson, "What is Pop Art?," pp. 60-61. This is evidently the work described in Johnson, "The Image Duplicators," p. 28, and reproduced in Drs. Phyllis and Eberhard Kronhausen, *Erotic Art,* 2d ed. (New York: Grove Press, 1968), vol. 1, p. 186.

56. Donald Factor, "An Imaginative Exhibition . . . ," *Artforum* 2, no. 10 (April 1964): 23.

57. For the response of the commercial artist who designed the Brillo box that Warhol appropriated, see Grace Glueck, "Art Notes: Boom?" *New York Times,* May 10, 1964, p. 19; L.C., "Andy Warhol," *Art News* 63, no. 4 (Summer 1964): 16; and Smith, *Art and Films,* pp. 467-468.

58. Smith, *Art and Films,* p. 322. Ivan Karp also used this term at the time; see Calvin Tomkins, "A Good Eye and a Good Ear," *The New Yorker,* May 26, 1980, p. 62.

59. Of course, the historical roots of this genre go back to Duchamp's *Trap,* 1917, a coat rack that he attached to the floor.

60. This sculpture was included in her February 25–March 21, 1964 exhibition at the Stable Gallery. Lyman Kipp's painted plywood sculpture, *Andy's Carte Blanche,* 1965, exhibited in the *Primary Structures* exhibition at the Jewish Museum

in New York in 1966, apparently comments on the formal issues at stake in Warhol's "Boxes."

61. Eleanor Ward, in Wilcock, *Autobiography & Sex Life,* unpag.; Smith, *Art and Films,* p. 508.

62. Smith, *Art and Films,* pp. 216 and 396.

63. Sidney Tillim, "Andy Warhol," *Arts Magazine* 38, no. 10 (September 1964): 62; Glueck, "Art Notes," p. 19, had also commented on the surprisingly large number of sales.

64. Ward in Wilcock, *Autobiography & Sex Life,* unpag.; Smith, *Art and Films,* pp. 322 and 508.

65. For Warhol's unrealized exhibition "with live people hung on the walls as works of art," see Smith, *Art and Films,* p. 321.

66. For one example of the awareness of the Oldenburg/Warhol connection, see Emily Tremaine, "Her Own Thoughts," in *The Tremaine Collection: 20th Century Masters* (Hartford, Conn.: Wadsworth Atheneum, 1984), p. 29. The best account of these installations and happenings is Barbara Haskell, *Blam! The Explosion of Pop, Minimalism, and Performance, 1958-1964* (New York: Whitney Museum of American Art, 1984).

67. Smith, *Art and Films,* p. 255.

68. Barbara Rose, *Claes Oldenburg* (New York: Museum of Modern Art, 1970), p. 69.

69. Rainer Crone, *Andy Warhol* (New York and Washington, D.C.: Praeger Publishers, 1970), p. 30.

70. Smith, *Art and Films,* p. 323.

71. According to Martin Tolchin, "World's Fair Guards Increased to Curb Pilferage at Pavilions," *New York Times,* April 18, 1964, p. 16, Warhol himself requested the murals' removal, since they had not achieved the desired artistic effect. Architect Philip Johnson acted as Warhol's spokesperson.

72. David Bourdon, "Andy Warhol," *Village Voice,* December 3, 1964, p. 11.

73. Calvin Tomkins, in *The Scene* (New York: Viking Press, 1976), p. 19, and Smith, *Art and Films,* pp. 226-227. For his paintings Warhol cropped the photograph's horizontal composition, rotated its orientation, and changed colors. Patricia Caulfield, the photographer and executive editor of the magazine, brought a suit against Warhol for his appropriation, culminating in an October 1966 law case; see Gay Morris, "When Artists Use Photographs: Is It Fair Use, Legitimate Transformation, or Rip Off?" *Art News* 80, no. 1 (January 1981): 102-106.

74. For examples, see Rainer Crone, *Andy Warhol: The Early Work, 1942-1962* (New York: Rizzoli, 1987), no. 135, and Andreas Brown, *Andy Warhol: His Early Works, 1947-1959* (New York: Gotham Book Mart Gallery, 1971), p. 72.

75. Warhol described how he decided if a photograph or a friend's idea was useful in Malanga, "Conversation," pp. 126-127.

76. "Saint Andrew," *Newsweek*, December 7, 1964, p. 103; Crone, *Andy Warhol: Das zeichnerische Werk, 1942-1975* (Stuttgart: Württembergischer Kunstverein, 1976), p. 74, points out that Ben Shahn's poster for this election—an image of Goldwater with "Vote Johnson" as a legend—was the inspiration for Warhol's 1972 *Vote McGovern* screenprint.

77. Thomas Hess, "Andy Warhol," *Art News* 63, no. 9 (January 1965): 11.

78. For Warhol's tendency to read reviews of his shows, see Smith, *Art and Films*, p. 495.

79. Coplans, "Early Warhol," p. 52; Coplans's interpretation was dismissed by Carter Ratcliff, "Andy Warhol: Inflation Artist," *Artforum* 23, no. 7 (March 1985): 70.

80. Crone, *Andy Warhol*, p. 30, insists that these paintings are meaningless. Warhol, however, associated flowers with funerals in a radio interview that he gave in the fall of 1963. See Printz, "Painting Death in America," p. 103.

81. Bourdon, "Andy Warhol," p. 11.

82. Hess, "Andy Warhol," p. 11.

83. *Newsweek*, December 7, 1964, p. 103A.

84. Carter Ratcliff, *Andy Warhol* (New York: Abbeville Press, 1983), p. 54, incorrectly claims that Warhol installed the "Flowers" over *Cow Wallpaper* in Paris, and his figure 53, which shows the April 1966 Castelli exhibition, is miscaptioned.

85. According to Crone, *Andy Warhol*, p. 307, for this exhibition, which he dates incorrectly to 1964, Warhol prepared 100 variations in a $5 \times 5''$ format, 132 in $8 \times 8''$, and 62 in $14 \times 14''$; according to Jean-Pierre Lenoir, "Paris Impressed by Warhol Show," *New York Times*, May 13, 1965, p. 34, Warhol estimated the number of paintings to be "about 395 when I last looked."

86. Warhol and Hackett, *POPism*, p. 113.

87. Ibid., p. 112. At the same time, Warhol told John Ashbery that he had Renoir in mind. See "Andy Warhol Causes Fuss in Paris," *International Herald Tribune*, May 18, 1965.

88. L. M. Butler, "Andy Warhol—The Man and His Art Challenge Definition," *Boston After Dark* (October 1966).

89. Junker, "Andy Warhol, Film Maker," p. 208.

90. Warhol and Hackett, *POPism*, p. 111. A selection of Shore's photographs was published in *Andy Warhol*, 3d ed. (Stockholm: Moderna Museet, 1970), unpag.

91. Smith, *Art and Films*, p. 357; in an earlier interview in Wilcock, *Autobiography & Sex Life*, unpag., Ivan Karp explained that Warhol collected "hundreds" of photographs of cows to explore the suggestion's potential. Spiess, "Critique of Emotionlessness," p. 124, claims that Warhol chose the image for his wallpaper from a magazine photo contest.

92. Smith, *Art and Films*, pp. 358 and 397; Warhol first exhibited the 1964 *Self-*

*Portrait* at the *Artists' Self-Portraits* exhibition at the School of Visual Arts in January 1965. According to Peter Gidal, *Andy Warhol: Films and Paintings* (London and New York: Studio Vista/Dutton Picturebook, 1971), p. 70, Rudolph Burckhardt took the photograph that Warhol used for his 1965 *Self-Portrait*. For Warhol's early predilection for self-portraits, see Smith, *Conversations*, p. 17.

93. Conversation with Holly Solomon, May 21, 1988. Warhol later made a ninth version to include with these for his October-November 1966 retrospective at the Institute of Contemporary Art in Boston. The Solomons acquired this as well, on condition that Warhol destroy the silkscreen.

94. Crone, *Andy Warhol*, p. 30. The "Silver Pillows" were displayed as trophies at the October 10, 1967 meeting of E.A.T.; see *E.A.T. News*, November 1, 1967, unpag., for photographs of the event.

95. Conversation with the author, October 17, 1987.

96. According to Rose, *Rauschenberg*, p. 116, both Rauschenberg and Stella wore light bulbs for heads in the production of Kenneth Koch's *The Construction of Boston*, presented at the Maidman Playhouse in New York on May 4, 1962.

97. W.B., "Andy Warhol," *Arts Magazine* 40, no. 8 (June 1966): 46. According to Otto Hahn, "Rembrandt vidé de Rembrandt," in *Andy Warhol—Dossier 2357* (Paris: Galerie Ileana Sonnabend, 1967), unpag., Warhol requested that all of his works, regardless of subject matter, be referred to as "the things he loves" or "the clouds."

98. Warhol and Hackett, *POPism*, p. 149.

99. For these specially plasticized "Flowers," see *A Report on the Art and Technology Program of the Los Angeles County Museum of Art, 1967-1971* (Los Angeles County Museum of Art, 1971), pp. 330-337. Jack Burnham, "Corporate Art," *Artforum* 10, no. 2 (October 1971): 68, saw this work as an allusion to Duchamp's *Étant donnés*.

100. Warhol and Hackett, *POPism*, p. 169.

101. The interior of one room of the miniature pop-up castle in *Andy Warhol's Index (Book)* (New York: Random House, 1967) is also decorated with *Cow Wallpaper*.

102. Carolyn Betsch, "A Catalogue Raisonné of Warhol's Gestures," *Art in America* 59, no. 3 (May-June 1971): 47.

103. John Perreault, "Andy Warhola, This is Your Life," *Art News* 69, no. 3 (May 1970): 52.

104. Leo Castelli, in Wilcock, *Autobiography & Sex Life*, unpag.

105. John Perreault, "Wallpaper," p. 27, and Douglas Davis, "Warhol for Real," *Newsweek*, June 7, 1971, p. 69.

106. See Smith, *Art and Films,* p. 298, for a reference to Warhol making "Mao" drawings on a copy machine in conjunction with E.A.T. The idea to fabricate *Mao Wallpaper* for this installation was suggested by Ileana Sonnabend; conversation with author, October 21, 1988.

**Nan Rosenthal**

## LET US NOW PRAISE FAMOUS MEN:

## WARHOL AS ART DIRECTOR

I wish to dedicate this talk to P. Reyner Banham, the great revisionist historian of modern architecture, who did so much thirty years ago to revise Siegfried Giedeon's version of the history of the subject. Banham did this in many ways. One was to demonstrate the significance, for modern architecture and for modern art, of vernacular and popular sources. For example, Banham showed how the appearance of mass-circulation magazines that Laszlo Moholy-Nagy read during his adolescence before World War I influenced the ideas Moholy formulated about painting and design during the 1920s.[1]

Banham died March 19, 1988. He was, along with the artist Richard Hamilton and the art historian and critic Lawrence Alloway, one of the spirits behind the exhibition, *This Is Tomorrow,* held at the Whitechapel Art Gallery in London in 1956. As is well known, that exhibition was one of the first to focus attention on the complex fascination which contemporary popular culture—particularly the American brand produced by Hollywood, Detroit, and Madison Avenue—held for a number of British intellectuals. The show contained Hamilton's collage *Just What Is It That Makes Today's Homes So Different, So Appealing?* (fig. 34). This memorable little work was blown up to mural size for the *This Is Tomorrow* exhibition. It featured a living room in which a television set, a tape recorder, a lampshade with a Ford logo, a mass-circulation love comic hung on the wall like a painting, and a canned ham on the coffee table all surround a muscle man who wields a giant Tootsie Pop in the region of his genitalia. This particular hard candy perhaps inspired Alloway

slightly later to give the movement Pop art its name.

It is relevant to the Warhol symposium today to remember that, for these three mentally agile Englishmen of the middle classes, who were in the 1950s beginning careers in a society still rigid with class distinctions, American consumer goods did not signify anything as one-dimensional as late capitalist decadence. Rather, in that country of expensive petrol and cashmere twin-sets worn with real pearls, American popular culture and its products connoted something genuinely interesting, fun, and, I think, transgressive. To employ conspicuously the bad taste assembled in the Hamilton collage—to use materials that Clement Greenberg had earlier denominated "kitsch" or "ersatz culture"—in that British society then, was not so much to predict what came to be called camp taste as it was to *épater* the aristocracy—or whomever in British society emulated aristocratic taste and style.

Andy Warhol reminded us of a related point, the potential of widely popular American products to obviate class distinctions, when he observed in his writing that on the occasion that President Eisenhower gave a Coca-Cola to Queen Elizabeth II, it tasted the same to her as to the guy on the street corner. Let me note in passing that, from the evidence of his writings, Warhol was a shrewd and mostly honest social critic.

I want to talk today about early Warhol paintings, that is, his high art production of the first half of the 1960s, and in particular about two paintings owned by the National Gallery of Art in Washington, D.C. I wish to examine a few of the ways that Warhol's college education and experience working as a commercial graphic artist in New York throughout the 1950s affected his approach to making high art. As Alloway has pointed out, Warhol alone of the Pop artists practiced as a commercial graphic artist working directly in the field of pop culture.[2]

The earliest painting I wish to discuss is *A Boy for Meg* (fig. 35), the *New York Post* front page painting, 72 by 52 inches, given

to the National Gallery by Emily and Burton Tremaine, who acquired it from Warhol in 1962. The date of the painting is late 1961 or early 1962. It precedes Warhol's adoption of photographic silkscreen techniques for making paintings, as is obvious if we compare his work to a reproduction of the original *New York Post* front page (fig. 36). (The *Post* page seen here is actually from the archivally preserved *Bronx Home News* edition of the November 3, 1961 *Post,* and the layout is slightly different from the no longer available edition that Warhol actually copied.) Warhol made his painting carefully by hand, presumably by using an opaque projector. There is clearly a difference between the graduated halftones of the actual printed front page and the less tonally graded faces of Princess Margaret and Frank Sinatra in the Warhol painting.

*A Boy for Meg,* with its two world-famous celebrities, is the immediate predecessor of the anonymously peopled *129 Die (Plane Crash),* 1962 (fig. 37), a painting I have always identified with. I was a *New York Post* general assignment reporter around that time and I used to cover such stories by visiting sundry hospital emergency wards to interview the families of victims of disasters as they viewed the charred bodies of their relatives. I never ceased to be amazed at the fact that the families were willing to be interviewed at such gruesome moments, nor did I cease to be embarrassed about my own complicity with my city editor's desire for juicy quotations from the grieving. However, the experience helped me to understand early on Warhol's acute grasp of the nearly universal will to be famous — to be in the papers — for fifteen minutes.

*129 Die (Plane Crash)* was Warhol's first disaster painting. According to the artist, his subject — a daily newspaper front page — was the suggestion, over lunch at Serendipity restaurant in New York, of his friend Henry Geldzahler, then the curator of twentieth-century art at the Metropolitan Museum. It may be worth mentioning here that Warhol was not the only artist of

his generation to incorporate the front page of a mass circulation newspaper into his art, which is to say, to use publicity and notoriety as subjects for his art. For example, in late 1960 the French artist Yves Klein produced his own parodic edition of the Paris paper *Dimanche* (fig. 38), and on its front page he shows himself in ascension, pretending to risk his life for his art. The Warhol front page paintings eerily anticipate his own appearance on the front page of the *New York Post* in June of 1968, after he was shot by Valerie Solanis (fig. 39).

Like Charles Stuckey, I want to speculate about Warhol's context, but not so much his high art context as about the period, as I've said, when he obtained his education. I believe that what I shall term Warhol's *design decisions,* that is, his conceptions for paintings, and his composition of them, as well as other formal decisions he made, for example about the use of color, are deeply informed by his college education and by his intense experience for a dozen youthful years in the world of commercial art in New York. Throughout the 1950s there Warhol daily observed art directors of magazines changing, cropping, and realigning pages, that is, working with and modifying rectangles destined to be printed in countless multiples (fig. 40). And he continually watched art directors getting ideas for sundry kinds of quickly readable graphics, be they book jackets, record covers, or advertising pages in a magazine. I think it will help us to understand Warhol's approach to making his paintings of the 1960s if we think about his methods in the context of the conventions of commercial art.

We might recall first that Warhol entered Carnegie Tech (as Carnegie Mellon University was known then), in his hometown, Pittsburgh, in 1945 at the age of fifteen. He graduated with a Bachelor of Fine Arts in a major called Pictorial Design at the age of nineteen. The two other options in the mid-1940s for Carnegie Tech students matriculating in the B.F.A. program were majors in Art Education (that is, preparation for teaching art in

high schools or elementary schools) and Industrial Design, which at Carnegie Tech really meant three-dimensional design, the design of products.

To go to art school at Carnegie Tech in those post-Depression GI bill years was to attend a quasi-professional school, in the sense that a law school is a professional school. It was not exactly an institution drawing upon the European art academy or conservatory model and not an institution focusing on developing the individual expressive talents of young painters willing to starve to create high art. While such may have been the goal at many of the artist-taught classes at the Art Students League in New York or at Hans Hofmann's classes in Provincetown, Carnegie Tech's curriculum, even though it produced Philip Pearlstein and other serious painters in those years, seems to have been focused on training designers and art teachers at least as much as it was training painters.

The very title of Warhol's major, Pictorial Design, hints at this. The Carnegie Tech course catalogues for Warhol's years show that the curricular requirements for this major did include "Drawing" and "Drawing and Painting," and these are described quite drily. The required courses also included "Mediums and Reproductions," described as

*Mediums used by the artist in making pictures for reproduction, the processes of reproduction by which they are transferred to the printed page, and the effect of the latter processes on the choice of medium and method of handling. 3 units per semester.*

"Pictorial and Structural Design" is described as

*Creative investigations carried on in 2 and 3 dimensions and directed to reveal the expressive resources of the contemporary artist-designer. Increased emphasis is placed upon the interdependence of principles of organization and the various personal and social motivations which impel the artist-designer to work. Experiences in both 2 and 3 dimensions*

*stimulate the student to develop an informed viewpoint toward his interests and capacities and toward a potential professional field; to reveal problems and influences common to fields other than his own. Prereq., A-501, A-502. 12 units per semester.*

The required junior and senior courses to which the greatest number of credit hours were assigned were "Pictorial Design I," described as follows:

*Through the conception and execution of illustration, advertising design and other types of commissioned work, emphasis is placed on the potentials of the artist as a social participator and collaborator. Critical analyses of professional examples provide motivation for awareness and evaluation of current directions in these fields. Letter and type forms, layout and graphics for expositional purposes are an integral part of the course. Prereq., A-503, A-504. 18 units per semester.*

"Pictorial Design II" was also a required course:

*Problems in illustration, advertising design and mural painting calling for solutions meeting specifications of a professional character alternate with those in which complete freedom of conception is encouraged. Increasing emphasis is placed on the interdependence of conception and technical accomplishment. Prereq., A-505, A-506. 18 units per semester.* [3]

This is hardly the occasion for even a brief history of art education in America. But let me remark that there are a number of reasons for this dry and professional approach to the study of art—well, to the study of becoming a "contemporary artist-designer," to quote again from the Carnegie Tech catalogue copy of the period—copy written the same year that Pollock painted his first classic drip pictures.

One reason was the empirical tradition that began to flourish in American higher education in the late nineteenth century, a tradition which thrived at a university—an institute—devoted first of all to engineering. A perhaps more important stimulus to

approaching art education as a matter of training professional designers was the example of the German Bauhaus and the way that example was absorbed in the United States. The primary lesson of the Bauhaus, its innovation in Europe in terms of art education, was to combine under one roof and in one curriculum what had in Europe previously been completely separate: education in the fine arts and the technical instruction offered by schools of arts and crafts. In addition, the Bauhaus promoted the challenge of designing products for German industry. This Bauhaus model proved in the course of the 1940s and 1950s to be very attractive to American universities. The carrier of these Bauhaus ideas closest to Pittsburgh was of course Laszlo Moholy-Nagy, the Bauhaus teacher, painter, sculptor, photographer, and editor who at the German school had been responsible, with Josef Albers, for teaching the famous foundation course there. Moholy's New Bauhaus, or Institute of Design in Chicago, was a fashionable, in the sense of hip, if financially shaky institution in the 1940s. Aspiring artists knew about it the way they knew about Cal Arts in the early 1970s or Yale in the 1960s.

Moholy's book *Vision in Motion,* published in 1947, the year after his death, was probably the most influential text in American art education of the period. It is not surprising, therefore, that one of Warhol's classmates at Carnegie Tech recalls buying the book and recalls as well that Warhol borrowed it from him and spoke to him about it with enthusiasm.[4]

There are a great many lessons that Warhol might have absorbed from Moholy's *Vision in Motion* and from Moholy's autobiographical fragment, *Abstract of an Artist,* also published in 1947 in Robert Motherwell's "Documents of Modern Art" series. (It is worth recalling that there were not a great many art books in those days.)

One lesson Warhol may have absorbed from Moholy's books we see much later in Warhol's "Reversal" series (fig. 33); these silkscreen paintings of the late 1970s appear to draw upon

Moholy's fondness for printing his photographs in both positive and negative form and publishing them side by side, as he did in *Vision in Motion* (fig. 41). Warhol almost certainly drew some lessons from the way that, throughout his books, Moholy juxtaposes examples of high art with reproductions of commercial art, such as advertisements. One conclusion that might be drawn from these visual juxtapositions is that high art is not morally superior to commercial art. This is somewhat different from the interpretation of Bauhaus ideology presented in those days at the Museum of Modern Art in exhibitions and in the program of the design department there, where the message, I think, was that the creativity of high artists—particularly those in the Constructivist tradition—can provide visual aides to the makers of commercial art and the designers of products. In effect, that geometric abstract painting can, as De Stijl theory would have it, rid the world of kitsch.

I would like to think that Warhol was familiar with a remarkable statement that Moholy published in Germany in 1925 and reprinted in his American books of 1947:

*People believe that they should demand hand execution as an inseparable part of the genesis of a work of art. In fact, in comparison with the inventive mental process of the genesis of a work, the question of its execution is important only in so far as it must be mastered to the limits. The manner, however, whether personal or by assignment of labor, whether manual or mechanical, is irrelevant.*

In *POPism: The Warhol '60s*, Warhol's memoir of that decade coauthored by his friend Pat Hackett and published in 1980, Warhol wrote that he ". . . was never embarrassed about asking someone, literally 'What should I paint?' because Pop comes from the outside, and how is asking someone for ideas any different from looking for them in a magazine?"[5] The statement is disarmingly honest about Warhol's sources (the people he knows and the mass circulation magazines that littered his workplaces),

and the statement counters much of the rhetoric about artmaking from the late nineteenth century through Abstract Expressionism, which assumed, from the hard, gemlike flame of creativity said to generate art for art's sake to the lonely existential decisions said to produce masterpieces of New York School abstraction, that art was made from the *inside,* the inside of the creator. Warhol is suggesting in his words "Pop comes from the outside" that making art is a collaborative not isolated process. And he is also pointing, in plain English, to the importance of getting an "idea."

Rainer Crone has pointed out that in Warhol's drawings of the 1950s, the artist used color two-dimensionally, that is, atonally. He applied it within the blotted outlines of drawings as a kind of local color, to identify the object (figs. 77 and 78). That is a designer's method: identify your product. Crone has said this is depersonalized. I would say, not exactly. Rather, a designer is in charge of the colors; he then is the conceptual artist, so to speak, of colors and indeed of the entire layout. I think Warhol learned this approach to painting when he was obtaining his B.F.A. in Pictorial Design and from learning while he was earning as a very young man befriending art directors in the New York commercial art world.

I propose that we think of Warhol as the *art director* of his paintings of the early 1960s. I wish to focus not so much on his choices of particular common images, say, the Campbell's soup cans, as on the ways that he approached painting these. The way Warhol does this is the opposite of the Museum of Modern Art lesson about the Bauhaus, whereby a style of high art may improve product design. Warhol as art director of his paintings takes appearances, compositions, methods such as tricks of cropping and laying out a painting, and so on, from the techniques of commercial art. An irony here is that at this art historical moment of second-generation Abstract Expressionism, suspicions had accumulated about the spontaneity involved in making such

art, and in the context of such suspicions, the blatant artificiality
of Warhol's art-director methods is what has the impact of sin-
cerity. Around 1960 it was becoming more sincere to design
than to express.

Warhol clearly had an excellent memory for other people's
design solutions and he took ideas freely, even rather noticeably
if you were among the cogniscenti. While I am not proposing
that the way Warhol took other people's design solutions means
that in the early 1960s he produced simulacra and conducted ap-
propriation in the recent, aggressively self-conscious senses of
those terms, clearly his activity leads in that direction.

For example, I had always admired Warhol's design solution
to the problem of making an uncorny and effective political
poster, such as his attention-getting *Vote McGovern,* 1972 (fig.
42), a large edition silkscreen print. I had thought it was a clas-
sic instance of a graphic designer's thought-through solution to
the problem of how visually to state the best possible reason, in-
deed, to vote for McGovern: Nixon. I can still recall my amuse-
ment when I first saw this print in a museum in a town which
least needed persuasion, Berkeley. And then recently, in Rainer
Crone's new book on Warhol, I found a reproduction of the di-
rect antecedent of Warhol's design solution: a Ben Shahn politi-
cal poster, in an offset edition of five hundred, from 1964.
Under his caricature of Barry Goldwater, the then right-wing
Republican candidate for president, Shahn has put the legend,
"Vote Johnson" (fig. 43). Crone is concerned to compare Shahn's
and Warhol's handling of graphic design, for example, their let-
tering, and he says that by comparison to Shahn's, Warhol's is
graffitilike. While Shahn was a highly successful painter and suc-
cessful commercial artist in the 1950s, and while it is interesting
in this context that he was both, and while there seems little
question that Warhol in his 1950s drawings adopted a Shahn-like
style, I think it is most interesting that what Warhol took from
Shahn in this instance is what an art director in an ad agency

would term a design solution—a visual/verbal idea that solves the problem of communicating a message quickly.

I was reminded of another instance of this kind of absorption of a design solution when looking at reproductions recently of Warhol's paint-by-numbers pictures, the "Do-It-Yourself" paintings and drawings of 1962 (figs. 44 and 45). While his title is of course ironic and while his subject here raises the same issues that his purportedly hands-off methods do, we may wonder whether he did it entirely himself conceptually. The wonderment occurs if we examine a poster by the New York designer Tony Palladino, produced in 1959 (fig. 46). Under its brightly painted Matissoid flowerpot there is a paint-by-numbers set, in pale gray. Palladino then was a hot young designer of graphics, and he is still very much in demand. I picked up this reproduction of his 1959 poster from him at Wells, Green, and Rich, the big ad agency, where he has a large office (and where, like Warhol, he wears jeans).

Palladino designed this poster to advertise the School of Visual Arts in New York. Like so many art directors and commercial artists of quality, Palladino then taught at the School of Visual Arts part-time. The poster happens to have been the school's first to advertise itself, and it was designed for and posted abundantly in a place where none of us in New York then could have failed to see it: the subway stations in Manhattan. That, at any rate, is where I first saw it, at many stops, and I presume that is where Warhol first saw it as well.

You may notice that in the Palladino of 1959, unlike the Warhol of 1962, the painted image, that is, the graphically bold, easily-read-from-a-distance flowerpot, does not follow the outlines of the gray paint-by-numbers still life underneath it. This Palladino image is thus intended to signify that at the School of Visual Arts, unlike Palladino's notion of an academic art school, you are not taught to paint by formula. At that time, in its gentle wit and visual sophistication as an advertisement (this is a sub-

way poster, after all, of the same era as "You don't have to be Jewish to eat Levy's") it also shows how a designer arrives at a solution to an advertising problem, which was the main course then served by the School of Visual Arts.

I began to think seriously about Warhol as a clever *designer* of paintings, in terms of composition and color, when the National Gallery briefly borrowed his large *Mona Lisa,* 1963 (fig. 47). As we all know and as Warhol who went constantly to art galleries in the late 1950s knew, vanguard artists at that time did not make "relational" paintings anymore. If such an artist were thinking about composition then, he or she did not, after Barnett Newman's *Onement I,* 1948, Pollock's *Lavender Mist,* 1950, Johns's *Target with Four Faces,* 1955, or Stella's *Black Paintings* of 1959, make paintings in which a tree or abstract shape at the left balanced asymmetrically yet congenially with a tree or abstract shape at the right.

One of Warhol's solutions to compositions, a common one by then, was of course the grid, and Warhol used grids so often and so insistently that we associate them with him perhaps more immediately than we do with obvious precedents such as Johns's *Gray Numbers,* 1958 (fig. 9). For example, there is Warhol's *Handle With Care — Glass — Thank You,* 1962 (fig. 7), or the portrait of Ethel Scull, 1963 (fig. 48). Another example is his *Marilyn Diptych,* 1962, a grisaille grid, juxtaposed with a multicolored grid, which we might rename *Andy's Frank's Jasper's Dilemma.* Or there are the self-portraits of the mid-1960s. We not only associate the grid with Warhol, we hang his paintings in grids whether he did or not. At least we did at the National Gallery (fig. 49) with Warhol's *32 Campbell's Soup Cans,* 1961-62, when Irving Blum lent them to us for several years. Our chief designer at the gallery wished to hang these thirty-two small canvases in two rows of sixteen, but their owner would have none of it.

The ubiquity of the grid in post-Cubist painting has been discussed often. Warhol may have hit upon grids anywhere — in

the work of Rauschenberg and Johns which he so admired or in photography, for example, Walker Evans's famous *Photographer's Window Display,* 1936 (fig. 50). What I wish to show is how clever a designer Warhol could be with composition and with color to signify an idea even with something as basic—as obvious—as a grid. This is apparent if we look at his ten-foot-tall *Mona Lisa,* which I believe to be one of Warhol's finest paintings. The occasion for his making this 1963 work and related, smaller "Mona Lisas," of which there are at least three, was when André Malraux, then the French minister of culture, agreed to the request of the Kennedy White House and the National Gallery of Art to lend the Leonardo from the Louvre to the National Gallery in Washington and the Metropolitan Museum in New York. This produced an immense amount of attention from the mass media and long lines outside both institutions.

Warhol's comment on the event, the details of which he knew at firsthand from his friend, Henry Geldzahler, the Met curator, was to use the ubiquity of the Mona Lisa image to reinforce his already demonstrated interest in reproduction and repetition. The Duchamp source—Duchamp's mustached reproduction of the Louvre Leonardo, *LHOOQ*—is obvious, and by then Warhol also had the example of Rauschenberg's frequent incorporation of reproductions of old master pictures into his combine paintings.

But it is not simply that the images repeat in the big Warhol *Mona Lisa* painting. They do so in a way that signifies at a secondary level to emphasize mechanical reproduction, that is, high-speed printing. For this painting looks like an early proof from a high-speed press, with its images slightly askew. And it is rendered in precisely the same hues that are used on color bars by photographers, designers, art directors, and printers to test the accuracy of the color when photographic transparencies are employed to print reproductions. By choosing precisely the col-

ors that appear in chart form at the side or bottom of trans-
parencies destined to become reproductions, Warhol evokes the
issue of reproduction and reinforces our awareness of how often
the *Mona Lisa* is reproduced.

This *Mona Lisa* may also be Warhol's most Rauschenberg-like
composition, displaying, as it does, the syncopated grid charac-
teristically used by the artist who, Warhol wrote, was the "fa-
ther of painting." This syncopated grid—we can observe it in a
work such as Rauschenberg's *Gloria,* 1956 (fig. 51)—is some-
thing Warhol rarely employed. He does it in this instance for the
reason I have explained, to suggest a high-speed press proof.

To return to the main point here, that Warhol sometimes
used color and composition as an art director or designer of ad-
vertisements uses them, to signify content at a secondary level,
just as the hue of his *Red Race Riot,* 1963, seems to suggest that
blood may be shed, an examination of the National Gallery's
painting, *Let Us Now Praise Famous Men (Rauschenberg Family),*
1963 (fig. 52) is instructive. It is one of at least five portraits of
Rauschenberg as an infant with his parents and extended family
that Warhol made in late 1962 and early 1963. He had the silk-
screen for it made from a snapshot which Rauschenberg loaned
to him. I believe it is the first portrait Warhol made of someone
who was not—*quite* yet—a nationally-famous celebrity. That is,
it is preceded by Warhol's Troy Donahues, Warren Beattys,
Marilyns, some of the Lizzes, and also by the Gallery's *A Boy for
Meg,* a portrait of sorts. The Gallery's Rauschenberg portrait is
the most eloquent of the five paintings in the Rauschenberg
group, in part because of the elegant, subtle way Warhol handled
its color.

The title of the painting, *Let Us Now Praise Famous Men
(Rauschenberg Family),* is interesting and very unusual in Warhol's
work. Most of his titles, such as *Three Elvises* or *Sixteen Jackies,*
are fairly deadpan labels, emphasizing seriality and repetition.
But the title of this work functions on several levels to lend con-

tent to the portrait itself.

The introductory phase (originally from Ecclesiasticus 44:1) was the adopted title of a documentary report of the late 1930s about three tenant farmer families in the southern United States. This report contained photographs by Walker Evans, such as *Sharecropper's Family, Hale County, Alabama,* 1936 (fig. 53), and a long, poetic prose text by James Agee. Like Evans's photography, the text by Agee sought to treat the members of the three tenant farmer families as dignified individuals and to avoid the muckraking bathos of much typical New Deal propaganda against rural poverty. The Agee text had been assigned originally as an article by *Fortune* magazine and was then rejected by the Luce publication because, in one historian's view, it was insufficiently patronizing toward its subject.[6] Instead, Evans and Agee published the report in book form. Although favorably reviewed by a few distinguished intellectuals, it sold only three hundred copies.

Curiously, Agee's and Evan's *Let Us Now Praise Famous Men* was reissued in the same year, 1960, that Warhol made his first high art paintings. In that brief interstice between the old and new left, the book immediately became a cult item, one that Warhol obviously knew.

In 1962 Edward Steichen's show for the Museum of Modern Art, *The Bitter Years, 1935-1941: Rural America as Seen by the Photographers of the FSA* (Farm Security Administration), exhibited a number of Walker Evans photographs, including the Bud Fields family group shown here (fig. 53). This Evans photograph happens to be the one in the book *Let Us Now Praise Famous Men* that most resembles the photograph of the Rauschenberg family that Warhol obtained from Rauschenberg to make his gridded portrait paintings. The year of the Rauschenberg family snapshot must be 1926, as Rauschenberg, the infant in it, was born in late October 1925. His parents are to the right, the sundry aunts and uncles and cousins are to the left. The place is

Port Arthur, Texas, where the Rauschenberg family, while not tenant farmers, were devoted members of the Church of Christ and not at all well off. Indeed, Rauschenberg used to joke about being "poor white trash."

If Agee's book title *Let Us Now Praise Famous Men* was sadly ironic and intended to convey dignity—the three sharecropper families he wrote about were hardly famous before he wrote about them, and they never, obviously, obtained the perks of fame—Warhol's title is, ironically, serious, and conveys dignity as well. Warhol, we learn a few months after he made the painting from his interview with Gene Swenson that appeared in *Art News,* will speak of everyone becoming famous for fifteen minutes. And in this painting, he designates an *artist* famous. Warhol shows that despite what both the Rauschenberg family photograph and the Agee-Evans book connection to it suggest is an image of a no-account background, you can, the year before Robert Rauschenberg's retrospective at a New York museum and the year before he won the grand prize at the Venice Biennale, become famous. Given Warhol's rural Slovakian immigrant parents and his father's occupation as a coal miner, there is perhaps some autobiographical identification with his subject in this series of paintings.

In the National Gallery painting from the series, Warhol reinforces the connection to the Evans-Agee book with his use of color. Nearly six of the eight rows of Rauschenberg family snapshots are silkscreened in a sepia color. This lends an old-timey feeling, one we are reminded of by sepia-color albumen prints. Artificial sepia toning of photographs was an invention of the 1920s which by the 1950s was being used by art directors of magazines and ad agencies as a standard visual reference with a conventionalized meaning: age, old-timeyness. In the Utica Beer and Morton Salt ads of the early 1960s that I am showing here (figs. 54 and 55), it helped to dress the players in the advertisements in antique clothing meant to invoke the good old days and

the authenticity of the past. But the main point is that the ink in which these monochromes are printed is a brownish sepia, the code for old-fashioned.

In the Warhol painting, the two rows of Rauschenberg family snapshots above the sepia-colored series are silvery, that is, black ink instead of brown on a silvery ground. This is a color combination which, in the context of this photograph presented *as* a photograph (one which if you don't look too hard could have been made by the photographer Walker Evans) evokes that once essential chemical of the medium of photography, the silver halide that receives the light. I would argue that unless we are to understand Warhol as a very late Symbolist, his handling of color—the sepia to connote age, the black on silvery gray to connote photography—are the thoughtful choices of an art director, who reinforces his icon (and his index, but that's another story) with connotative color.

Some final words and images on Warhol as a *designer* of paintings: a juxtaposition of his painting *210 Coca-Cola Bottles,* 1962 (fig. 56) and an advertisement for Hunt's Catsup that appeared in *Vogue* and *Harper's Bazaar* in 1956, during Warhol's heyday as an illustrator for magazine art directors (fig. 57). I think a juxtaposition of these images explains why this assembler of objects (Warhol's career as a collector is being auctioned off as we meet at this symposium) did not, in his high art after 1960, use the medium of collage. Because layout and design of the printed rectangle, the format he always used, is of course a species of collage. You put it all together—you do your pasteup— before the work is a final product, before it is printed on one plane.

## Notes

1. I am enormously grateful to the historian of photography, Christopher Phillips, whose warm collegial response to my ideas about Warhol in relation to professional commercial art, whose scholarship, and whose personal archive of visual material about the mass media in the 1940s and 1950s have been essential to this talk. I wish also to thank Margaret Magner for her industrious and intelligent help with its research.

2. Lawrence Alloway, *American Pop Art* (New York: Collier Books, 1974), p. 104.

3. These courses in Pictorial Design were taught by, among others, Robert Lepper, whose instruction in relation to Warhol's work has been discussed by David Deitcher in a paper delivered at the 1989 College Art Association meeting entitled "Andy Warhol and the Social Construction of the Late Modern Artist."

4. Patrick S. Smith, *Warhol: Conversations About the Artist* (Ann Arbor, Mich.: U.M.I. Research Press, 1988), p. 21.

5. Andy Warhol and Pat Hackett, *POPism: The Warhol '60s* (New York: Harcourt Brace Jovanovich, 1980), p. 16.

6. William Stott, *Documentary Expression and Thirties America* (New York: Oxford University Press, 1973), passim and p. 270.

Benjamin H. D. Buchloh

# THE ANDY WARHOL LINE

I adore America and these are some comments on it. My image is a statement of the symbols of the harsh, impersonal products and brash materialistic objects on which America is built today. It is a projection of everything that can be bought and sold, the practical but impermanent symbols that sustain us.

—Andy Warhol[1]

The style and subjects of Andy Warhol's drawings, paintings, and silkscreen prints have been traced by critics and art historians to sources as different as the orientations of the historians themselves. In the very first review that Warhol's drawings ever received, the critic aligned them perspicaciously within a tradition ranging from Aubrey Beardsley to Charles Demuth, observing their slightly perverse fragility. Others subsequently discovered— and the evidence seems to support their case—that Warhol's drawing style was primarily influenced by the neoclassical Henri Matisse and the drawings of Jean Cocteau, and others yet discovered the presence of Paul Klee and Alexander Calder.[2] Ironically, the most obvious source for the drawing style of the early work, locally close at hand but art historically not exactly quite as ennobling, to my knowledge has never been mentioned: the late 1940s illustrations by Saul Steinberg (fig. 58).

And more than twenty years after that initial review, on the occasion of Warhol's first major drawing retrospective, Rainer Crone's scholarly catalogue essay examined the relationship between Warhol's work and the social realist traditions of American drawing, ranging from John Sloan to Ben Shahn.[3]

Most obvious of all, even though not at all sufficiently explored, is the presence of the New York Dada legacy in Warhol's drawings as they evolve in the early 1960s, in particular the mechanical drawings of Francis Picabia from around 1916 and the drawings of Man Ray from the late twenties to the late thirties (fig. 59).

Yet none of these historical affiliations seems ultimately satisfying and moreover none of these efforts to trace the development of Warhol's drawings historically can explain the actual transformation occurring inside the technique of drawing itself as it is practiced by Warhol in the beginning of the 1960s. It seems impossible to discover any singular aspect of the legacy of Sloan or Shahn in the illustrative elegance and in the decorative vapidity of Warhol's work of the early sixties. In fact, its nonchalance and seeming complicity with commercial design appear to operate on the exactly opposite side of Sloan's critical realist reportage, and the drawings most certainly would have to be situated even further from Shahn's accusatory and activist drawing style. Warhol's "readymade" drawing style condenses all of these legacies in the early 1960s—the decadence of Beardsley, Cocteau, and Demuth, the neoclassical linear elegance of Matisse, the realist attention to vernacular detail of Sloan, and the cynical anti-aesthetic of Picabia and Man Ray—when he copies magazine covers and photographs of Campbell's soup cans, tracing the drawings from an opaque projector's image.

The drawing *Ginger Rogers,* 1962 (fig. 60), exemplary for Warhol's approach, follows the typography and commercial layout and copies the photographic reproduction of a magazine cover in a laconic and deadpan attitude, synthesizing the boredom and routine of the commercial artist with the naive pleasures of a child's tracings. Only contour lines seem to have found the artist's attention while modelling and chiaroscuro are reduced to a sketchy minimum, and evidently drawing as spatial delineation is completely absent. Large surfaces inside the repro-

duction of the photograph have been replenished by Warhol
with listless schematic hatching lines, which, paradoxically not
only function as indicators of color, background, and shadow but
also assume the function of a "free" gestural linear movement in
an otherwise totally contained image. The found image functions
as a template for the drawing as process as much as for the
drawing as representation. Eliminating all choices concerning
composition, modelling, and spatial conceptualization, it also
seems to preclude all individual decision making processes. The
process of manual execution is thereby systematically deper-
sonalized: drawing as the innermost mark of artistic authenticity,
as gesture of expression, as the handwriting of interiority, is re-
placed by a concept of artlessness, by a concept of drawing as
the mere imprint of the most common denominators of
representation.

Thus, even when looking only at one single aspect of War-
hol's work, the "style" of his drawings, we are already con-
fronted with a first set of contradictions and two possible
answers come to mind. The first one would argue that Warhol
had absorbed influences from opposite sources indiscriminately
while studying to become a commercial artist. Warhol, as is
common in that profession, plundered the legacies of modernist
high art for purposes of product styling and propaganda, so that
none of the individuals of those legacies would have been any
more meaningful to him than another. The second answer
would force us to realize from the start that this type of tradi-
tional stylistic analysis (as much as an iconographic one for that
matter) is bound to fail in Warhol's case as much as it had failed
already in the confrontation with Dada's transformation of rep-
resentational modes after 1913. This answer would force us to
recognize that this conflict inside the traditional technique of
drawing originates in a far more fundamental set of contradic-
tions with which Warhol's work has confronted its audience
since its beginnings — whether one locates these around 1952

with the earliest work in the blotted-line technique of reproduction (figs. 77-79), employed while Warhol was still primarily working as a commercial artist, or whether with the first silk-screen painting, *Baseball,* 1962 (fig. 61), when Warhol's career and commercial success in the sphere of high art actually began.[4]

These are the contradictions evidenced in the work's consistently ambivalent relationship to both mass culture and high art. We are not thinking primarily of the quotations of mass cultural imagery—after all they had been an acceptable convention if not founding condition of modernism since the mid-nineteenth century. Rather we are thinking of the way in which Warhol underlined at all times that the governing formal determination of his work was the distribution form of the commodity object and that the work obeyed the same principles that determine the objects of the cultural industry at large. Those principles (commodity status, advertisement campaign, fashion object) had been traditionally believed to be profoundly heteronomous to the strategies of negation and critical resistance upon which modernist artistic practice had insisted. Warhol in fact had been quite explicit about these goals, for example in his notorious statements from *The Philosophy of Andy Warhol:*

*Business art is the step that comes after Art. I started as a commercial artist and I want to finish as a business artist. After I did the thing called "art" or whatever it's called, I went into business art. I wanted to be an Art Businessman or a Business Artist. Being good in business is the most fascinating kind of art.*[5]

As a consequence, when it came to the judgment of Warhol's relationship to the desubliminatory potential of mass culture, critics and historians of the most divergent positions and methodological approaches suddenly found themselves in the company of their opponents. Certain aesthetic attitudes of the European left of the late 1960s (as embodied for example in

Crone's early monograph) perceived Warhol's work as a critique of the ruling conventions of high art. The work's emphasis on artistic deskilling, its lack of criteria of authenticity, its rejection of originality and uniqueness—all of these desubliminatory aspects were perceived as oppositional acts which could subvert the traditional division of high culture from mass culture. Supposedly these features of Warhol's work would defy the cultural hierarchies, the privilege, control, and legitimation that were traditionally issued by the management of the high culture apparatus, the institution of the museum. Furthermore, Warhol's work seemed to assault traditional artistic role definitions and their implicit adherence to the principle of the division of labor. The work's emphasis on anonymity and collective production seemed to abolish the ruling principle of the specialization of the artist which condenses "creativity" in the exceptional individual to compensate for the destruction of individuality in the collective.

Not surprisingly, it was precisely this antihierarchical emphasis that disqualified Warhol's work in the eyes of his conservative detractors. His rejection of craft- and skill-oriented modes of aesthetic production, his disdain for the essential concepts of author, of authenticity and originality, and the crudely commercial aspects of his cultural venture, were blamed for the beginning of a constant decline of aesthetic standards throughout the 1960s and 1970s. In the eyes of the cultural right, this Warholian decadence was only reversed with the advent of the rapidly reconstituted genius figures of the 1980s such as Anselm Kiefer and Julian Schnabel. Here is a statement by a particularly trustworthy eyewitness of the early moments of critical reception of Warhol's work and that of Pop art in general:

*Well I would say that all the conservative critics go on denying any value to even Jasper Johns or Rauschenberg and those of course will deny that there is anything of real interest in Andy . . . But the serious*

*critics are for the '60s and I don't speak about those that write in the*
New York Times *like Canaday or Kramer who are conservative, not
to say reactionary, but any kind of serious critic here and in Europe
will give a lot of credit to Andy Warhol as a terribly important
artist. . . .*[6]

Hilton Kramer had in fact attacked Pop art and Andy Warhol
violently on several occasions and he would continue to do so in
spite of its increasing success and institutional power. He had
criticized in particular the affirmative implications of Pop art in
his contribution to the panel discussion, "A Symposium on Pop
Art," at the Museum of Modern Art, organized by Peter Selz in
1962:

*It is Duchamp's celebrated silence, his disavowal, his abandonment of
art which has here — in Pop Art — been invaded, colonized and ex-
ploited. . . . Pop Art does not tell us what it feels like to be living
through the present moment of civilization — it's merely part of the evi-
dence of that civilization. Its social effect is simply to reconcile us to a
world of commodities, banalities and vulgarities — which is to say an
effect indistinguishable from advertising art. This is a reconciliation
that must — now more than ever — be refused, if art — and life itself —
is to be defended against the dishonesties of contrived public symbols
and pretentious commerce.*[7]

Kramer's criticism is of interest in several respects. First of all,
at first glance it might suggest a dependence upon Greenbergian
modernism, whose desperate defense of high art's waning auton-
omy and resistance against the onslaught of mass cultural barbar-
ism are buttressed by Kramer's call to maintain and defend the
boundaries between the two spheres. High culture for Kramer
seems to function as a late narcissistic refuge, as a domain of
privileged experience devoid of conflicts with the world of com-
mercial mass culture. His type of hegemonic high culture has to
be first of all protected from audiences emerging from other

classes and culture, as well as from the increasing evidence of
the inextricable contradictions inside this privileged experience
itself, the conflicts that exist inside the boundaries of that elitist
conception of the high cultural sphere. Thus Kramer's defense of
modernist high culture is in fact a far cry from Greenberg's ear-
lier notorious statement on the problematic relationship between
high art and mass culture in his essay "Avantgarde and Kitsch,"
which concludes with the emphatic words: "Today we look for
socialism *simply* for the preservation of whatever living culture
we have right now." Only a faint echo seems to reverberate in
Kramer's concluding statement: "This is a reconciliation that
must—now more than ever—be refused, if art—and life
itself—is to be defended against the dishonesties of contrived
public symbols and pretentious commerce."

The second aspect of Kramer's argument is his indictment
of Pop art for having made artistic practice indistinguishable
from the strategies of advertisement itself and having become
tautological in the process, operating thereby as mere affirma-
tion and reconciliation. This argument, however, not only na-
ively presupposes the historical possibility of continuity of the
artistic critique and transcendental negation that the Abstract
Expressionists had reactivated in the New York School context
and imbued with new credibility. It also fails to recognize that
the aesthetic program of the Duchamp–John Cage legacy from
which Pop art had emerged was precisely a critique of that re-
constitution of modernism; its goal was to cancel that transcen-
dental position (and its implied space of privileged experience).
Its ambition had been to question the dubious claims and un-
manageable aspirations of the previous generation by breaking
down traditional artistic categories, by challenging the status of
the unique artistic object, by denying the criteria of validation
dependent on authorship and originality. In short the increas-
ingly obvious contradictions between mass-cultural and high-
cultural production and the need to incorporate these contradic-

tions *within the aesthetic construct itself* had at least partially moti-
vated the emergence of Pop art. As is well known, none of the
political questions, which still had been asked by Greenberg at
least as late as 1939, would be asked by that generation which
took a position of seeming affirmation for political reasons as
much as for aesthetic ones.

Paradoxically, it is in this argument against affirmation that
the reactionary criticism of Kramer parallels the Warhol crit-
icism articulated by the radical left, in particular the politically
conscious generation of (European) artists of the late 1960s.
Their argument equally criticized Warhol's apparently affirmative
and tautological position since Warhol's work seemed to ruth-
lessly dismantle the differentiated modes of experience embodied
in the modernist legacy, a legacy which after all represented the
epitome of bourgeois high culture and subject construction. The
radical left of the late sixties accused Warhol of complying with
the general agenda of desublimation at work in the culture in-
dustry at large with which his activities seemed to merge in an
increasingly perfect fusion. These critics who were defending
the modernist legacy (as Theodor Adorno and Greenberg had
argued earlier) perceived modernist high art as a form of resis-
tance against the premature collapse of the contradictions of
modernism in bourgeois society: on the one hand, to construct
objects which contained the extremely specialized knowledge
and differentiation inherent in the conventions of artistic skills
and aesthetic cognition; on the other hand, to incorporate into
those constructs the radical anti-aesthetic and egalitarian im-
pulses originating in high art's continuous efforts to assimilate
(and to replace) the desubliminatory project of mass culture.
This type of criticism equally associated Warhol with the reac-
tionary implications of the Duchampian position of radical anar-
chism which supposedly obliterates the conflicts within which
artistic objects are constituted by seemingly abolishing all dis-
cursive and institutional contradictions.

On a more obvious level (outside of the work itself, that is) there is sufficient evidence that Warhol's personal "politics" had been indifferent from the start, not to say that they had always been as cynical and opportunistic as they would obviously become by the 1980s. Thus for example, at the climax of political protest against the U.S. war in Vietnam in 1968, Warhol answered the question whether he would consider himself to be quite apolitical:

*Well, the reason I don't sort of get involved in that is because I sort of believe in everything. One day I really believe in this, and the next day I believe in doing that. I believe in no war, and then I do believe in war if you have to do it. I mean, what can you do about it?*[8]

Warhol's long-time collaborator of the sixties, Paul Morrissey, transcends Warhol's camp ambiguity and makes his arch reactionary, chauvinist, imperialist political views clearly heard (appropriately placed in a pornographic entertainment magazine). While it seems somewhat inappropriate as a testimony for Warhol's own political attitudes in the late 1960s, the statement certainly testifies to the seamier side of the environment of Warhol's Factory:

*I don't know much about Reagan. He's denounced for putting down student uprisings, but to me that sounds good . . . Instead of wandering around taking drugs and not knowing what to do with themselves, American hippie kids should go to a country, colonize it and make a new civilization there. . . . Americanize it, Europeanize it, Irishize it!*

*Certainly to Americanize it would be the best thing: America has the best civilization in the world as far as improvements and everything are concerned. . . . I like what John Wayne says and whenever he talks I find that I agree with him 100 percent.*[9]

And, at first glance, it would seem that the final destruction of the liberalism of the 1960s in the politics and ideology of the 1980s did not deter Warhol from fully participating in the reac-

tionary culture of the Reagan decade. Quite the opposite, if we judge the political position of Andy Warhol Enterprises by the editorial policies of Warhol's magazine *Interview* during the Reagan era. Its dedication of covers and neoconservative cult stories to the likes of Nancy Reagan, Imelda Marcos, and Joan Rivers would indicate that Warhol's ruthless opportunism and business ventures thrived more than ever during that period.[10] The frequently recounted sentimental anecdotes of Warhol's religious devotion to the homeless and hungry on Thanksgiving Day and Christmas Eve only show the flip side of that bourgeois bigotry that glamorizes the very figure whose social and economic politics have created the new masses of urban poor in the first place.

Warhol's elusive disdain for the manifest social and political realities of his last decade align him historically with the aloofness, unreliability, and cynicism that distinguished a certain type of modernist artist from Charles Baudelaire and Édouard Manet onwards, ranging through Oscar Wilde to Francis Picabia and Duchamp. Whenever this lineage is constructed as the genealogy of the dandy in modernism it is forgotten that Warhol, however, entered this tradition at a historical moment when ruling class attitudes to the cynicism of the seemingly apolitical modernists had already profoundly changed. As Walter Benjamin formulated with prophetic insight in his last work, the *Passagenwerk*:

*Baudelaire had the good fortune to be the contemporary of a bourgeoisie which could not yet use the asocial type that he represented as an accomplice. It was left to the bourgeoisie of the twentieth century to incorporate nihilism into its apparatus of domination.*[11]

Yet the evidence of Warhol's essentially reactionary political attitudes does not answer the questions which his work provokes aesthetically and there is not a single instance of a direct correspondence between Warhol's political consciousness (or, rather, the absence of it) and the oeuvre's interventions in traditional

ideologies of artistic production and reception. This contradic-
tion would be confirmed by the simultaneity of a reactionary
contempt for Warhol as articulated by cultural conservatism on
the one hand and the optimistic reclamation of Warhol as a radi-
cally egalitarian populist by Marxist historians and critics on the
other.[12]

The contradictory character of his work would moreover
be confirmed by the fact that one can find in each instance a re-
newed gesture of parodic anticipation and annihilation of the
functions assigned to artistic production within the realm of
contemporary spectacle culture, an erosion of the high cultural
fetish object and its actual functions within the culture industry
(a claim that hardly any of the younger Europeans and American
artists could make in their pretense to reconstitute subjectivity
and identity within the business of high art). In an era of re-
newed commodity magic in art, when the pre-Duchampian
ideals of perceptual experience have been artificially revitalized,
Warhol's strategies disintegrated this false magic at all turns.
When the postmodern techniques of appropriation, the recyc-
ling of found imagery, became a fashionable strategy, Warhol had
already provided a series of canvases with negative imprints
("Reversals," 1979, fig. 33) and a second group of paintings
("Reversals: Retrospectives," 1979) which ganged up and re-
peated the entire catalogue of Warhol's images (a convincing ges-
ture to remind us of the functions and the history of the
strategies of found imagery and appropriation). When with the
rise of neoconservative politics and the corporatization of the art
world the recollection of fascist imagery became fashionable,
Warhol had already contributed his cult of Leni Riefenstahl (in
true American camp fashion) and used the light architecture of
Albert Speer's Nuremberg Rally Grounds as yet another
seemingly random topic for his paintings. When a whole genera-
tion of young Italian artists acceded to fame by rediscovering the
legacy of late Giorgio de Chirico, Warhol provided the most lit-

eral and mechanistic paraphrases of that work, transforming de Chirico from a historical reference into a mere quotational resource from which the new fashion object could be constructed (fig. 62). And during the climax of an atavistic relapse into the assumption that gestural painterly procedures could carry unmediated emotional meaning, Warhol responded with two groups of supercilious paintings, the "Oxidation" paintings (fig. 8) and the "Rohrschach" paintings, both coolly dismantling that myth of a newly found painterly expressivity.

Even in his last phase, at his most corrupted and debased moments, Warhol maintained a strategic acuity that anticipated in parodic moves (and in the seemingly outrageous statements of *The Philosophy of Andy Warhol: From A to B & Back Again,* in 1975) the actual transformations soon to be executed by the managers of the culture industry in the domain of high culture production and reception, changes to which most other artists were still blindly subjected. Thus it is hard to imagine a more accurate collection and depiction of the unique fusion of *arriviste* vulgarity and old-money decadence, the seamless transition from the powers that produce and control corporate culture to those that govern American high cultural institutions than the endless number of commissioned portraits of the American ruling class of the last decade. Or it is equally difficult to think of a more grotesque indication of the degree to which corporate power has invaded and dominates institutional cultural policies and the objects of its exhibitions than in Warhol's final collapse of an exhibition of paintings and drawings with an advertisement campaign for Mercedes Benz, at first delivered to a German museum (and subsequently to New York's Guggenheim Museum). Warhol's legacy has taught the artists of the late 1980s that they—like mass-cultural magazine editors—only have to be concerned with the management of a more or less arbitrary copy around the advertisement core of their product, only have to be concerned with the management of their public image and art

world standing in order to qualify as an investment opportunity, to be eligible for corporate collectibility and to qualify for the advertisement functions of real estate ventures and new product promotions.

This unresolvable ambiguity in Warhol's work between an apolitical conservatism and a camp aloofness on the one hand and a topically subversive precision in pictorial production on the other has been lucidly described by T. J. Clark in the context of a discussion of Manet's work, an artist who, equally disguised as a dandy, concealed all political implications of his work. Clark writes:

*The value of a work of art can not ultimately turn on the more or less of its subservience to ideology; for painting can be grandly subservient to the half-truths of the moment, doggedly servile and yet be no less intense. . . . But one thing that does not follow from it, as far as I can see, is that viewers of paintings should ignore or deny the subservience, in the hope of thereby attaining to the "aesthetic." It matters what the materials of a pictorial order are, even if the order is something different from the materials, and in the end more important than they are.*[13]

It is the word "intense" by which Clark's statement dodges the most difficult aspect of the question that it so brilliantly poses: How can there be an aesthetic and subversive "intensity" in a work and where does it originate in a personality (in our case, Warhol) whose political positions are opportunistic, conformist, and conservative? I would argue that one of the reasons for Warhol's "intensity" derives from the precision with which he — more than any other artist since Duchamp — has incorporated into the conception of his work the actual social and economic transformations which now determine ideological and aesthetic representations. If it was Duchamp's achievement to have defined the work of art within the framework of the commodity fetish, then it is Warhol's achievement to have defined

artistic production in terms of the fetishization of the sign and
pure sign exchange value.

In the same manner that Jean Baudrillard has argued that
it is no longer possible at this point to talk about exchange value
without talking about sign exchange value, Warhol's work has
made it clear that it is the structure of the *system of representation*
which is at the center of his operations, not merely the shocking
iconography of mass culture as generations of modernists (and
his fellow Pop artists and their current rediscoverers) had de-
ployed it. Rather than maintaining a separate status for the work
of art and defending it against the processes of commodification
and reification, Warhol has developed strategies which transform
his work from its inception into what Baudelaire had called in
his essay on the Exposition Universelle in 1855 the "absolute
commodity." In his recent discussion of Warhol's work,
Baudrillard suggests that Baudelaire's and Warhol's conception
of the work of art as the absolute commodity defies both the di-
mension of use value and exchange value and enters the domain
of pure sign exchange value, the domain of Baudelaire's "fashion
object."[14] What Baudrillard does not reflect upon, however, is
that the social functions of this Baudelairean position have un-
dergone the historical changes recognized already in the late
1930s by Walter Benjamin in his discussion of Baudelaire in the
*Passagenwerk* quoted above, namely that the absolute commodity
has long since lost its character of absolute negation in the same
manner that the nihilist — still useless for bourgeois ideology
during Baudelaire's lifetime — had become an essential element of
the apparatus of late capitalist domination in the twentieth cen-
tury. The conditions of semantic atrophy acquired by the abso-
lute commodity under late capitalism function now merely as an
affirmation of a universally governing principle of sign exchange
value as it rules everyday perception. Once the contradictory
halves of mass culture and modernist avant-garde culture have
collapsed into each other in the advanced forms of the culture

industry, artistic objects participate enthusiastically in a state of general semiotic *anomie,* a reign that Warhol called the "business art business."

Michel Foucault, in an essay discussing Warhol's work (among other topics), has described these conditions of an anomic experience:

*"It's the same either way," stupidity says, while sinking into itself and infinitely extending its nature with the things it says of itself. "Here or there, it's always the same thing; what difference if the colors vary, if they are darker or lighter. How stupid life is, how stupid women are, how stupid death is! How stupid stupidity is!"*[15]

What then is the historical space occupied by Warhol's aesthetic *anomie,* constantly expanding in a manner that makes him seem by now as insurmountable as Picasso (and after him Duchamp) appeared to several generations of artists and critics before? By collapsing the readymade representation of the mass cultural object into the high cultural construct and by mapping the aspirations of high art onto the practices of the culture industry, Warhol has moved artistic thinking to a historic threshold from which three distinct possibilities emerge.

The first one is obviously the one he has chosen (and dozens of small-time gadgeteers, from Ashley Bickerton to Jeff Koons to Haim Steinbach, have followed him like sorcerer's apprentices): to reinforce the erosion of the high art-mass culture dialectic and install oneself firmly and comfortably in the commercial success that the apparatus of domination holds for all purveyors of affirmative ideologies (such as advertisement designers, fashion diagnosticians, copy writers). The second option—and that is the one which has dominated the institutions and the market for the last ten years—is to reinstitute traditional artistic role models, object conditions, and production procedures. In an artificially reconstructed separate realm of high art, seemingly uncontaminated by any mass-cultural or industrial evidence,

these restorative acts are claimed as gestures of critical resistance against the fatal legacies of Warhol (and ultimately Duchamp), only to be reclaimed all the more urgently as the spectacular exceptions to the rule of the culture industry's voracious demand for images of legitimation. In that reclamation, they undergo, unwillingly, their reduction to the fashion object and its inherent fetishization of sign exchange value, precisely those processes that Warhol's work anticipated (and thereby at least contained) within its own construction.

And third, it seems Warhol's lesson has opened the way to reconsidering the artificially maintained precarious balance between the mass-cultural and the high-cultural object. That balance appears now all the more artificial since his followers—like the Duchamp epigones before them—have installed themselves comfortably in the newly opened paradigmatic territories to deliver the goods. They do not even attempt to challenge that balance in the manner that Warhol (and certainly Duchamp when defining it originally) actually did. After all, Warhol's work had unsettled for a considerable amount of time any secure notion about the object status of his artistic production—a virtue and a threat which is certainly absent from the work of the contemporary gadgeteers. Instead of merely continuing within the firmly established conventions of mass cultural quotations and delivering them as the most traditional painterly/sculptural objects to an unquestioned discursive, economic, and institutional framework, another type of work emerged from that legacy. This practice now, however, transposes Warhol's radical destabilization of the aesthetic object onto the framing conditions of representation and instead of comforting itself in the anomic condition of the readymade and the universal reign of sign exchange value, this work departs from the assumption that critical intervention within the realm of representation is in fact the motivating force of aesthetic practice (as it clearly was in Warhol's work throughout the sixties). It implies a dimension of critical instru-

mentality (which, even when disguised as absolute passivity, op-
erated in Warhol's radical devotion to the factual image). But, in
clear opposition to Warhol, this attitude, upon which neither
"factories" nor "enterprises" can be built, assumes the possibility
of resistance against the universalization of *anomie* as much as it
rejects the passive acceptance of being contained in hetero-
nomous systems of representation.

## Notes

1. Andy Warhol, in "New Talent USA," *Art in America* 50, no. 1 (1962): 42.
2. See James Fitzsimmons, "Andy Warhol," *Art Digest* (New York) (July 1952): 4.
Warhol's classmate at the Carnegie Institute of Technology, Arthur Elias, com-
pared his early work to Klee and Calder drawings.
3. Rainer Crone, *Andy Warhol: Das zeichnerische Werk, 1942-1975* (Stuttgart:
Württembergischer Kunstverein, 1976), passim. Trans. and ed. as *Andy Warhol:
The Early Work, 1942-1962* (New York: Rizzoli, 1987).
4. In contradiction to Rainer Crone's catalogue (which identified the painting
*Troy Donahue*, 1962, as the first of the silkscreen paintings), Warhol identified
*Baseball* as his first silkscreen painting in an interview with Barry Blinderman,
*Arts Magazine* 56, no. 2 (October 1981); reprinted in *Artwords 2*, ed. Jeanne Siegel
(Ann Arbor, Mich.: U.M.I. Research Press, 1988), pp. 15-23: "The silkscreens
were really an accident. The first one was the *Money* painting, but that was a
silkscreen of a drawing. Then someone told me you could use a photographic
image, and that's how it all started. The *Baseball* painting was the first to use the
photo-silkscreen" (p. 17).
5. Andy Warhol, *The Philosophy of Andy Warhol: From A to B & Back Again* (New
York: Harcourt Brace Jovanovich, 1975), p. 92.
6. See Leo Castelli, interviewed by David Bailey in *Andy Warhol: Transcript of
David Bailey's ATV Documentary* (London: Bailey Litchfield and Mathews Miller
Dunbar, 1972), unpag.
7. Hilton Kramer, in "A Symposium on Pop Art," edited by Peter Selz, *Arts
Magazine* 37, no. 7 (April 1963): 36ff. Or, for another example of Kramer's fore-
sight: "The vogue of bluff and entertainment, whose reigning masters are cur-
rently Robert Rauschenberg, Larry Rivers and Jasper Johns, is directly
connected, of course, with the debacle of the De Kooning 'school' and the pro-
gressive desuetude of De Kooning's own work over the past decade." See Hilton
Kramer, "Notes on Painting in New York," in *New York: The Art World*, ed. James

R. Mellow, Arts Yearbook 7 (New York: Art Digest, 1964), p. 12.

8. Richard A. Ogar, "Warhol Mind Warp," *The Berkeley Barb,* September 1-7, 1968, n.p.

9. Jonathan Rosenbaum, "Conversation with Paul Morrissey," *OUI* (1971).

10. For a discussion of Warhol's relationship with the Reagan White House and previously with the Pahlavi dynasty, see Robert Hughes, "The Rise of Andy Warhol," in *The New York Review of Books,* February 18, 1982, pp. 6-10; reprinted in *Art After Modernism: Rethinking Representation,* ed. Brian Wallis (New York and Boston: The New Museum of Contemporary Art and David R. Godine, 1984), pp. 45-57.

11. Walter Benjamin, *Das Passagenwerk* (Frankfurt am Main: Suhrkamp Verlag, 1983), vol. 1, p. 486.

12. After Rainer Crone's earlier attempts to claim Warhol for a tradition of politically motivated and socially conscious realism in his study *Andy Warhol,* trans. John W. Gabriel (New York: Praeger Publishers, 1970), a much more complex argument has recently been made by Thomas Crow. He suggests that we see Warhol's work in the light of the subversive subcultural ventures of the 1960s, developed in the hope of establishing a truly "popular" Pop culture. See Thomas Crow, "Saturday Disasters: Trace and Reference in Early Warhol," *Art in America* 75, no. 5 (May 1987): 128-136.

13. T. J. Clark, *The Painting of Modern Life (Paris in the Art of Manet and His Followers* (New York: Alfred A. Knopf, 1984), p. 78.

14. The earlier literature frequently suggested situating Warhol in the Baudelairean tradition of dandyism and its concern for the fashion object. This argument has been made most convincingly in Jean Baudrillard's recent essay on Andy Warhol, "De la marchandise absolue," *Artstudio* (Paris) 8 (1988): unpag. (special issue on Andy Warhol).

15. Michel Foucault, "Theatrum Philosophicum," *Critique* 282 (November 1970): 902ff; English translation in *Language, Counter-Memory, Practice: Selected Essays and Interviews,* ed. Donald F. Bouchard and Sherry Simon (Ithaca, N.Y.: Cornell University Press, 1977), p. 189. I have slightly altered the translation to restore the original's rhetorical impact.

Rainer Crone

FORM AND IDEOLOGY:

WARHOL'S TECHNIQUES

FROM BLOTTED LINE TO FILM

*Each of the arts has its physical aspect, which can no longer be looked at as it was previously, it can no longer escape the influence of modern science and modern* practice. *Neither material nor space, nor time have been the same during the past twenty years as they were from the beginning. We must be prepared to accept that such great innovations will change all techniques in all the arts, thereby influencing creativity itself, and perhaps going so far in the end as to transform the concept of art in itself in the most exciting way.*[1] (figs. 63 and 64)

This theme outlined by Valéry, of artistic techniques as a medium of creativity seen against the background of changing times and the resultant transformation of concepts of art, forms the basis for my discussion of the artist Andy Warhol. My use of the word *artist* (as opposed to *painter* or *sculptor*) in this context is by no means as casual or impulsive as it might be thought. I should like to emphasize that Warhol expressed himself creatively within the same tradition as such artists as Moholy-Nagy, Rodchenko, and others from Eastern and Central Europe in the 1920s. He did so not only as a graphic artist, painter, or sculptor, but also to an equal extent in such media as photography, film, video, and writing. Although the development of Andy Warhol's various artistic techniques forms the main subject of my lecture, it is important not to overlook the fact that this evolution takes place against a background of linked development

between form and ideology, and art and politics. This feature
has been particularly prominent since the end of the eighteenth
century and has been frequently discussed (one need only recall
such names as David, Gros, Géricault, Delacroix, etc.). It cannot
be my task here to deal with this aspect in all its ramifications,
but I should at least like to point out how decisive is this dialec-
tically determined correlation between form and ideology in its
contribution to a proper understanding of artistic techniques
and their major role in a particular work, as well as to an under-
standing of the hermeneutic implications of such a work.

Warhol had a high regard for the work of Bertolt Brecht,
both as an author and a theoretician. It is of particular relevance
to our present discussion that, in the 1920s, in his "Require-
ments for a New Form of Criticism," Brecht maintained that the
aesthetic criterion should give way to the criterion of useful
value:

*The possibility of creating a new aesthetic should be rejected. This
means that, faced with an assessment of this formulation, we should
ask: who benefits from it? Given the situation in which we live, some-
thing may have been formed for its aesthetic qualities, it may be splen-
did, but it can still be wrong. Because something possesses beauty it
should not be immediately taken as true, because what is true is not
necessarily considered beautiful. Beautiful things should be regarded
with extreme mistrust.*[2]

The relationship between form and ideology is both so central
and so complex that only an explicit analysis of these two appar-
ently incompatible areas could offer a full understanding of both.
The two should be seen only in conjunction since they are mu-
tually illuminating. Thus, while the observation of either in isola-
tion may yield information of some value, it is not fully
satisfactory. The form of a painting—its structure and its pro-
cess of production—is often more indicative of larger meanings
than its specific subject, and this is particularly true for its rela-

tionship to a particular ideological situation. This is often simply because the intention of the artist is more oblique, the creator's grasp of the formal structure is more direct than his grasp of the content would appear to be.

Thus the ideological position of a work within a certain period can often be more clear from its form than from its subject. After all, form is not representation of and for itself. It is in this context that the writings of Robbe-Grillet, the early essay by Susan Sontag, "Against Interpretation," written in 1964, Roland Barthes's 1967 essay, "The Death of the Author" (more accurately translated as "The Absence of the Author"), and the distinction between writing and literature made by these and other critics such as Derrida are effective in confirming the point I want to make regarding Warhol's techniques. "The absence of the author (like Brecht, we might speak here of a real 'alienation,' the Author diminishing like a tiny figure at the far end of the literary stage)," Roland Barthes writes, "is not only a historical fact of writing: it utterly transforms the modern text (or—which is the same thing—the text is henceforth written and read in such a way that in it, on every level, the Author absents himself)."[3] However, long theoretical and conceptual discourses are not ideal for discussing the way in which this relationship between form and ideology acquires substance. Since this relationship manifests itself directly in the work, I shall illustrate it through a number of specific examples. This outlining of the development of Warhol's techniques not only can provide us with implicit insights into this complex area, but can also reveal the conclusive and consistent way in which Warhol designed a system of depersonalized techniques from the late forties onwards. This system evolved from the primitive manual techniques of the "blotted line" to his technologically perfect system of reproduction through film recordings.

Warhol was responsible for a large number of artistic techniques. There were wide variations in quality, but to provide a

clearer picture I shall first give a complete listing of them in chronological order. The reproduction techniques employed during the 1940s and 1950s (a period during which Warhol's work is usually and incorrectly considered merely "commercial art") were:

1. Blotted line technique (since the late forties) (fig. 65)
2. Offset printing technique (since 1953) (fig. 66)
3. Stamping technique (since 1955) (fig. 67)
4. Gold leaf/gold wafer technique (since 1956) (fig. 68)

The following methods of picture production were employed beginning in September 1960 and form a consistent outgrowth of the various printing and reproduction techniques of the fifties.[4] Listed chronologically, they are:

5. Painted, exact copies of pictures with formal graphic alienation effects (from September 1960 to the fall of 1961) (fig. 69)
6. Painted copies of other images, but stylized through graphic simplification (from November 1961) (fig. 70)
7. Exact, hand-painted copies that are faithful reproductions of the original (1961) (fig. 71)
8. Pictures produced using stencils (from February 1962) (fig. 72)
9. Pictures printed using rubber and wood block stamps (from July 1962) (fig. 73)[5]
10. Pictures produced using the silkscreen process, in an exclusively photomechanical way, principally without manual influence on the canvas (from August 1962) (fig. 74)[6]
11. Film technique (since 1963) (fig. 75)
12. Films with special effects: the *strobe cut* (since 1966)

I will now discuss all the different techniques from the 1940s through the mid-1960s, emphasizing their significant conceptual implications.[7]

## 1. Blotted line technique

The blotted line technique is one of a group of monotype print-
ing processes, along with linotype, stamp printing, etc. It is the
simplest kind of monotype, similar to offset printing, and pro-
duces a light, delicate, and partly broken outline. It is this tech-
nique which accounts for the predominantly graphic character of
Warhol's drawings. The first examples can be found in the draw-
ings Warhol made during his studies in Pittsburgh at Carnegie
Tech between 1945 and 1949. No doubt they derive formally
from Ben Shahn's *broken line,* although their graphic incisiveness
and quality make them vastly superior to the latter (fig. 86).

Warhol himself cited several advantages of this process.
The same drawing could be used several times more or less as a
stamp or stencil. It was even possible to allow colleagues or as-
sistants to undertake the entire process on their own, without
anybody being able to distinguish whose hand had produced a
particular graphic work. In addition, it became apparent later, in
1954, that no visual distinction could be drawn between a pho-
tomechanically produced offset reproduction of such a blotted
line drawing and the "original." "I like to have my drawings re-
produced," Warhol was fond of saying.[8] Philip Pearlstein, War-
hol's classmate at Carnegie Tech and roommate until 1951, was
asked whether Warhol had taken his example from anyone else,
and replied that Warhol "discovered the blotted line all himself,"
even adding: "Andy invented printing."[9] This method of drawing
can be considered the first step in Warhol's adoption of mechan-
ical reproduction methods, which progressed from rubber and
wood block stamps and stencils to their culmination in the re-
fined printing technique of seriagraphy. It is thus essential to any
understanding of Warhol's pictorial work produced in the 1960s.

The process itself is simple enough: a drawing is first made
in lead on water-resistant paper. The lines are then retraced
with black ink on top of the lead, and the paper is wetted.

While the drawing is still wet, it is pressed onto a second sheet. This is the first printed sheet, and thus becomes the "original" print. The process can be repeated as often as required, and the retracing of the original lead drawing and the printing process itself can even be carried out by another person. As a slight variation, a pane of glass or transparent paper was sometimes used as the printing block. Placed over a photograph, it allows the required lines to be traced in ink. This can then be pressed onto the sheet of paper to produce the "original" print.

This method is basically a graphic process for mechanically multiplying or reproducing an artist's drawings. Compared with relief (letter press, wood and lino cut, and so on) and intaglio (copper, zinc, etc.) printing, this planographic method represents the most modern form of printing and has evolved from lithography, which was invented by Aloys Senefelder in 1796. Technically it is similar to offset printing, which is currently used in a number of different variations, and is the simplest and cheapest mass-production method available, with the exception of recent developments in photocopying processes. Offset printing has one further part to play in the printing process, to ensure that the printed image appears the way it was originally drawn or written. Apart from the degree of automation employed, the offset printing method is identical to the technique of the blotted line in Warhol's drawings. Because Warhol's "original" is itself printed, it is difficult to distinguish such an image from an offset print, especially since Warhol tended to apply color manually to offset prints (fig. 77) and hand prints alike (fig. 78). Halftone printing using a photomechanical process is another principle that has been applied in the visual arts, in the form of screen printing, and this is a modern process that is also used in offset printing. However, Warhol never used chiaroscuro — shading or halftones — in his drawings, preferring instead to draw lines with a constant intensity/density by using a ballpoint pen (fig. 79). It is worth pointing out that Warhol has always

confined himself to planographic offset printing (the only exception being his rare use of stamp printing). This decision is all the more remarkable because the chosen printing methods differ fundamentally from those used traditionally even by such twentieth-century artists as Picasso and Matisse, to mention only two artists whose graphic work has had an impact on Warhol (fig. 80). In the case of the latter artists, the line did not serve only as a contour; its thickness, intensity, and gestural inflection were also significant features, and reproduction processes were thus selected that produced copies of the original drawing that conveyed these uniquely personal formal and expressive aspects. Warhol's style of drawing, on the other hand, was so close to the final result of a printing process, namely offset printing, that we may refer in his case to a reciprocal relationship between style and technique, a relationship in which the method of representation conditions the form of the original. From the formal point of view of the art historian, this represents a new and original "stylistic" development, and one which can only be explained by referring to recent technological advances.

These observations illustrate how important it is to understand the fundamental and subtle working processes involved in the production of a specific kind of art in order to appreciate that art adequately and to be able to interpret it effectively.

## 2. Offset printing technique

Warhol began to get involved in photomechanical printing methods such as offset, often referred to as offset lithography, in the early 1950s, and certainly no later than 1953, with the publication of the books *Love is a Pink Cake* (fig. 79) and *A is an Alphabet*. All of Warhol's books and pictorial folders, along with the numerous greeting cards, the "Happy Butterfly" (fig. 81) and "Happy Bug" day cards, were printed using the offset method. They were colored in afterwards, often by friends. Even on the closest inspection, no graphic difference or distinction in techni-

cal quality is identifiable between the usual lithographs, tradi-
tionally recognized and sold as original prints with a maximum
run of up to one hundred copies, and the offset prints, which
are merely regarded as technical reproductions. This applies par-
ticularly to the monochrome drawings. Consequently, the argu-
ment as to whether such works by Warhol are originals or
reproductions is only of "academic" interest. Moreover, Warhol's
style of drawing, and his techniques using the blotted line or
ink, deliberately obscure the distinction between the original
and its reproductions. In many cases it is difficult or even impos-
sible to distinguish between an original drawing and a hand-
colored offset print. The fact that Warhol deliberately obscured
these distinctions is apparent when we compare original drawings
with their offset reproductions in his exhibitions in the 1950s.

### 3. Rubber stamp technique

In 1951 Warhol moved from a communal apartment to his own
apartment on the East Side (73rd Street). Soon afterwards he
became acquainted with the painter and commercial artist
Nathan Gluck, whose graphic work was similar to Warhol's and
who collaborated with him until 1961. Thus we may refer to a
kind of Warhol studio, because many commercial illustrations
were produced by his collaborator Nathan Gluck, although they
were signed "Andy Warhol." In the late fall of 1953, Mrs. Julia
Warhola, the artist's mother, began adding Warhol's signature
along with text and symbols to accompany his drawings.
Throughout the entire time that he was engaged in commission
work, the general form of her handwriting was one of a naive
filigree script (with many orthographic errors). The collabora-
tion with Nathan Gluck was not primarily concerned with meet-
ing the sharp increase in demand for illustrations and drawings
from the "Warhol Studio," but rather represented a logical form
of cooperation facilitating the use of the "blotted line" tech-
nique. By 1955 Warhol and Gluck had also developed their

stamping technique, employing a unified system of many different stamps to represent a wide variety of motifs (fig. 26). The stamps were cut from rubber, and a separate box was provided for each subject area. Printing with black ink produced images that were graphically similar to those formed by the "blotted line" technique. According to Gluck, he often received his instructions over the telephone or in writing from Warhol (who had by now become a busy and well-paid commercial artist) telling him how certain orders for drawings were to be executed. This led to a massive increase in production: little souvenir cards and greeting cards produced by Warhol are reported to have turned up everywhere. Thus, this working method, which aimed at maximizing quantity through repetition, determined the appearance of the graphic image, a reciprocal interweaving of style and production method that is even more obvious in Warhol's later work.

Warhol was always interested in such collaborative working methods; for example, it was reported that:

*Pages of bugs or butterflies which have been mass-printed in black and white and then hand-colored — no two alike — by Warhol and friends with the added greeting — Happy Bug Day! or Happy Butterfly Day! . . . I helped . . .: great fun deciding which color to use where.* [10]

### 4. Gold leaf/gold wafer technique

Warhol's use of gold and silver is enhanced by the application of cheap, mass-produced gold-leaf hearts, lilies, and other embellishments (fig. 82).

The use of gold and silver, and especially of prepared leaf and other materials, like the blotted line technique and the unusual practice of allowing his mother to write the inscription and signature of the paintings, is an intentional device employed by Warhol to depersonalize the production of artworks. Like the blotted line technique, which is unusual in that the actual visual

result is not achieved by the intervention of the artist's own hand but, rather, by an impersonal printing process, the use of applied gold and gold leaf insures that it is largely immaterial who performs the actual drawing, provided that those concerned are agreed on the choice of subject and composition. The blotted line technique was again used with the gold drawings.

The highly idiosyncratic nature of Warhol's subjects in the 1950s limited somewhat the actual achievement of depersonalization, while not conflicting with this general tendency. Warhol thus entrusted the execution of his works to "anyone" in order to subvert the traditional originality of a work of art in the "age of mechanical reproduction" (Walter Benjamin). This subversion of the dogma of the original, of the unique production of the artist, was further signaled by the "faking" of the signature, the traditional autograph guarantee of artistic authorship. In the course of his subsequent artistic development, Warhol moved consistently toward greater degrees of depersonalization both in subject matter and artistic technique.

This increasing mechanization of method, which led to the production of silkscreen pictures by 1962, the peak of the process in the context of easel painting, would culminate logically in Warhol's films. Warhol's employment of this medium reduced to a minimum the use of the human hand, relying only on the mechanical processes of the camera and laying bare in purest form its function in the recording of the image.

At the same time, Warhol's displacement of complete creative control from the hands of the uniquely talented individual artist opened up the creative process to his co-workers. This aim coincided with the ideas of John Dewey, which were most influential in the first half of the twentieth century and which promulgated the belief that everyone could be creative. And it accords most significantly with the views of Moholy-Nagy as put into practice in his New Bauhaus in Chicago, with its emphasis on collaborative craftsmanship supplanting dependence on the

individual designs of an "artist-genius." In contrast to the prevailing attitude in American art of the 1950s, no particular significance was attached to form or to style, which is determined by the chosen technique.

In examining Warhol's pictorial techniques in terms of their development, it seems appropriate to stress that Warhol worked from this time forward mainly with existing pictorial material that he found, usually in photographs: "Andy used things that existed already. He would trace photographs."[11] In this respect also we may turn to Moholy-Nagy as an important precursor and proponent of the idea that artists should use photography as a mechanical method of reproduction and depersonalization. As Moholy wrote in an essay published in 1936:

*in this connection it cannot be too plainly stated that it is quite unimportant whether photography produces "art" or not. Its own basic laws, not the opinions of art critics, will provide the only valid measure of its future worth. It is sufficiently unprecedented that such a "mechanical" thing as photography . . . should have acquired the power it has, and become one of the primary objective visual forms. . . .*[12]

The instructions given over the telephone or in writing by Warhol on the way in which he wanted his illustrations prepared, and the fact that friends joined in the coloring of his drawings, recall Moholy's telephone pictures and his rejection of an overemphasis on individual aspects in a work of art. In the chapter entitled "Objective Standards," that contains illustrations of a fashion showroom installed by Moholy, as well as examples of window dressing, Moholy wrote:

*This is the place where I may state paradoxically that, in contemporary art, often the most valuable part is not that which presents something, but that which is missing. In other words the spectator's delight may be derived partly from the artist's effort to illuminate the obsolete solutions of his predecessors. My desire was to go beyond vanity into the realms of objective validity, serving the public as an anonymous agent. An air*

*brush and a spray gun, for example, can produce a smooth and imper-
sonal surface treatment which is beyond the skill of the hand. I was not
afraid to employ such tools in order to achieve machine-like perfection.
I was not at all afraid of losing the "personal touch," so highly valued
in previous painting. On the contrary, I even gave up signing my
paintings. I put numbers and letters with the necessary data on the
back of the canvases, as if they were cars, airplanes or other industrial
products. I could not find any argument against the wide distribution
of works of art, even if turned out by mass-production. The collector's
naive desire for the unique can hardly be justified. It hampers the cul-
tural potential of mass consumption. In the visual arts we already have
mass-produced engravings, wood cuts etc. My photographic experiments,
especially photograms, helped to convince me that even the complete
mechanisation of techniques may not constitute a menace to its essen-
tial creativeness. Compared to the process of creation, problems of ex-
ecution are important only in so far as the technique adopted—
whether manual or mechanical—must be mastered. Camera work, pho-
tography, motion pictures and other projective techniques clearly show
this. It may happen that one day easel painting will have to capitulate
to this radically mechanised visual expression. Manual painting may
preserve its historical significance: sooner or later it will lose its in-
clusiveness . . . In 1922 I ordered by telephone from a sign factory five
paintings in porcelain enamel. I had the factory's color chart before me
and I sketched my paintings on graph paper. At the other end of the
telephone the factory supervisor had the same kind of paper, divided
into squares. He took down the dictated shapes in their correct position
. . . true, these pictures did not have the virtue of the "individual
touch," but my action was directed exactly against this over-emphasis.
I often hear the criticism that, because of this want of the individual
touch, my pictures are "intellectual." This is meant as a derogatory
term, referring to a lack of emotional quality.* [13]

It is not my intention here to stress the similarity between the
production methods used with the silkscreen pictures (which
were to some extent communicated to the printing works by

telephone) and those of Moholy, but rather to state the degree—
*grosso modo*—to which Warhol succeeded in the practical ap-
plication of ideas that arose initially in the Bauhaus in Germany
and were subsequently reformulated in the United States.

In this particular context Warhol offered revealing remarks
only on one occasion, in 1963, when referring to his attitude to-
wards the relationship between commercial art and mechanically
produced panel pictures. "Was commercial art more machine-
like [than silkscreen paintings]?" Warhol was asked. He
responded:

*No it wasn't. I was getting paid for it and I did anything they told me
to do. If they told me to draw a shoe, I'd do it, and if they told me to
correct it, I would—I'd do anything they told me to do, correct it and
do it right. I'd have to invent and now I don't; after all that "correc-
tion," those commercial drawings would have feelings, they would have
style. The attitude of those who hired me had feeling or something to
it; they knew what they wanted, they insisted; sometimes they got very
emotional. The process of doing work in commercial studios was
machine-like, but the attitude had feeling to it.*[14]

This was the first interview that Warhol gave, and according to
Malanga it was one of his few "serious" interviews. We should
therefore consider it as a very important source of information
and a key to an understanding of his work. Its importance is en-
hanced by the fact that Warhol primarily explained his ideas in a
visual way, hardly using verbal forms at all. In this 1963 inter-
view, Warhol continued:

*It's hard to be creative and it's also hard not to think what you do is
creative or hard not to be called creative because everybody is always
talking about that and individuality. Everybody is always being cre-
ative. And it's so funny when you say things aren't, like the shoe I
would draw for an advertisement was called a "creation" but the draw-
ing of it was not.*[15]

The following sentences from the same interview reveal his

ghts about various mechanical and individual aspects: "I
k everybody should be a machine. I think everybody should
everybody," and "somebody said that Brecht wanted every-
to think alike. I want everybody to think alike." These
ments certainly paraphrase Brecht's ideas on "the increasing
entration of mechanical means," and it thus seems appro-
e here to offer some of Brecht's remarks on the process of
'mechanized theater," his epic theater which was also crit-
d for being too intellectual, too didactic, cold, and unemo-
al. He stated:

*"fear" of or flight "from the mechanical" . . . is overcome by
ting mechanical aspects" . . . "into effect." One can only "come
rms" with "the mechanical tendency" of the "age" by "making it
able" for something: the creation of a new quality through the
titative summation of given elements. The "mechanical" speech
singing required when practicing didactic drama are one of a
ber of ways of preventing a "mechanical training" and of creating
w kind of "freedom."*[16] (Quotation marks are Brecht's)

reas, in the 1950s, Warhol sought a technique favoring the
ction of individual style in promoting depersonalization, by
beginning of the 1960s he had augmented this technique by
ersonalizing the content. Creativity shifted from the individ-
possibilities of a "talented person" to the selection of
ities.

**ecisely copied paintings with formal graphic alienation effects**

his technique, Warhol photographed details from newspaper
ertisements, and then used a slide projector to project the
eloped color slides onto a primed canvas (fig. 83). He next
d either a brush or a pencil to trace the outlines. These pic-
es were executed in a very casual way, but the main features
identifiable. The choice of the detail from the advertisement
ears to be random, and unwanted areas were casually filled in

by colored pencils or acrylic paint, sometimes supplementing or cutting off the motif. No particular importance was attached to the use of uniform working materials. Sometimes the colors applied were allowed to run to the bottom edge of the picture, and at times the letters of the text were left incomplete. This technique was deliberately intended to create an amateurish and imperfect effect. Since Warhol's pictures were not imagined by the artist, but rather were found and then copied or reproduced (from advertisements, comics, etc.), this approach differs fundamentally from the preconceived pictorial concepts of Abstract Expressionism, despite the apparent formal similarities. Similar "stylistic" devices can be found in the drawings of "Dollar Bills" and "Campbell's Soup Cans" which were first created in 1962.

Warhol's strategy becomes even clearer when we compare pictures completed at different dates dealing with the same subject matter. For instance, there are three different versions of *Before and After*. The first version, *Before and After I* of 1960 (fig. 5), retains fragments of text, presumably advertising copy, which is cut off by both the top and left side of the canvas, and seems to have been placed almost at random. The edges of the images are not completely straight and more importantly they do not coincide with the edges of the panel in which they are placed: large white zones of unequal height border the images on top and bottom. Splashes of paint dripping down into the white margin and blank spaces in the black area indicate that this work was deliberately executed in haste. With *Before and After* [II] of 1960 (fig. 84), this informality of treatment has been greatly reduced. Only the roughly sketched outlines of the features of the profile, faces, and a much slighter irregularity of edge in the images testify to the continued informality. In *Before and After III*, painted a few months later (fig. 85), the apparent casualness is eliminated. Outlines are reproduced with sharpness and clarity, the faces are no longer cropped by the edges of the image, and the images themselves are clearly placed on center in the canvas,

bordered by a painted hard-edged octagonal frame. Since it is safe to assume that all the images were based on the same original design, this third painting in the series, with its facial features reproduced in stylized form, can be seen from an aesthetic viewpoint to demonstrate a formal stylization through graphic simplification. It can thus be included in the next category listed below.

### 6. Painted copies stylized through graphic simplification

In the fall of 1961, Warhol applied himself to a technique in which slide projections were used as a means of making painted copies of images which were then stylized through simplification of their graphic elements. This group of works includes in particular paintings that use images from the title pages of three New York tabloids (figs. 35, 37, and 70). It is possible that he was here influenced by Moholy-Nagy's book, *Vision in Motion,* showing the illustration of a title page from a well-known newspaper.[17] Warhol attached considerable importance not only to the subject of such images, but also to format, and displayed a particular preference for pages devoted almost entirely to pictures, with very little text. These three panel paintings were created between November 1961 and June 1962.

A comparison of *A Boy for Meg* (fig. 35) with the original title page reveals that the typography has been adopted faithfully, down to the finest detail possible (lettering that was too small was simply left out). The copy of the title photograph retained only the typical features of photography, simplifying the graphic lines and leaving out areas that tended to interfere. Unlike Lichtenstein's pictorial approach,[18] however, no effort was made to alter the existing proportions.

### 7. Exact painted copies that are unaltered reproductions of the originals

This third group contains pictures with the closest affinity to

mechanical reproduction. Any differences that do exist are only apparent following the closest scrutiny (fig. 86). At the same time, the range of subjects has been considerably widened. In addition to a simple, larger-than-life Coca-Cola bottle as the center of an advertisement, there is also a group showing features specifically associated with advertising: calling upon the consumer to "Say Pepsi Please," "Drink Coca-Cola," and "Close Cover Before Striking." This group also includes the "Do-It-Yourself" pictures (fig. 44), with their numbered areas of paint, assigning instructions rather than permitting individual creative choices, and the "Dance Diagrams" (fig. 10).

### 8. Pictures reproduced with the aid of stencils

From February/March 1962 onwards, Warhol used stencils, for example in the preparation of *Handle With Care — Glass — Thank You* (fig. 7), *Martinson Coffee,* and the series of "Campbell's Soup Cans" (figs. 49 and 87). The series of thirty-two individual images in a smaller format has become particularly well known. They were exhibited at the Ferus Gallery in Los Angeles in June 1962 at Warhol's first one-person show of panel paintings.

Presumably it was Warhol's efforts to present the essential features of each theme by means of visual signals, here focused on the quantitative aspect of mass consumer goods, that led him to apply a technique that offered a simpler and above all a more appropriate method than the precise manual transferral achieved using slide projection.

### 9. Pictures printed using rubber stamps and wood blocks

The *S & H Green Stamps* (fig. 73) and *Airmail Stamps* (fig. 88) of 1962 form another group from the consumer sector calling for display on a mass scale. Since the actual size of the originals dictated that the copies be depicted in a relatively small format, Warhol went back to a reproduction technique that he had pre-

viously employed in the fifties, the use of rubber stamps and wood blocks to create printed images. The reintroduction of this technique was restricted to this small number of pictures produced entirely during the summer of 1962.

## 10. Pictures produced using the silkscreen process, in an exclusively photomechanical way, without any manual influence on the canvas

The methods used until this time had only permitted reproduction with stencil-like stylization. It was probably the difficulties involved when they were applied to portraiture that led Warhol to consider the use of silkscreening (figs. 15, 48, and 74). He had been familiar with the technique, its applications, and its graphic impact since his early days as a window dresser in Pittsburgh.[19]

Any inquiry into the particularly academic issue of whether Warhol or Rauschenberg was the first to apply the silkscreen printing method simply poses the wrong question. It is obvious that the silkscreen method was a particularly appropriate method of production in Warhol's artistic development, furthering his specific aims. Even during his period as a student he must have been aware of Ben Shahn's use of silkscreening for making prints as early as 1941.[20] The use of silkscreen printing cannot be considered a qualitative advance when used simply as one among a number of possibilities for expression, or even as a formal contrast to manually produced pictures, as in the case of Rauschenberg, but only when, as an exclusive and specific means of expression, it emphasizes the artist's own particular characteristics. And this certainly applies to Andy Warhol. A long process of development using different methods of reproduction culminated in his application of silkscreening in August 1962, for his treatment of a photograph of the actor Troy Donahue.[21]

*A few years ago the glory of our age, a machine, was born, and day in, day out, it amazes our minds and shocks our eyes. Before one hundred years have passed this machine will have become the brush, the palette,*

*the paints, the skill, the experience, the patience, the accuracy, the col-
oration, the luster, the pattern, the completion, the extract of painting
. . . do you not believe that art will be killed off by the daguerreotype
. . . When the daguerreotype, this great child, has grown, when all its
art and strength have come to fulfillment, genius will seize it by the
neck and call out loud: Come here! Now you're mine! Let's work
together!*[22]

Photographic techniques can be used in silkscreen printing for
the preparation of the screen. The silkscreen is a kind of stencil,
but when used in conjunction with photographic processes the
results can be much more varied. A woven material is tensioned
onto a wooden frame, coated with a photosensitive emulsion and
exposed next to a photographic slide. On being developed with
hot water, the emulsion dissolves, leaving the fabric in the unex-
posed areas in its original state, while the exposed areas have
been imprinted with the photographic image. The screen can
then be used to print on any surface, such as paper or canvas, by
pressing ink or paint onto the screen with a scalpel of exactly
the same size as the frame. If several colors are desired, a sepa-
rate screen must be prepared for each, and these are used in the
required sequence. This is still the simplest and cheapest print-
ing method and has an advantage over other methods such as
etching or lithography because it allows an unlimited number of
prints to be run off.

After choosing this motif, a photograph taken from a mag-
azine or newspaper, Warhol would send the original image to
the silkscreen works, giving instructions about the size of screen
and the number of colors to be used. The printers would then
bring the finished screen to Warhol's Factory (figs. 89 and 90).

### 11. Film technique

Warhol's first films were silent, and were made with a stationary
camera. The significance of these films lies in their radical dis-

closure of the structure of the film medium (figs. 13, 14, and 75). The method can be used by anybody, just as Warhol's painting method can: he reduced film to its simplest elements. At the same time, in the course of his development in film, Warhol has succeeded in showing all the structural possibilities inherent in the medium. He has proven wrong the assertion that film provides an objective picture of reality—the environment—demonstrating that the opposite is true: film is manipulation (and manipulators make film). "History books are being rewritten all the time" (Andy Warhol, 1963). Just as there is no such thing as an objective history, there is no objective film: filming a person or thing influences it and our perception of it. One of the express purposes of Warhol's early films is to make us conscious of this. The person who speaks of these films as boring or dilettantish is measuring them against the standards of American or European commercial films—films that are bound by conventional requirements in both structure and content that do not allow them to be either boring or dilettantish; otherwise they might enlighten instead of obscuring. Whether he is working at painting, producing books, or making films, Warhol analyzes the structure of his medium, and by reducing formal considerations to a minimum, he exploits the autonomy of the apparatus and the conditions of production, which determine the character of the product. Obeying the machine in order to make use of it—this is Warhol's aesthetic principle.

The films made since 1964-65, for the most part, use the "sync sound" technique (the sound being recorded directly onto the film while it is being shot), and were usually shot by a stationary camera. Some are based on "playscripts" (Ronald Tavel, Chuck Wein), although they only loosely followed these scripts.

### 12. Films with special effects: the strobe cut

The strobe cut, along with other generally used means of structural analysis, is a typical feature of Warhol's films and of his

technique since early 1966. The strobe cut is achieved during shooting, the camera producing a fully exposed frame each time the filming stops. Using this particular stylistic element, Warhol was able to achieve and make use of a unique technical process. Used in a positive way, to clarify and depict the content, he was able to attain his objectives in the most effective way possible. Whereas Brecht created "moments of alienation" in a simple sense, by interrupting the narrative, Warhol, who rejected any sort of story line, made use of the strobe cut to interrupt the depiction of a person or the reproduction of a conversation or an action. "The action recalls work by Brecht or Godard, and by interrupting the narrative the viewer is kept at a distance, in order to remind him that it is, after all, only a film shot with a camera, which can be turned on and off, thereby bringing a screen existence alive, or killing it again by turning a switch on or off."[23]

In the course of this lecture, we have reviewed Warhol's fascinating and carefully conceived development of artistic techniques, featuring many varied methods of reproduction. These range from the most technically primitive to the most advanced technological means of visual reproduction. The program has its historical roots in the early nineteenth century and ends with the present day.

In closing, I should like to offer a few thoughts about this program. It is intended to be more than simply a portrayal of the artistic and technical skills of one of this century's major artists. It is also meant as a broadly based outline of a conceptual system that may be capable of creating a visual language that could provide the structural basis for a communication technology in the visual arts in the coming decades. Such a strategy has been rapidly adopted in literature and literary criticism, where it has met with an appropriate response by leading figures such as Alain Robbe-Grillet, Susan Sontag, Roland Barthes, and Jacques Derrida.

## Notes

1. Paul Valéry, *Pièces sur l'art* (Paris: Gallimard, 1930), p. 112.

2. Bertolt Brecht, *Schriften zur Literatur und Kunst*, Vol. 1, Collected Works, vol. 18 (Frankfurt am Main: Suhrkamp Verlag, 1967), p. 113.

3. Roland Barthes, "Death of the Author," in *Image, Music, Text* (New York: Hill and Wang, 1977), p. 186.

4. These techniques are limited to his paintings and do not include the objects/ sculptures he started to produce in 1964 like the Brillo boxes. But in most of these cases, too, the artist applied the silkscreen technique. In his *Last Show*, for which Warhol announced "the end of painting," in 1966 at the Leo Castelli Gallery, he produced printed wallpaper with a cow as the motif and helium filled floating silver pillows, a number of which exited through the open windows.

5. Warhol had used rubber and wood block stamps before in works on paper, but never on canvas.

6. Occasionally, Warhol added here and there a hand-painted color or painted over some areas.

7. In the seventies and eighties, Warhol returned to a combination of his reproduction techniques and overtly hand-painted gestural pictures as well as to hand-drawn graphite drawings. In addition, a special category was formed by his famous oxidation paintings, shown at Documenta in 1982.

8. According to Nathan Gluck, his assistant since 1951.

9. According to Philip Pearlstein; see Rainer Crone, *Das Bildnerische Werk Andy Warhols* (Berlin: Wasmuth KG, 1976), pp. 253-271.

10. Ibid., p. 126.

11. Ibid., pp. 272-294.

12. Laszlo Moholy-Nagy, *The New Vision* (New York: Wittenborn and Company, 1928), p. 53.

13. Ibid., pp. 79-80.

14. Gene Swenson, "What is Pop Art?" *Art News* 62, no. 7 (November 1963): 26.

15. Ibid.

16. Reiner Steinweg, *Das Lehrstück: Brechts Theorie einer politisch-aesthetischen Erziehung* (Stuttgart: Metzler, 1976), p. 143.

17. Laszlo Moholy-Nagy, *Vision in Motion* (Chicago: P. Theobald, 1947), p. 307, illus. 16.

18. See Albert Boime, "Roy Lichtenstein and the Comic Strip," *Art Journal* 28, no. 2 (Winter 1968-1969): 155-159.

19. See the interview with Robert Lepper in Crone, *Das Bildnerische Werk*, pp. 234-242.

20. See John D. Morse, ed., *Ben Shahn* (New York: Praeger Publishers, 1967),

p. 77, illus. 14, 15.

21. This date is a *terminus post quem,* which is given on the newspaper in which this image is printed.

22. Antoine Wiertz, quoted by Walter Benjamin, *Kleine Geschichte der Photographie* (Frankfurt am Main: Suhrkamp Verlag, 1963), p. 9.

23. Gene Youngblood, "Andy Warhol," *Los Angeles Free Press,* February 16, 1968.

Trevor Fairbrother

SKULLS

I

Created during the Bicentennial year, Warhol's "Skulls" belong
to the now benighted heyday of disco, drugs, and sexual promis-
cuity. From our current perspective, they seem to mark the re-
surgence of skull imagery that accompanied punk culture,
escalating threats of nuclear and ecological disasters, and the
AIDS epidemic. Warhol drew connections between what at the
time were opposites — disco conformity and punk nihilism — by
perceiving the yearning and desperation behind both. With
hindsight, Thelma Houston's 1976 line, "I can't stay alive with-
out your love, don't leave me this way," and the Sex Pistols'
1977 dream holiday escape, "I wanna go to the new Belson . . .
I'm gonna go under the Berlin Wall," fed similarly urgent needs.
The "Skulls" command the energy of a disco call to "Shake Your
Groove Thing" *and* have the effrontery of punk snubs to the
blandness of the mid-seventies. Back then, one of the reasons to
visit the disco epicenter, Studio 54, was the chance to see and
be seen by Andy. He was so good for 54's business that they gave
him a garbage can full of money for his 1978 birthday: great
publicity for all involved.[1] Although his 1979 book, *Andy Warhol's
Exposures,* ended with descriptions of new punk clubs downtown,
it devoted most space to showcasing his chumminess with first-
name celebrities: Bianca, Liza, and Jackie fed Warhol's fame by
letting it mingle with theirs. He called this his "Social Disease."
The only paintings by Warhol to be found in *Exposures* are
"Skulls," shown hanging in his Union Square studio (fig. 91).
Why did he raise the spectre of death in this buyer's guide to

hedonism? And why did he take time to paint this morbid sub-
ject, the antithesis of his society portraits?

Death was probably the most important underlying theme
of Warhol's work after 1960, and antagonism and paradox (pur-
views of the social/sexual outlaw) shaped his point of view. Four
small paintings made in the early eighties (and often used as
gifts) serve to illustrate his continual fingering of mortality as
well as his propensity for the grotesque (whether whimsical, fac-
tual, or both). A heart-shaped candy box (love token as commer-
cial product) provided one composition, only to be replaced by
the real thing, a disembodied heart, in another. Then there were
two textual items, secular guidelines for the heart: a screened
reproduction of a poster outlining heart attack symptoms (fig.
92), and another of the page from the 1982 Manhattan phone
book where the word "heart" appears.

Studies of Warhol have tended to stress divisions by classi-
fying periods, subjects, painting styles, or his intentions (from
socially concerned to sycophantic). But following his death, and
in anticipation of the much-needed retrospective, it is useful to
examine unifying factors. As Warhol said in 1975, "Even when
the subject is different, people always paint the same painting."[2]
Death was a major theme. Another less acknowledged concern
was the particular beauty of execution that he achieved. During
his lifetime few rewarded his paintings with the respectful atten-
tion of connoisseurship. A false assumption persists that his anti-
establishment/sixties values somehow precluded the notion that
he might want to make paintings possessing beauty. One crucial
aspect of his aesthetic sensibility made this inattention possible,
namely his genius for making things so simple — conceptually
and formally — that we are still sometimes afraid to trust him or
the work. Likewise, he wanted all his work to be "pretty,"
which creates problems for people who expect serious, pithy
work to be somber.

Before discussing the "Skull" paintings in detail, it is cru-

cial to understand that they involve procedures and aesthetic de-
cisions identical to those governing Warhol's earliest silkscreened
paintings, such as the similarly multicolored "Marilyn Monroe"
pictures. The procedure has been described many times, but it
needs repeating, since an improbable image (fig. 93) has recently
been published twice as one of several hypothetical source pho-
tographs which Warhol supposedly "transformed" to "con-
struct" his own image of Marilyn for silkscreening.[3] The
publicity photograph in figure 93 is evidently from the same ses-
sion as the photograph Warhol actually used, but to get from
that photograph to the one Warhol silkscreened requires another
pose, a new facial expression, and different lighting.[4] Such schol-
arly mistakes contradict the basic facts of Warhol's working
method. He chose a photograph, cropped it as necessary, then
ordered a silkscreen in a specified size. Variations occurred
when screening the reproduction onto the canvas. The artist
controlled the density of the paint, allowing the black images to
vary between faint and darkly saturated. This was the moment—
the traditional one of applying paint to canvas—when he elabo-
rated or transformed the presentation of his photographic mate-
rial. The initial shock and lasting significance of his use of
silkscreening was that he reproduced the images as he found
them. For Warhol the manipulation of photographs would be
both too much fuss and too arty. It would destroy the crucial
tension between the mechanical aspect (the photo-generated
screen) and his version of traditional hand-finish. The bluntness
of Warhol's semi-industrial technique would have been admired
had he practiced a handicraft or studio graphics. Instead, he was
widely criticized for conflating "high art" with mechanical re-
production. But his achievement was precisely this inspired mar-
riage of minimalism, simplemindedness, and the beauty that a
cheap, or low, or partially prefabricated solution can possess. He
banished the mysteries of artistic creation from his "Factory,"
where making a painting had roughly the same number of steps

as a cake mix, and selling one involved "Small, medium, or large? And how many?"

In 1977 Warhol made a portfolio of seven screenprints demonstrating the successive stages whereby he typically constructed his images. The subject was the hammer and sickle, but the process was identical for the "Marilyns," the "Skulls," and in fact for all his paintings and prints in which the photographic screen is presented against a multicolored ground.[5] (To take the "Marilyns" as an example, the different hand-painted color areas that must be completed prior to the superimposition of the black screened image are those demarcating hair, teeth, skin, eye shadow, lipstick, dress, and background.) It is significant that Warhol felt the need to spell out the basics of his long-standing working method in the 1977 hammer and sickle portfolio, for at this time he was elaborating the abstract, painterly, and decorative potentials of his technique, and to these ends exploring the patterns of shadows cast by his subjects.

II

The "Skulls" and the "Hammer and Sickle" series were made in the same year, but only the latter were featured in a New York exhibition (Castelli, January 1977). The "Skulls" remain lesser known, having received virtually no critical opinion during the artist's lifetime. They were shown in Heiner Friedrich's Cologne and Munich galleries in 1977-78, and eventually Friedrich acquired most of the larger canvases for the Dia Art Foundation.[6] Warhol bought the skull depicted in the paintings in a Paris flea market in the mid-seventies, and on his return to New York he polled his closest associates at the Factory about using it as a subject. His business manager, Fred Hughes, the oracle of uptown taste, recalled the great things Zurbarán and Picasso had done with skulls. His studio assistant, Ronnie Cutrone, the oracle of downtown attitude, agreed that the subject was a classic, and that it would be "like doing the portrait of everybody in the

world."[7] Since it is impossible to determine visually whether a
skull is male or female, Cutrone's wry observation also suggests
that Warhol's universal death's head portrait was a counter-
balance to his ongoing campaign for portrait commissions from
the rich and successful.

Ronnie Cutrone was asked to shoot black and white photo-
graphs of the skull, side-lit for dramatic shadows. Warhol's skull
drawings — tracings of the projected photographs — show the
range of images that Warhol first worked with (fig. 94). Four
photographs and a drawing after each of them became the basis
of a portfolio of four screenprints published by Andy Warhol
Enterprises in 1976.

The smallest skull paintings (15 × 19") used four different
compositions (fig. 95). Their four respective silkscreens were
made from three different photographs. (Two of the screens
used the same photograph: the one in the bottom right of figure
95 is a reversed detail from that in the bottom left.) The com-
position in the top left of figure 95 was blown up for use in a
large and a giant format (72 × 80", as seen in fig. 96, and
132 × 150", as seen in fig. 97). The dynamism of the large
"Skull" paintings was evident in the most celebratory way when
eight were hung on one wall at Dia's 77 Wooster Street space in
1987-88 (fig. 96). It would be a compliment to say that they
would make great billboards.

The composition Warhol chose for the large and giant size
canvases was the one with a careful balance between the skull
and the ambiguously open space around it, and a play between
the tight dark shadow and the bright dome of the cranium (figs.
96 and 97). This three-quarters view gives the skull a somewhat
biomorphic, pear-shaped profile, without missing any of the clas-
sic skull features — the black holes of eyes and nose, and fanglike
teeth in a grin of death. Ronnie Cutrone realized that in this
particular set-up, the shadow suggested the head of a foetus. He
says he emphasized the effect when he was setting up for the

photograph, after accidentally discovering a suggestion of birth in the shadow of death. It is not known if this contributed to Warhol's eventual preference for the image.

In discussing any of Warhol's later painting projects, one must remember that in 1965-66 he had announced his retirement from painting in favor of moviemaking. As it happened, Hollywood did not move fast enough, Warhol was shot, and after a slow convalescence, he decided "it was easier to paint than to try the movies."[8] He remained lackadaisical about the importance of his paintings compared to his other activities, and showed no public excitement about his return to painting. Nor did he express sadness when the seventies ended: "[They] were sort of quiet . . . nothing really different happened in art."[9] Although they were created in a context of simulated indifference on Warhol's part, the "Skulls" offer a virtuosic demonstration of his painting style—his ability with both brush and silkscreen.

To paint his favorite composition (figs. 96-99), he divided the canvas into four areas—the background space or wall, the foreground support, the skull, and its shadow—each of which was painted a different color. Finally, the photographic silkscreen was superimposed, usually in black. The shapes of the four background color areas were usually varied for expressive effects: for example, the area denoting the skull in figure 98 is particularly elongated; in other works the area denoting shadow may be extended as far as the bottom or left side of the canvas. When the underlying color areas are significantly dropped on the compositional frame (as in fig. 99), the slippage gives a metaphysical effect: one imagines a flesh-pink blank head giving way to a green skull.

The color of the silkscreened skull photograph was not always black: the yellow screen over a white ground in figure 97 recalls the same effect in a large 1963 *Mona Lisa* (fig. 47). Overall, Warhol's palette had not changed much from the sixties to the eighties. His color denotations continued in their arbitrari-

ness: the skull color area beneath the silkscreen was as likely to
be red or flesh pink or lavender as it was white. In this way he
stressed the decorative, and established a mode of disjunctive
logic.

There are obvious differences in the surface of the "Skull"
paintings when one compares the larger sizes with the smallest.
On close inspection they are equally painterly, but the impact is
inevitably more conspicuous on the smaller scale. For all sizes
the density of the screened image, and its variously deformative
interaction with the heavily impastoed surface beneath it, is a
source of major differences. The proportions of the larger can-
vases are more square, and hence by comparison the small works
are frequently more intense as compositions and in painterly ef-
fect (compare figs. 97 and 98).

The issues of painterliness and the spectre of Abstract Ex-
pressionism that the "Skulls" address so pointedly were first sys-
tematized by Warhol in his 1973 "Mao" paintings. Like the
"Skulls," the "Maos" had come in three sizes. For their installa-
tion in Paris in 1974, Warhol hung them on his *Mao Wallpaper*
(fig. 3).[10] (Before his death Warhol thought about a skull wall-
paper for the Dia exhibition.) The "Mao" series was simpler
than the "Skulls" since they were all based on the same
photograph—the only one Mao sanctioned—known to Western
youth from his "little red book."

Warhol's painterly painting has been interpreted as a limp-
wristed, ironic spoof of macho Abstract Expressionist style. His
brush strokes have been described as "flat" and "drained . . . of
any distinctive personality."[11] The artist himself jokingly played
up the idea that he could not paint, and that he was better at
drawing.[12] But one must not forget—just because the desired
impact was to seem noncommittal and detached—that an active
effort on Warhol's part created the look of his paintings and his
persona. There is a stylistic consistency between his loosest
painting style of the seventies and his earliest Pop drawings in

the distracted patchiness and childlike/Twomblyesque scribblings. Warhol's painterly style persisted through his career. He spoke of the dilemma he faced in 1960 between his "lyrical" style with its "gestures and drips" and his "hard" style without hand gesture.[13] Works like *Peach Halves,* 1961, with its messy background and runny paint, were superseded by the well-known impersonal style with flat, evenly applied color beneath the screened photograph. However, a picture like *Red Race Riot,* 1963, demonstrates a continued interest in the painterly with its smeared, misty pinks and reds in place of the usual monochrome of the majority of disaster pictures.

The choice between the painterly and the hard style came regularly into place throughout the seventies when it helped to underscore the characterization of a portrait. Thus drips and atmospheric washes might evoke sensitivity, and gesturalism might suggest boldness or passion; hard edges confirmed apparent hardness, testified to great features and contours, and came in useful for a quick, clean, and peppy treatment when the subject was not very inspiring.

In 1975, the year before the "Skulls," Warhol painted black transvestites for a series he called "Ladies and Gentlemen" (fig. 100). The painterliness of the earlier "Maos" was intensified, and these works established the luscious paint surface that was then used for the "Skulls." Many of the "Ladies and Gentlemen" actually surpassed the "Skulls" in marvelous, crazy paint effects. What is significant is that Warhol controlled the painterliness of a given series in accordance with its subject matter. Thus he is relatively more contained in treating a skull than a transvestite. In the skull paintings, the liveliness of the brushstrokes contradicts both the certainty of the photographic silkscreen and death itself. For the drag queens, the *extremely* lively paint has other associations: the heightened excitement and/or the scary confusion of being man and woman, and perhaps Warhol's memories of such friends from the sixties speeding on amphetamine.

## III

Warhol's thematic treatment of death began in 1962 with *129
Die (Plane Crash)* (fig. 37), a very large hand-painted rendering of
a tabloid front page wholly devoted to the crash of a Boeing 707
jet at Orly Airport, Paris. That accident took place in June, just
two months before Marilyn Monroe's suicide, which not only
kept his thoughts on death but inspired Warhol's elegaic 1962
"Marilyns." Within a year he had formulated an idea about the
escalation of violence that would be realized in his new silk-
screen style: "My show in Paris is going to be called 'Death in
America.' I'll show the electric-chair pictures and the dogs in
Birmingham and car wrecks and some suicide pictures."[14] War-
hol gave his "death series" two parts: the famous and the "peo-
ple nobody ever heard of." He said of the latter, the suicides
and car crash victims, "It's not that I feel sorry for them, it's just
that people go by and it doesn't matter to them that someone
unknown was killed . . . I still care about people, but it would be
so much easier not to care, it's too hard to care."[15] The "Skulls"
might be thought of as a third part of the series, not overtly
lurid or topical, but universal.

Even though much of Warhol's classic sixties imagery—
money, green stamps, consumer products, pulp publications,
popular idols—is read primarily in terms of the opium of the
American middle class, his sense of the impermanent occa-
sionally slipped into these subjects. For example, the paintings
and drawings of soup cans with torn labels, of opened cans (fig.
71), and of flattened cans; or those showing rows of Coca-Cola
bottles whose contents range from full to empty (fig. 56). We
accept his need for The American Dream, but are still learning
the extent to which morbidity and The American Way of Death
informed his personality. One might speculate that his Central
European—Czechoslovakian—heritage predisposed him to the
grim and the anguished (and to the humorous, for that matter).

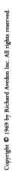

Richard Avedon, *Andy Warhol, artist, New York City, 8/20/69,* black and white photograph, 14 × 11″.

His childhood was impoverished, plagued by illness, and dominated by Catholicism. Henry Geldzahler remembers midnight phone calls from Warhol in the mid-sixties: ". . . he would say that he was scared of dying if he went to sleep."[16]

The shooting of Warhol in 1968 brought him close to death, and changed him for ever. In 1969 Richard Avedon made photographs of the scars as they healed. In 1970 Warhol also bared himself for an Alice Neel portrait (promised gift to the Whitney Museum of American Art, New York): his clasped hands and closed eyes suggest saintly withdrawal from the wounded body into a world of prayer or meditation. No stranger to the voyeuristic impulse, Warhol allowed these other artists to explore their fascination with him, knowing how their images would embellish his *outré* celebrity. It is not surprising that over fifteen years later he had himself photographed in the lobby of a new studio wearing his latter-day ratty wig and standing behind a clotheshorse hung with brilliantly colored examples of the corsets his wounds forced him to wear.[17]

The medieval attitude to death is recalled by the untender, unsentimental look Avedon took when he photographed Warhol's body. Figure 101, a detail of a late Gothic tomb sculpture, shows the sutures on two royal corpses made after the entrails and heart have been removed in preparation for burial. In 1980 Warhol said that the kind of eulogy he would like ("a Pop eulogy . . . just the surface of things") was the kind Larry Rivers had given at Frank O'Hara's funeral: apparently Rivers described the poet's mutilated body and the effects of surgery until the mourners screamed for him to shut up.[18] Following his accident, Warhol took a closer look at the aging and occasionally the scars of his friends. For example, in his 1985 book *America,* he included a profile shot of the late Truman Capote, showing off gruesomely large facelift scars across the temple and around the ear. Strongly reminiscent of Warhol's 1964 "Most Wanted Men" paintings, this image of Capote exemplifies the artist's examina-

tion of fame, sexuality, and death as fates in the lives of people
to whom he was drawn. On the facing page Warhol admitted
that he had felt like a nobody at Capote's costume ball with "the
densest concentration of celebs in the history of the world," but
concluded, "I wonder if anybody ever achieves an attitude where
nothing, and nobody, can intimidate them."[19] Warhol evidently
empathized with Capote's fear of aging and death, but to ward
off self-righteous interpretations he included on the text page a
smaller photograph of Capote in a saucy mood, sticking his
tongue out and being kissed by a dog.

In *America,* Warhol used several graveyard photographs as
an accompaniment to a commentary on his shooting: "I always
wished I had died, and I still wish that, because I could have got-
ten the whole thing over with . . . I never understood why when
you died, you didn't just vanish. . . . I always thought I'd like my
own tombstone to be blank. No epitaph, and no name. Well, ac-
tually, I'd like it to say 'figment.'"[20] This laconic attitude found
the perfect expression in his idea of the blank: this was either a
large section of canvas which was not silkscreened or else an ad-
ditional monochrome panel that created a diptych, as in the
1963 *Blue Electric Chair* (fig. 102). With chilling, minimal matter-
of-factness, this formal device allowed him to articulate the an-
tagonism of life and death, the idea of death as the nothingness
of a blank afterimage, and the perception of that bare figment of
color as escape from a society that commits electrocution. At
this moment in time Warhol suddenly stood for something
new—his performance made the tragic overtones of the Ab-
stract Expressionists and the aestheticism of others seem over-
wrought. As in the case of the late Gothic tomb sculpture (fig.
101), the best analogies for his examination of death are found in
preindustrial periods when mortality was neither sentimen-
talized nor anxiously ignored. Then, precedents for Warhol's for-
mal opposition can be found. For example, in one 1487 Swiss
portrait (fig. 103) the subject, holding a flower, faces his own

decaying body in the pendant panel. (The iconography of the flower in the Swiss portrait-in-life-and-death prompts the suggestion that one aspect of Warhol's 1964 silkscreened flowers was surely that of memento mori.) Another telling comparison is a seventeenth-century French print titled *The Mirror of Life and Death* in which a body is bisected into fleshed and skeletal halves.[21]

Although Warhol never used the blank for his "Skull" paintings, its spirit was certainly evoked by the empty space enveloping the subject. The skull occupies a setting of isolation, otherness, and separation. And in such a charged space the skull's shadow takes on similar associations. Shadow connotes death, or ghost or spirit. When its underlying color area spreads gapingly across the canvas the shadow of the skull can assume the presence of the blank areas in Warhol's early paintings about death. Soon after the "Skulls," Warhol worked on a group of paintings which he called "Shadows" (fig. 32). They were to have the appearance of abstractions, and a subject with no physical reality, nothing. Each unit was a monochrome canvas with one or two photographic screens: all had an extensive grainy shadow (from Ronnie Cutrone's photographs of pieces of cardboard in raking light), and some had an additional screened image of loosely brushed paint. Warhol thought of the project as one enormous painting with enough parts to fill most gallery spaces. These works were first exhibited in New York in January 1979, and subsequently 102 of them were acquired by the Dia Art Foundation. At that time the artist denied that they were art, but supposed that they were "disco decor" since "the opening party had disco."[22] Again he embraced (and used as a barricade) activities that would confound the taste of hidebound conventionality: silkscreening; disco; passive painterly painting; dozens of similar canvases ostensibly with no subject; decor aesthetic. His attitude suggests that unless one accepts all this as signs of life, one is faced with death of the spirit. He wove into his treat-

ment of the light/shadow, life/death theme layers of challenges to exercise the tolerance/prejudice the viewer brings to the work.

Melancholic identification with the word "shadow" was the basis of a self-portrait in the 1981 screenprint portfolio *Myths* (fig. 104). This bestiary of popular culture idols of Warhol's day (The Star, Uncle Sam, Superman, The Witch, Mammy, Howdy Doody, Dracula, Mickey Mouse, and Santa Claus) ended with the radio show hero, The Shadow. For the other portrayals, he worked with or closely evoked the original characters; so it comes as a surprise when, in *The Shadow*, Warhol himself looks out from the right and casts a large silhouette of his head in shadow on the wall behind him. Again, such a terse conjunction of the notions of life and death has affinities with earlier tomb sculptures; for example, in 1709 Giuseppe Mazzuoli carved portrait busts of a couple for a Roman church, one on a plinth bearing the word NIHIL, the other UMBRA (Latin for *nothing* and *shadow*).[23]

### IV

The "Skulls" immediately preceded the explosion of punk anti-culture. In his 1977 book *White Trash*, Christopher Makos— whose work appeared regularly in Warhol's *Interview* magazine— published seminal photographs of the New York punk world along with candids of prophets—Man Ray, Warhol, Tennessee Williams, Iggy Pop, Patti Smith, and Divine. In figure 105, Makos is seen with a friend who wears on his jeans a button for Warhol's 1977 movie *Bad*, an ironic collaging of the weird brand of deadly urban violence reported in tabloids. In an excellent discussion of Warhol and punk, Andrew Kagan wrote: "Warhol . . . has generally maintained the image of a crazed, stupefied, degenerate. . . . [His] paranoias drove him behind that blank adolescent mask of inert indifference and aimless defiance, which seems to declare . . . 'Who cares?' What it really says is nothing at all, which is what makes . . . Warhol so fundamental to Punk."[24]

The punk period witnessed a renaissance of tattooing—a
practice which visibly asserts our ritualistic "uncivilized" past,
and one in whose pictorial language the skull looms large. Be-
cause of a slew of "primitive" and sexual associations, the tattoo
is proscribed by traditional Western conventions. But tattoos
persist, serving to decorate, seduce, shock, scare, to declare non-
conformity.[25] Warhol's courting of death was one of his tattoos,
entangled with all the other facts of his nonconformity. His own
tattoolike exhibitionism at the 1977 opening for his "Hammer
and Sickle" paintings (fig. 106) drew together various structures
of power and pleasure: the art world/gallery system brand of
capitalism; a communist emblem rendered in paintings titled
*Still Life,* in which the shadow seems more real (threatening)
than the subject itself; Warhol's long (threatening) association
with leather, homosexuality, and gay rights and aesthetics; disco
madness as the latest social marketplace and entertainment
industry.

In 1978, the year of his fiftieth birthday, Warhol painted
self-portraits with a skull close to his head (either balanced on
his shoulder, as in figure 107, or on his head). The personal as-
sociation with death, and now perhaps a private readiness for it,
became overt. At about the same time he made another self-
portrait (fig. 108) showing himself being strangled. (The hands
in this image belong to Victor Hugo, the leather-clad person-
ification of communism in figure 106.) We might choose to see
in Warhol's "Skulls" and these self-portraits an echo of the Mex-
ican view of death. Writing in 1961 about the annual Mexican
celebration of the Day of the Dead, Octavio Paz observed:
"There is perhaps as much fear in [the modern Mexican's] atti-
tude as in that of others, but at least death is not hidden away:
he looks at it face to face, with impatience, disdain, or irony."[26]
In the latter half of the seventies Warhol may have experienced a
growing sense of guilt, and an even greater need to confront
death, for he wrote in 1980: "Some of those kids who were so

special to us, who made our sixties scene what it was, died young in the seventies."[27]

<div style="text-align:center">V</div>

When he painted the "Skulls" in the 1970s, Warhol and his Factory circle were working with the European art market more closely than ever before, and it is tempting to read into this series a new strategy to engage in pictorial traditions that have always been a part of the Old World art market. (It is wrong, however, to assume that because he was a Pop artist he was learning about such things as the *vanitas* still life for the first time: a knowing openness to art history had been essential to his personal style as an illustrator in the fifties.) Relating Warhol's "Skull" paintings to skulls in earlier art is an easy game. His are so uncompromisingly casual and minimal that they could be modern stand-ins for all religious works and *vanitas* still lifes that include skulls. Since the sixteenth century, Jesuits have promoted the contemplation of death as a spiritual exercise. The skull became a symbolic detail in compositions as an attribute of St. Francis of Assisi, of hermit saints, and of the penitent Magdalen. Two years before Warhol painted the "Skulls," the Metropolitan Museum of Art purchased the earliest *vanitas* still life in existence (fig. 109), a 1603 Dutch painting by Jacques de Gheyn the Elder. I do not know if it influenced Warhol in any way, although I suspect that any art image combining death and money would interest him. Certainly it articulates symbols of transience in ways that he would have appreciated. A tulip on one side is balanced by a puff of smoke on the other. The figures at the top represent Democritus and Heraclitus, Greek philosophers who respectively laughed and wept at the world, pointing to an enormous bubble (the world as figment).

Cézanne said "A skull is a beautiful thing to paint." In the last ten years of his life, he painted *Young Man With Skull* (1896-98, Barnes Foundation) and a series of still lifes of skulls. But no

matter how hard we try to see a Cézanne skull in the 1927 for-
mal terms of Roger Fry—"merely a complicated variation upon
the sphere"—we cannot shake the association with death. Now
we have also come to appreciate the biographical content of
these late works as they relate to Cézanne's morbidity, his life-
long sense of guilt, and his conversion to Catholicism in later
life.[28] Similarly, Picasso's paintings and sculptures of skulls in the
early 1940s cannot be disassociated from his experience of Paris
under Nazi occupation.[29]

In painting the skull, Warhol chose a subject that was per-
haps an obvious one for him, and yet his interpretation was
memorable, paradoxical, and beautiful. Rather than drain its
meaning, his reductionism created a statement that could stand
comparison with any image of a skull, and could speak to any
death threat (not only to people, but also ideas, beliefs, or the
artist's own career). In fact, Warhol related his "Skulls" to Italian
fascism in 1977: "We've been in Italy so much, and everybody's
always asking me if I'm a communist because I've done Mao. So
now I'm doing hammers and sickles for communism, and skulls
for fascism."[30] By inviting comparisons with fascist emblems,
such as figure 110, he risked criticism and misinterpretation
rather than repress any possible association that the "Skulls"
might carry, whether intended or not. The "Skulls" now come
to mind when thinking of any of his allusions to death. In his
last book, *America,* an aerial photograph of factories, parking
lots, and a gaping, canyon-sized mining site accompanied his am-
bivalent thoughts about our waning belief in technological mira-
cles: "Now it seems like nobody has big hopes for the future.
We all seem to think that it's going to be just like it is now, only
worse. But who's to say that this idea is any more realistic than
dreaming about robots?"[31]

## VI

A late and unorthodox Warhol portrait of Philip Niarchos made

use of a CAT scan of the subject's head rather than the usual Polaroid snapshots (fig. 111). The work involved a silkscreen of the CAT scan and another of a drawing Warhol traced from it. This macabre painting must in one sense be Warhol's most truthful portrait, since flattery was clearly not an option. Although it was a representation of scientific observations, this was not a viable form of portraiture since the subject was unrecognizable. However, this exception proves that Warhol's regular commissioned portraits were almost as momentary as an X-ray. Lacking the repeated sittings and personal exchange of conventional portraiture, they stand for the culture that pushes the button and pulls the trigger. With the flash of the camera the Polaroid is done and the subject's spirit has been stolen.

Warhol made his scariest, and what turned out to be his last, self-portrait early in 1986. At that time he was also experimenting with a new form of abstraction, a new kind of blank for the mid-eighties — paintings of camouflage patterns. Like his "Shadows" project, camouflage was a subject that was real, but ultimately symbolized nothingness — in this case, invisibility. But it also implied modern combat: a stance of aggression or resistance, for causes unspecified. In this way, the "Camouflage" works were as universal as the "Skulls." When Warhol used the greens and browns of "real" camouflage, he suggested two potential opposites — either the military or the military surplus (a source of cheap clothing). When the colors were red-white-and-blue and pink, the irony became more overt.

In a memorial tribute to Joseph Beuys in the summer of 1986, Warhol reused his 1980 photograph of Beuys as a silkscreen over a camouflage background, producing the perfect tribute to an artist who provoked so much debate over alternatives to our current social and military systems. At the same time, Warhol was preparing an exhibition for Anthony d'Offay: he elevated a withering self-portrait photograph used earlier that year on T-shirts for Keith Haring's Pop Shop to large paintings

with camouflage backgrounds (fig. 112). The last edition he signed (*Parkett,* no. 12) was a machine-sewn photo multiple of anatomy class skeletons hanging up at the New American Academy of Art (fig. 113). Thus his obsession with disappearance and his scrutiny of death persisted to the end. The thoughts of death that filled Warhol's last years—the camouflage idea, the tragic self-portrait, the paintings of Leonardo's *Last Supper*—span back to the first death and disaster works of 1962. In the intervening decade, the "Skulls" carried the theme and kept Warhol's edge as sharp and repellent to normalcy as it had ever been.

### Notes

1. Barbara Graustark, "Newsmakers," *Newsweek,* August 21, 1978, p. 73: "Studio 54's Steve Rubell . . . presented a gleaming garbage can filled with 1,000 one dollar bills."

2. Andy Warhol, *The Philosophy of Andy Warhol: From A to B & Back Again* (New York: Harcourt Brace Jovanovich, 1975), p. 149.

3. Thomas Crow, "Saturday Disasters: Trace and Reference in Early Warhol," *Art in America* 75, no. 5 (May 1987): 133: ". . . Warhol builds a certain distance and reserve into his Marilyn images . . . through an initial transformation of his photographic material." The publicity photograph presented as the one Warhol manipulated (fig. 93 above) appeared on page 130. Crow's image and idea were repeated by Bradford R. Collins in "The Metaphysical Nosejob: The Remaking of Warhola, 1960-1968," *Arts Magazine* 62, no. 6 (February 1988): 53, figs. 15, 16: "Warhol's desire to subvert the claims of Marilyn's physical beauty is nowhere more evident than in the way he altered his source photograph."

4. See Ronald Alley, *Catalogue of the Tate Gallery's Collection of Modern Art Other Than Works by British Artists* (London: Tate Gallery, 1981), p. 762: "The photograph used by Warhol as the basis for all his paintings and prints of Marilyn Monroe [illustrated page 761] was a 20th Century Fox still, publicity for the film *Niagara,* 1953, taken by Gene Kornman (information from John Kobal)." This reference was given by Mark Lancaster, "Letter to the Editors," *Art in America* 76, no. 1 (January 1988): 21.

5. The seven screenprints of "Hammer and Sickle (Special Edition)" are reproduced in *Andy Warhol Prints: A Catalogue Raisonné,* ed. Frayda Feldman and Jörg Schellman (New York: Abbeville Press, 1985), p. 65.

6. An accurate count of Warhol's "Skull" works will have to await the catalogue raisonné being prepared by Thomas Ammann Fine Art (who were unable to help me in 1988). Dia Art Foundation owns two giant (132 × 150″) and eight

large (72 × 80″) paintings and fifteen drawings. At least thirty small paintings (15 × 19″), at least two more large size paintings, four collage studies for the "Skull" screenprints, and an unknown number of drawings exist in the artist's estate and private collections.

7. I am grateful to Fred Hughes and Ronnie Cutrone for this information. The present whereabouts of the skull is not known, although it is possible that it is in one of the "Time Capsule" storage boxes Warhol habitually sent to a warehouse.

8. Barry Blinderman, "Modern 'Myths': An Interview with Andy Warhol," *Arts Magazine* 56, no. 2 (October 1981): 145.

9. Paul Gardner, "Gee, What's Happened to Andy Warhol?" *Art News* 79, no. 9 (November 1980): 73. Warhol predicted ". . . the '80s are going to be more exciting."

10. Photographs of Warhol's installations of his *Cow Wallpaper,* of the Maos on his *Mao Wallpaper,* of the *Portraits of the '70s* show at the Whitney, and of the "Shadows" can be compared in Charles F. Stuckey, "Andy Warhol's Painted Faces," *Art in America* 68, no. 5 (May 1980): 104-108.

11. John Paoletti, brochure on Warhol's *Still Life 1976* for *MATRIX 50* (Hartford: Wadsworth Atheneum, 1979): ". . . through the thinness of his application Warhol has characteristically drained the broad brush strokes of any distinctive personality, thus flying in the face of earlier critical and popular appraisals of abstract expressionism as a record of the psyche of the artist. Warhol himself remains anonymous in these paintings as he does in all his work."

12. See, for example, Trevor Fairbrother, "Warhol Meets Sargent at Whitney," *Arts Magazine* 61, no. 6 (February 1987): 67. Warhol states, "No, I can't [paint]. I was asked to leave school, then I had to come back, and then I learned how to paint, and then I couldn't really do it as well as everybody else. So, I learned to draw better. I can draw better really."

13. Andy Warhol and Pat Hackett, *POPism: The Warhol '60s* (New York: Harcourt Brace Jovanovich, 1980), p. 7.

14. Quoted in Gene Swenson, "What is Pop Art?" *Art News* 62, no. 7 (November 1963): 60. Immediately before this remark, Warhol described having recently been in a crowd on 42nd Street when a cherry bomb was thrown: "I felt like I was bleeding all over. I saw in the paper last week that there are more people throwing them—it's just part of the scene—and hurting people."

15. Quoted in Gretchen Berg, "Nothing to Lose: Interview with Andy Warhol," *Cahiers du Cinéma in English* 10 (May 1967): 42-43. In *POPism* (p. 60), Warhol explained that, unlike all his friends, he did not stay distraught by President Kennedy's assassination because he was "bothered . . . [by] the way television and radio were programming everybody to feel so sad." In this situation he felt more inclined to follow a Hindu custom: "[Once] I was walking in India and

saw a bunch of people in a clearing having a ball because somebody they really liked had just died and . . . I realized then that everything was just how you decided to think about it."

16. Quoted in Jean Stein and George Plimpton, *Edie: An American Biography* (New York: Alfred A. Knopf, 1982), p. 201.

17. Photo by Jonathan Becker reproduced in *Vanity Fair* 50, no. 7 (July 1987): 74.

18. Warhol and Hackett, *POPism*, p. 186.

19. Andy Warhol, *America* (New York: Harper & Row, 1985), pp. 66-67.

20. Ibid., pp. 126-129.

21. The print is reproduced in Philippe Ariès, *Images of Man and Death,* trans. Janet Lloyd (Cambridge, Mass.: Harvard University Press, 1985), fig. 289. Such juxtapositions of life and death follow the tradition in Gothic and Renaissance tomb sculpture of placing on top of the monument a representation of the person in life, and beneath it, or in relief on the sides of the sarcophagus, a representation of the decaying body or the skeleton; for examples, see Erwin Panofsky, *Tomb Sculpture: Four Essays on Its Changing Aspects from Ancient Egypt to Bernini,* ed. H. W. Janson (New York: Harry N. Abrams, 1964), figs. 262, 324, 331, 354, 364.

22. Andy Warhol, "Painter Hangs Own Paintings," *New York Magazine* 12 (February 5, 1979), reprinted in *Warhol Shadows* (Houston: The Menil Collection, 1987).

23. For illustrations, see Ariès, *Images of Man and Death,* figs. 273 and 374 (tombs of Angelo Altieri and his wife Laura di Carpegno, Santa Maria in Campitelli, Rome).

24. Andrew Kagan, "Most Wanted Men: Andy Warhol and the Anti-Culture of Punk," *Arts Magazine* 53, no. 1 (September 1978): 121.

25. See Chris Wroblewski, *Tattoo: Pigments of Imagination* (New York: Alfred van der Marck Editions, 1987). I showed illustrations from this book in my lecture.

26. This 1961 essay is reprinted in Octavio Paz, *The Labyrinth of Solitude,* trans. Lysander Kemp et al. (New York: Grove Press, 1985); for the quotation, see page 57. In the lecture, I showed a photograph of three candy skeleton heads reproduced in María Teresa Pomar, *El Día de los Muertos: The Life of the Dead in Mexican Folk Art* (Fort Worth: Fort Worth Art Museum, 1987), p. 72, and the etching *Female Dandy* by José Posada (1851-1913).

27. Warhol and Hackett, *POPism,* p. 299.

28. See Theodore Reff, "Cézanne: The Severed Head and the Skull," *Arts Magazine* 58, no. 2 (October 1983): 84-100.

29. I want to note how closely the aesthetic and humanistic sensibility of Dominique de Menil, whose collection includes a variety of skull images and artifacts, resembles that of Warhol. As early as 1965, she had included a Warhol electric chair painting in the exhibition *Unromantic Agony* (University of St.

Thomas, Houston), which also included *Guernica* studies by Picasso, torture in-
struments, crucifixes and pietàs, and African masks and fetish figures. The
Picasso skull images shown at my lecture were *Death's Head* (1943, bronze
and copper, Musée Picasso, Paris) and *Skull and Pitcher* (1945, oil on canvas,
The Menil Collection, Houston).

30. Glenn O'Brien, "Interview: Andy Warhol," *High Times,* no. 24 (August
1977): 22. Skulls decorated the banners and caps of the Milizia Volontaria per la
Sicurezza Nazionale, an Italian fascist paramilitary organization, between 1922
and 1943. They also appeared on the caps and collar patches of certain German
army regiments in 1939. See Andrew Mollo, *The Armed Forces of World War II:
Uniforms, Insignia and Organization* (New York: Crown Publishers, 1981).

31. Warhol, *America,* pp. 186-187.

I would like to thank the following people for their help with this project: Tim
Albright, Richard Avedon, Douglas Baxter, Steven Bluttal, David Bourdon, Ron-
nie Cutrone, Mario Diacono, Shelley Dowell, Peter Freeman, Vincent Freemont,
Gary Garrels, Russell Hamilton, Erica Hirshler, Fred Hughes, Tim Hunt, Nor-
man Keyes, Margery King, John Kirk, Christopher Makos, Barbara Martin, Har-
riet Rome Pemstein, Bonnie Porter, Neil Printz, Joel Michael Rothschild, Jay
Shriver, Janice Sorkow, Peter Sutton, Allan Tannenbaum, Carol Troyen.

**Simon Watney**

### THE WARHOL EFFECT

> But couldn't everyone's life become a work of art?
> —Michel Foucault[1]

> When the going gets tough, the tough go shopping.

A little over one year after Liberace's death from AIDS, his estate was auctioned to benefit the Liberace Foundation for the Performing and Creative Arts, which grants college music scholarships. The *New York Times* reported that Liberace's possessions "brought new meaning to the concepts of compulsive shopping and conspicuous consumption. It took 24,000 square feet of the Los Angeles Coliseum to display the contents of his five homes, 22,000 objects in all, not including his cars and trucks."[2] One fan, who had traveled from Texas, explained: "I thought he was the greatest entertainer of all time. If you saw him in person, he made you feel as elegant as he was." She went to the auction "over the objections of her husband . . . a retired judge." In Britain, the *Observer* described "two hundred elderly women" who had turned out to attend the Star's London memorial service: "just like him they wore their biggest jewels, their brightest dresses and their bravest make-up."[3] The orders for the service were embossed with imitation diamonds.

It should already be apparent that the press coverage of the Liberace auction conforms strictly to the conventions of "Tinseltown" Hollywood journalism. Within this discursive formation, Stars are "unrecognized" or "ignored," then "discovered." They are subsequently "neglected," seen to be "fading" or "falling" before they are "rediscovered." If they have died, they are "re-

suscitated," even "resurrected," according to a well-established narrative logic. In this vision of things, the Star manifests his or her quintessential uniqueness in a lifestyle which must dramatize and draw together the necessary themes of talent, celebrity, and wealth. This permits of a wide variety of "legendary" resolutions, from the type of flamboyant ostentation and exhibitionism associated for example with Liberace, to an equally scandalous austerity, e.g., "Millions in the bank, but she lives on Graham Crackers."

AIDS has provided journalists with the opportunity to combine these two familiar themes into an innovative trope. Thus the *Sun* contrasted Liberace "DAZZLING . . . in his heyday" to "SLIPPING AWAY . . . today Liberace is a shadow of his former self."[4] It also licenses a sadistic revenge on the body and the posthumous reputation of the dead Star. Thus, if we choose, we may read how "Hollywood toyboy tells of hell with gay superstar: Liberace Made Me Share Bed With Seven Dogs."[5] The same industry which has consistently made it impossible for lesbian and gay Stars to "come out," gleefully charges them with sexual hypocrisy once they are safely (and for the newspapers, profitably) dead.

Yet what is the status of the sexuality of the Star? As Rock Hudson pointed out in a moving late interview, when asked if playing straight ever bothered him: "I'm always playing, hopefully, somebody other than myself, so I'm used to it. It's a job. I'd like any role that stretched me where I was credible. But I'm not about to drag myself up in leather or in chiffon, and that's where that aspect of Hollywood stereotypes is, at the moment."[6]

At this point it is helpful to turn to a recent text which deals with the issues of representation, sexuality, and Stardom, with sophistication and intelligence. In *Katharine Hepburn: The Thirties and After,* Andrew Britton establishes a set of firm analytical distinctions between an actor's *person,* the *persona* which is constructed around them via publicity and their association with

particular genres of performance, and the individual *parts* actors play in different films or performances.[7] These distinctions are especially helpful when we approach the complex figure of Andy Warhol, which remains distinctly coherent and consistent from the vantage point of every institution with which he chose to involve himself—from cinema and photography, to the art market and the social world celebrated in so much of his work and life.

In the same edition of the *New York Times* which described the Liberace auction, John Russell wrote that "One of the more remarkable of current art-world phenomena is the afterlife of Andy Warhol,"[8] of which this collection of papers is of course a part. Biographies have already been announced, to satisfy that curiosity which seeks to "know" the artist, in the mainstream tradition of art critical and art historical humanism, and invariably finds the artist as the unique and irreducible source of his or her work. The art market has an equal investment in the intentional, authorial presence of the artist, authenticating individual works as their value is transformed from questions concerning the aesthetic and the social, to the purer semiotics of exchange. Yet Warhol constantly aspired to detach himself from a traditional authorial role, to dissolve himself into an inviolable *persona*. In this context it is significant that it was a salesroom commentator, Geraldine Norman, who noticed that the auction by Sotheby's of Warhol's collections of paintings, furniture, bric-a-brac, and so on, could be looked on as his "last work of art."[9]

Strangely, at first, we recognize that Warhol's death has in no way constituted an interruption of his career, at any level of commentary. Thus the British "quality" press responded to the Warhol auction with precisely the same mix of shrill anti-Americanism and equally plain old-fashioned national philistinism, that it had reserved for his earlier work. "Warhol: A $35m Junk Hype" screamed the *Observer*, where we were reliably informed that "in the final run-up to the mammoth 10-day sale of

his collection . . . there were still critics who could not decide whether the so-called 'Pope of Pop' was a shaman or a sham."[10] "It is surely ironic," the writer continues, "that a collection with so much junk should stand as the apotheosis of the art sale in media terms." Singled out as "junk" are "the photographs of Red Indian chiefs," and "Duchamp's shovel, with the pretentious title 'etc. etc.' It would appear to mean that we must now admire the tawdry, the coarse and the ugly. We have the unfine arts." *Newsweek* was characteristically more cautious, with its jolly picture of "what may be the biggest garage sale ever."[11] Yet precisely *because* of its sickening snobbery, the *Observer* draws attention to the conflicting traditions concerning artistic identity which operate in the contemporary marketplace. For in one sense, Warhol simply cannot be reconciled to the type of the heroic originating Fine Artist required as the price of admission to the Fine Art tradition. In such terms he is indeed "coarse," if by that we understand the sense of *threat* which informs such judgments. And certainly Warhol himself was perfectly straightforward when he said in his last interview that, as far as he was concerned, "an artist is anybody who does something well, like if you cook well."[12]

We should not underestimate the significance of this carte blanche refusal of post-Renaissance aesthetic hierarchies, and the professional identities which they established. As Stuart Morgan points out, in the course of his early work Warhol "gradually departed from ideas of original creation, indeed, from the idea of a person altogether."[13] The paradox however remains that whilst it seems that it is precisely this scooping out of the authenticating *person* from the *persona* which constitutes a radically destabilizing achievement, this same process can immediately be recuperated by another route. Hence we should understand the recent tendency to displace Warhol the Star, or Warhol the Business Artist, in favor of Warhol the Good Catholic, Warhol the Carer for the Homeless at the Church of Heavenly Rest. This

role is immediately far more in keeping with the connotations of renunciation and asceticism which Ernst Kris and Otto Kurz describe as the most widely recognized attributes of artistic "genius."[14] A "true" authenticating Warhol is thus discovered "behind" his supposed "roles," a homespun Saint Andy, who can hardly be closely related to Warhol the shrewd Upper East Side collector, so assiduously fabricated by Sotheby's in the likeness of an ideal client.

It is a commonplace of Warhol criticism to observe his central concern with the nature of representation as such, with the status of imagery, with seriality, with notions of authenticity and originality—both in the sense of authorship and innovation. Thus, for example, Warhol's portraits exemplify his disinterest in any appeals to psychological or biographical notions of "depth" or "insight." Warhol's portraits scrupulously refuse banal notions of "character," supposedly revealed in physiognomy. On the contrary, his portraits carefully rob their subjects of individuality, as they become "Warhols," objects in a market economy, defined by simple and clearly recognizable stylistic resemblances. What they register is the sitter's prior position in the much larger system of public representations, of *personas.* By the mere fact of contingency with such figures of Marilyn Monroe, Elizabeth Taylor, Jackie Kennedy, Mao, and so on, *anyone* can assume celebrity status. It is on this simple yet sophisticated principle that his commissioned portraits depended.

Warhol's portraits thus depict the institutions which control and define public visibility, and the faces which embody their authority—cinema, art, politics, advertising, television, the state, and so on. The Star is thus constituted by the technologies of mass reproduction, and represents the interests and values of the institutions employing them. The Star's *persona* is thus an ideological *effect.* The Star personifies, or impersonates, an institution as it wishes to be seen. The Star does not generate his or her own meaning. The Star is one term in an elaborate system of

signs. There is thus no necessary connection whatsoever between the Star's *persona* and *person*. The *persona* may draw on the *person,* and may embody profound contradictions concerning, for example, the status of women, artists, etc. Yet the *persona* is always a construct, a product, an artifact, functioning in a complex arena of conflicting social and economic values and relations. Warhol's work demonstrates more profoundly than any other artist that the art market is no different from any other market. The artist creates demand. The buyer purchases identity. The artist who can manipulate this greed for contingent celebrity becomes, by contingency, a Star. But Stardom—an effect of signs—does not make an artist of a Star. A great exhibition remains to be made of paintings by Stars.

The artist confers identity, and thus exposes its essential inauthenticity. No artist has ever undermined notions of Self more thoroughly or insistently than Warhol. No artist has ever explored more exhaustively the implication that the Self is merely "a practical convenience," as Leo Bersani puts it.[15] And nowhere in his work were these two related perceptions more critically involved than his posthumous auction—an event which he cannot even be said to have foreseen, let alone staged. What he did achieve was a collection which draws attention to collecting, both as an instinct and a taxonomical system. There is no evidence whatsoever that Warhol collected anything from motives of interest or pleasure or profit. He collected on the pure principle of collecting—a principle which, when directed, implies a purposive "collector." Warhol's collecting, on the contrary, only further undermines the notion of a coherent Self, a person to be found in his possessions, as Liberace's fans undoubtedly "found" their Star "in" their auction purchases. Yet the relic invariably points to the Star's absence, the Star's mortality. In Warhol's case this is all reversed. For he collected anything and everything, without regard to classification. Hence, by extension, he "collected" nothing, for his collection is

indiscriminate—as void of central purpose or subject as the Andy Warhol *persona*. The Warhol auction makes art of collecting itself, by drawing attention to the institutions which attend collecting (the museum, the auction room, the private gallery, the library, the supermarket), and the effect of the discrete, originating Self which they materialize and perpetuate. His career ended, as it began, with shop windows. He made an art of shopping.

In retrospect, Warhol's project seems close to Foucault's, in their analyses of the many concrete practices which cut across symbolic systems in the constitution of the Self, and not least in their shared refusal of the available categories of sexuality, which provide the sine qua non of political power and government in the modern period. Indeed, the gulf between Warhol and the mainstream representatives of "Pop" and the Fine Art tradition is nowhere more evident than in the smug conventional moralism of Richard Hamilton's obituary observation that Warhol surrounded himself with "the dregs of humanity in New York— transvestites, homosexuals, drug addicts; every kind of extrovert personality in this field who became part of his circus."[16] It is difficult to imagine a voice more foreign to Warhol, or more insensitive to the *prefigurative* aspects of his achievement. For Warhol was never an ironist. On the contrary, he spoke with extraordinary honesty and directness to any question asked of him. And besides, why should we doubt his word? What do such doubts tell us about *ourselves*? Asked if he ever saw anything that stopped him in his tracks, he replies quite simply and directly: "A good display in a window . . . I don't know . . . a good looking face."[17] Why should the gender of the face matter? What would it tell us about *ourselves*?

It is at this point that we may revisit the question of how a "life" relates to a body of "work." Warhol lived through, and mapped out, relations of power rooted in every kind of institutionalized fantasy. His work and life are intimately tied up with

the great themes of violence, desire, and death. Above all, he established a poetics of the provisional, an ultimately tragic recognition that there are no necessary connections between different areas of ourselves as individuals or as members of social groups. Here once more we might recall Foucault's speculative observation that

*in our society, art has become something which is related to objects and not to individuals, or to life. That art is something which is specialized or which is done by experts who are artists. But couldn't everyone's life become a work of art? Why should the lamp or our house be an art object, but not our life? . . . We should not have to refer the creative activity of somebody to the kind of relation he has to himself, but should relate the kind of relation one has to oneself to a creative activity.* [18]

This seems to me to be a much more helpful and productive way of approaching Warhol than restrictive attempts to measure him against the criteria of predetermined models of artistic value which his own work quietly invalidates, even as they struggle to indict or sentence or reprieve him. The analytical clarity with which his work exposes the limitations of such projects strongly suggests that Warhol is now safely indistinguishable from what vigorously survives as the ongoing critical intelligence and sensibility of the Warhol effect.

## Notes

1. Michel Foucault, "On the Genealogy of Ethics: An Overview of Work in Progress," in *The Foucault Reader,* ed. Paul Rabinow (London: Peregrine, 1986), p. 350.

2. Robert Reinhold, "Liberace Auction: Glittering Ghost," *New York Times,* April 11, 1988, p. A16.

3. Tim Walker, "High Camp and Low Church as Fans Remember Liberace," *The Observer* (London), September 13, 1987, p. 3.

4. Neil Wallis, "The Last Days of Liberace," *The Sun* (London), January 28, 1987, p. 9.

5. Roy Stockdill, "Kinky Love Life of the Piano King," *News of the World* (London), October 18, 1987, p. 23.

6. Boze Hadleigh, "Scared Straight," *American Film* (January-February 1987): 50.

7. Andrew Britton, *Katharine Hepburn: The Thirties and After* (Newcastle upon Tyne: Tyneside Cinema, 1984). See also Simon Watney's "Katharine Hepburn and the Cinema of Chastisement," *Screen* 26, no. 5 (September-October 1985): 52-62.

8. John Russell, "The Season of Andy Warhol: The Artist as Persistent Presence," *New York Times,* April 11, 1988, p. C13.

9. Geraldine Norman, "When a Lifetime's Shopping Becomes a Cultural Event," *The Independent* (London), February 26, 1988, p. 20.

10. Peter Watson, "Warhol: A $35m Junk Hype," *The Observer* (London), April 24, 1988, p. 57.

11. Cathleen McGuigan, "The Selling of Andy Warhol," *Newsweek,* April 18, 1988, p. 60.

12. Paul Taylor, "Andy Warhol: The Last Interview," *Flash Art,* no. 133 (April 1987): 43.

13. Stuart Morgan, "Andy & Andy, the Warhol Twins: A Theme and Variations," *Parkett,* no. 12 (1987): 35.

14. Ernst Kris and Otto Kurz, *Legend, Myth, and Magic in the Image of the Artist: A Historical Experiment* (New Haven: Yale University Press, 1979), p. 114.

15. Leo Bersani, "Is the Rectum a Grave?" *October,* no. 43 (Winter 1987): 222.

16. Gordon Burn et al., "Andy Warhol, 1928?–1987," *Sunday Times Magazine* (London), March 29, 1987, p. 36.

17. Taylor, "Andy Warhol: The Last Interview," p. 44.

18. Foucault, "The Genealogy of Ethics," pp. 350-351.

**Gary Garrels**   Does anyone have a place where they would like to begin this discussion?

**Benjamin Buchloh**   Actually I do. Since Trevor's wonderful presentation is fresh in our minds, I think we would do well addressing issues raised there. I think Trevor that you have much more convincingly than Thomas Crow argued that a traditional iconographic reading can be constructed with regard to a type of work in Warhol's oeuvre. This brings up the question that if this is such a compelling part of Warhol's work—and I think you have made the case very strongly—what is the other part and how do we relate the two? What is the iconography of those supposedly meaningless icons that are constituted as random, arbitrary, willful, as destructions of traditional referential iconography? How can these be reconciled with the powerful icons that emerge from the old iconographic approach—Warhol's obsession with death? How do you relate the two parts of Warhol's work as they emerge simultaneously?

**Trevor Fairbrother**   They don't necessarily emerge simultaneously. The work may be more intuitive at first, perhaps the disaster pictures, for example. He may have become more art historically aware. His sense of other art historical traditions may have grown after the shooting and after hanging around with Fred Hughes and as he politely puts it in the Sotheby sales catalogues, "our group," meaning the de Menils. I think being in Europe in the seventies, Warhol's historical consciousness grew. Is that what you mean? Maybe the work began as one thing, and it became richer in its reference.

**Nan Rosenthal**   Benjamin, what do you mean by the random sub-

jects? Can you give some examples?

**Buchloh**   Well, I think one can say Coca-Cola bottles, glass labels, dollar bills, all the wonderful extraordinary Campbell soup cans—examples of early work that Charles Stuckey showed in the morning. They cannot easily be integrated or even related to the emerging image around 1962 of the glamorous deity Marilyn Monroe who had just killed herself, which as Thomas Crow has argued is the beginning of Warhol's commitment to the death subject. If we construct this centrality of the iconography of death in Warhol's work, what do we then do with the rest of the pictures? That is the question. What place do they assume with regard to a traditionalist argument, since no such simple icono-graphic argument can be made for glass labels or Campbell soup cans. They all are objects of consumption but that is really in no way comparable to the death iconography.

**Fairbrother**   I would say, why limit our understanding to one cen-tral theme? Why not have several themes? Death in America is one theme. As his career unfolds, death becomes clearly a very strong theme. We become more aware of it. And after he died, maybe now we see death in the torn soup can label from 1962 which we would not have necessarily seen at the time. Maybe when it was made in 1962, it was a commercial product paint-ing. But certainly, I don't want to say that death is his only subject.

**Charles Stuckey**   We shouldn't give the impression, which I think we are, that suddenly around 1962 Warhol gets interested in death. There are earlier references: he copied a 1947 photograph in *Life* magazine of a child after the bombing of Shanghai in a painting made when he was about sixteen years old. Nor do I think that we want to give the impression that being fascinated with death is in any way abnormal. That is part of his notion of

focusing on things that are of the greatest interest to most people, even if it might not be commonplace to acknowledge that kind of interest.

**Buchloh**  There is something commercial about the way he uses death as an image, as well as something terribly moving about it, as you pointed out, Trevor.

**Fairbrother**  I think American notions about death, too, have become more evident. In the seventies there was a *New York Times* book review on some of Elizabeth Kubler-Ross's works. It listed over twenty books on death studies that had been made since the late fifties. In that sense, I think that Warhol really tuned in with that popular market and the American books about death.

**Stuckey**  Terry Southern, Holly Woodlawn, and all that stuff.

**Fairbrother**  In a way, the other major theme of Warhol's work is the cult of celebrity. Rainer, you found that book from 1960 by Edgar Morin called *The Stars*. It seems to me that Warhol had to have known that book as he probably knew the Octavio Paz book.

**Rainer Crone**  I don't think that the issues and questions raised here imply that these themes have to relate to each other—the Campbell soup cans and the theme of death. I don't think there is a consistency in themes throughout his work, even though there is a consistency in his work. But he just addressed different themes.

**Buchloh**  There is a structural problem. What I am trying to address is the problem that if we develop an iconographic reading in regard to one of the key subjects, yet remain with the usual reading of Warhol in regard to the other subjects as precisely

the destruction of the traditional iconographic function, then we face some kind of contradiction. If you look at the literature, one important quality of Warhol's work which has been pointed out again and again is its capacity to suspend the traditional function of iconographic representation, canceling out traditional iconographic readings. There is a degree of randomness, arbitrariness in the various objects that are chosen. I think you, Rainer, certainly have argued along those lines, as has Stephen Koch.

**Fairbrother** In a way also related to this would be the quote that is so often repeated: "The more you see something, the less horrible it becomes."

**Buchloh** Yes. All of these kinds of arguments have been made around Warhol.

**Fairbrother** I pulled out that other quote which is repeated less often where he says, "Yes, I do care about these things. It would be easier not to care." He almost always said both sides of anything. I think the reference about repeating something too much loses its power. We are a little too familiar with that.

**Rosenthal** Yes, I agree.

**Fairbrother** I think both are true, which is what maintains the tension in this work. At a given time one can believe in one side of the reading more, and at another time one can believe in another side.

**Crone** I would be interested in the opinions of the speakers today about the effectiveness and power of Warhol as a social critic, or whether he was at all. I think that Benjamin brought that up referring to the publication of *Interview*. Nan, you ex-

pressed very clearly your opinion this morning.

**Rosenthal**  I would like to hear this question discussed without any reference to intentionality. Do these works have an effect sustaining social criticism, rather than did Andy Warhol intend them that way.

**Buchloh**  What about your reference to Brecht, Rainer? Do you still believe that? You were the one who documented this extensively in your early publication. Was your understanding of Warhol's knowledge and the formative influence of Brecht a result of discussions with Warhol?

**Crone**  I never discussed anything with him.

**Rosenthal**  Doesn't one of Patrick Smith's interviews contradict the Brecht hypothesis?

**Crone**  I don't know the interview. What I know about the references to Brecht is the simple fact that in the early fifties when Warhol came to New York, he was involved for over two years with a theater group as a backdrop designer. As a member of the group, he would have discussed Brecht, whose theories were topical at the time. You could say that Brecht was a very "hot" author, especially because of the McCarthy affairs in those years. Off-off Broadway theater made close connections to this theme. Even when they did Shakespeare, it was experimental theater. And the backdrops were very specifically designed and very much discussed. They read within the group, and they discussed it all theoretically. So, if we give sources for Warhol's visual imagery, I think we have to grant this influence, too. How much this really affected his later work, or how much my interpretation of that in terms of alienation effect can be substantiated are questions which must be discussed separately. But I don't think

that the issue with Brecht is so much an issue here. I would go back to Nan's question of how much his work really poses a social critique within society. Trevor remarked that the Italians said Warhol was a communist because he painted the Mao pictures and the hammer and sickle, and he then answered by doing the skulls for the fascists. How would you interpret that?

**Fairbrother**  I had a hard time figuring out why the "Skulls" would be associated with fascism except that—as I learned fairly late— one of the first fascist armies in Italy had a skull as its insignia. Usually, the skull is an antifascist image, as we saw in Picasso's use of the skull.

**Crone**  I would say there are many references. The S.S. used the skull as a sign, also.

**Fairbrother**  They did? I didn't know that.

**Crone**  It is a very clear reference, at least in my opinion. I didn't know of the skull as a more indirect reference to the Holocaust, which I think you have with the image of fascism. It is these images which stick in your mind.

**Fairbrother**  I have another question in relation to the discussion about social criticism. Benjamin brought up the issue about *Interview* and the drift to the right in the seventies with, for example, Mrs. Reagan on the front cover. Yes, that's true, and yes, Warhol wanted to be rich, famous, and glamourous. But at the same time, it is dangerous to assume that there wasn't an element of cynicism about the whole magazine. It is such a camp, gossipy thing to want to hang out with those people. I think a lot of the time, if one likes that kind of publication, then one can read it and laugh that Mrs. Reagan is on the cover of Andy Warhol's *Interview*. It is also funny.

**Buchloh** That is the point when we have to stop and discuss the seriousness of the implications. How far can we go with the dandy attitude? Where does it become more than simply implication and indifference? I thought it was an interesting observation that in the book of photographs the only work that is present is the "Skulls." That again repeated the argument that Warhol was consistently critical, that he was assuming a position of critical negation, however well disguised, of facetious complicity, and so on. But how far can you go with this without sliding into the domain where you have to say putting Imelda Marcos on the cover facetiously, looking just as beautiful as Bianca Jagger on the preceding cover, is not simply an act of supercilious dandyism, but is more than that. It is an act of profound anomic cynicism, as I've called it, which simply says, there is no reality to any of these political questions. The only reality that counts is the glamour, the social life.

**Fairbrother** Maybe it's not good, but maybe it's also the lesser of two evils. I mean, Warhol comes out in favor of America, which is easy to call flagwaving. But maybe also he feels that America is slightly better than other alternatives, while not necessarily affirming Reagan's America. He begins his book *America* saying "America really is the beautiful." Maybe he means it is slightly more beautiful than other alternatives.

**Crone** It is also a basic question of strategy, Benjamin. You mentioned two artists, Buren and Broodthaers, as resisting the art system in general. Warhol didn't choose that way. He chose exactly the other way, the affirmative way of accepting the system as it is and trying to expose the system as significantly and as much as possible. One could see this as an authentic position, at least this is my judgment regarding the work of the early sixties. It is only of a theoretical conception of consequence to do what he did with *Interview,* although I admit that my back shivered

also once in a while when I looked through these pages at the superficiality to a degree that was really unbelievable. Then I saw myself as a sort of victim of this strategy in a way I felt uncomfortable about. I would even regret that I took the position I took in writing about Warhol. But basically his strategy is substantially different than the European strategy, at least in relation to these two artists and other artists and intellectuals during the late sixties. One additional comment I would like to make regarding the position of Buren and Broodthaers, at least as you presented it today, who were taking a more critical role in the late sixties. You have to see also the special historical context in which they were rejecting aspects of society as an anti-Vietnam War phase, and also as an anti-American phase in Europe.

**Buchloh**  But that is precisely the interesting contradiction. Most of the European left was at that moment reading Warhol as the great critical assault on traditional concepts of high culture. But I would like to respond to something Charles Stuckey brought up in our conversation over lunch—appropriately, the name of Dali. When Dali said Adolf Hitler is the greatest Surrealist, that is not so far away in terms of that kind of attitude from Andy Warhol putting Imelda Marcos or Nancy Reagan on the cover of *Interview* and claiming for himself a facetious alignment only. "I am only facetiously constructing an adulation of Leni Riefenstahl," which he did along with a number of others in the sixties. "I am only facetiously quoting Albert Speer in my painting, I really have nothing to do with this."

**Crone**  I sense a difference, Benjamin. The one thing is a judgment and the other is a documentary exposure.

**Buchloh**  To put Imelda Marcos on the cover of *Interview* magazine is a documentary exposure?

**Crone**   There was probably more to it.

**Buchloh**   People are on the cover of *Interview* magazine if they are glamourous, wonderful. I mean these are wonderful people, right? That is why you end up in *Interview* magazine—not because you are a crook.

**Rosenthal**   You are making an assumption, Benjamin, that Warhol favors all the celebrities he made portraits of. I mean, showing them is one thing, being positive about them is another. I think you are making an assumption that to pick a subject is to favor it, to be positive about it.

**Buchloh**   Wasn't that the effect? Either it had to be glamour that was recapitulated in the painting or the painting instantly generated continuation of the glamourization. Isn't that the way they inscribe themselves in this kind of mechanism?

**Rosenthal**   That has never been the way they worked on me.

**Audience**   In a funny way, your argument goes something like this. If *Time* magazine makes Khomeni "Man of the Year," or Adolf Hitler, which in fact happened, then somehow that is telling us something about *Time*. To be on the cover of *Interview* magazine was only possible if certain preconditions of the beautiful and glamourous were filled. That is really a mistake, because I would suggest that there is a censorship process going on.

**Buchloh**   No, there is a *selection* process going on. *Time* magazine is not the same as *Interview* magazine.

**Audience**   Mr. Crone's comment about the work being a social document or manifesto, I think, is much more accurate. If you want to talk about it in terms of systems then you have to talk

about it in terms of operation, not about a judgment, and I think *Interview* is much closer to something like that, especially the cover stuff. New Yorkers might buy into the fact that it is only the beautiful and glamourous, but I come from the Midwest and it's not read that way out there. It's something else.

**Buchloh** But you can't argue that it is read like *Time* magazine. It is not a journalistic tool for discussing current politics. That is not why Imelda Marcos was on the cover, or whoever else in that long list of rather weird people who appeared on the cover of *Interview*. They are not there as news, they are there as an affirmation of the rich, the powerful, and the glorious. Once again, this is a neutralizing attitude that says the picture has no meaning, the personality doesn't stand for anything. Leni Riefenstahl and Albert Speer are just another type of subject matter.

**Rosenthal** Benjamin, let's try this another way. Do you imagine that Warhol was positive about or admired all the traffic going through the Factory in the sixties? Second question, do you think he really enjoyed going to all those dinner parties every single night?

**Buchloh** It is a strange question. It is an interesting question.

**Stuckey** He early on said please don't look beneath the surface, it is completely superficial. And as soon as we start to look beneath the surface, we begin to sit here and hours go by and all the stores close and we can't go shopping.

**Fairbrother** I think several things are true with it. Yes, it was facetious. We can all perceive that but at the same time, I think he was also being honest on one level in his admiration. Yes, he must have admired Imelda Marcos.

**Buchloh**  I am sure that he did.

**Fairbrother**  Shoes and Marcos. This is a working-class person who longed to be glamourous. He was always honest about stuff like that.

**Crone**  I think basically what Warhol was about was: What is the effect? What is thought about, what is the real effect of criticism in a consumer society, of the social order? He has thought about this question being born where he was born, in one of the toughest places in the United States, near Pittsburgh. Growing up there under conditions of working-class poverty, seeing and reading the lies of the present system, of consumer society. To fight the system of consumer society, he took a different strategy than some idealistically oriented European artists. I admire this as much as the other side, but I maintain that one also has to accept that the American economic system is quite different than the European system. We teach people something very different in Europe than what would have meaning in the United States. I think Warhol simply assumed this was the most effective critique he could deliver, even though it might be interpreted by many people as opportunistic. Although I would never bring too much attention to biographical facts, I never knew of one biographical detail until I went to his memorial in St. Patrick's Cathedral, where it was mentioned he went every Easter and Christmas to give soup to poor people in the South Bronx. This is a small detail, but one which shows at least some of the structure of his mind, of his feelings. Maybe it has nothing to do with it.

**Buchloh**  Not that I can see, no.

**Audience**  I'd like to say something about that secret. Nobody knew about it, just like his works. They operate on a certain level where the actual intention is hidden. I find his work in-

credibly political straight through his career, whether it's the Coca-Cola bottles or the skulls. These various schemes act very well against each other, in creating an overall conceptual juxtaposition that is really loaded. I think he presents these things in a way that is not necessarily a reaction made from outside the system but it is a reaction of someone who is inside the system and who may not actually have made up his mind one way or the other at any point in time about the meaning of that position and then followed it consistently throughout his career.

**Buchloh** That question is, obviously, never to be solved. The question is whether the strategy of doubled affirmation, if we want to call it that, can truthfully be assumed in the 1970s, a strategy of any effort at destabilizing, criticizing, questioning, generating doubt. Or wasn't it clearly obvious by then that doubling affirmation is in fact affirmation and nothing else? It is simple to say that the work is political. Yes, we know that, but how is it political and what does it do and how does it operate are the questions that I think we must try to clarify.

**Audience** I was wondering what the function might be of the Nixon image, simply as an eminent example. What is the logic of a poster that shows an image of Nixon and yet says vote for McGovern? Could it in fact be a vote for McGovern poster?

**Buchloh** Yes, that is the one easy example that we have.

**Rosenthal** That is a rather unattractive image of Nixon, green.

**Fairbrother** Typically, he does both things. It was a poster done for the Democratic party, but there is an interview where someone says, "Are you a Democrat?" He won't answer, and they ask, "Are you a Republican?" And he says, "Well, I did a poster for McGovern, but I put Nixon's face on it."

**Crone**   Exactly, he doesn't even believe in parties.

**Fairbrother**   But we all know what the poster says.

**Rosenthal**   If Benjamin can bear to hear me talk about Yves Klein one more time, I think it's not unlike Klein's strategy, a range from utopian to dystopian, Duchampian to Malevichian, or being all things to all people. I think if we start to look at this, Warhol and Klein certainly are counterparts of one another in America and Europe. I think we might find the same thing with Beuys, a very similar kind of range working. I never thought Beuys was political at all. I mean the politics are preposterous, although certainly one could make an argument that he is political. This range business is what is so fascinating. That it repeats with several artists of the same generation, I find very interesting.

**Buchloh**   This follows the model of the indifferent dandy who makes these various statements concerning politics from a position of absolute detachment. Klein makes statements in the 1950s that are truly outrageous, for example, statements against Gandhi, about the necessity of removing the Gandhis of the world. In a famous statement he had a whole list of people, among them Gandhi and Sartre, who he suggested be put in the trash bins of history.

**Rosenthal**   I don't think so, Benjamin.

**Buchloh**   Well, I know the quote—I don't have it right here, but I can easily give it to you. It is the same attitude as Warhol's, in that it is provocatively outrageous in its political implications, yet at the same time easily neutralized by arguing that this is not a political statement. It is the statement of a dandy who has no political responsibility, who is speaking from a position of absolute indifference. There is a continuity between Klein and Warhol.

**Irving Sandler**  Mr. Fairbrother talked about the iconography of death, and you, Mr. Buchloh, raised the problem as well, but then you made the iconography and content of consumerism seem to be a kind of meaningless thing. However, there is an iconography, or what can be considered an iconography, and content of consumerism in Warhol's work, including his role as a performance artist. He takes the role of the celebrity in a consumer society which indeed may be, if not his greatest, at least a great work of art on Warhol's part. We haven't really dealt with the iconography and content of consumerism, and this puts us in a difficult position to decide precisely what the political stance of it is. This is one of the things that seems to be lacking in this analysis.

**Buchloh**  There is another statement by Warhol, and actually it is a very good hint, when he says "McDonald's is the most beautiful thing in the world. Peking doesn't have a McDonald's yet but Florence does." Obviously one cannot read this as just another facetious statement. But at the same time one knows very well that Warhol absolutely, emphatically subscribes to that as well. He made this statement in a moment in time when architectural historians and theoreticians talked about the necessity to reconstruct regional specificity and accused the legacy of American corporate culture as the major destructive force in architectural experience. He, Warhol, comes along and makes the statement that Peking and Florence need a McDonald's in order to have something beautiful. So there again you have the same attitude, with regard to the world of consumption.

**Fairbrother**  Yes, again it's both. It's like how awful that McDonald's will go to Florence and yet at the same time McDonald's is wonderful as a piece of Americana. He wants both. I remember Julia Child in the mid-seventies saying that McDonald's made her favorite french fry or something like that.

There are many, usually three or four different ways of reading whatever he said, it seems to me.

**Rosenthal**  Benjamin, I don't understand why you are assuming that a dandy is actually indifferent. I thought a dandy was someone who worked very hard at giving the *appearance* of indifference. In the moment when Warhol was communicating, especially in the early sixties, being cool was a way to communicate effectively. In fact, it was almost the only way. You wouldn't be very convincing if at the moment he came on the scene, you were overheated. It was almost a cliché, but here it is.

**Fairbrother**  And that is a biographical element of fear. My sense is that he was a terrified person. On the one hand, these statements are both tremendously arrogant—to answer someone's question with an absurdity—but at the same time, I think there was an element of fear. There is a kind of martyr complex in there as well.

**Stuckey**  There is something that you didn't bring up that I think is fascinating. Didn't Patrick Smith get into this notion that when his birthday was finally determined, it turned out to be the day the atom bomb had been dropped?

**Rosenthal**  Yes. August 6th.

**Stuckey**  And that those paintings of the atom bomb had to do with this notion that almost by destiny he had been fated to be obsessed with ultimate destruction and death.

**Fairbrother**  That is a very good point.

**Audience**  You mentioned before that you thought of Andy as being ambivalent. But I really think there is a big difference be-

tween calling him indifferent and calling him ambivalent. You said something about his political responsibility. I think it is possible for him to be politically responsible and to be ambivalent about any of the subjects that he dealt with. If you read his book, *The Philosophy of Andy Warhol,* he brings up so many different issues. He brings up death, among many others. And if he was indifferent, I don't see why he would bother writing about it. It's a human characteristic to be ambivalent. And where he was from, McKeesport, Pennsylvania, which is where I am from, the best thing in McKeesport is McDonald's. It's like the Museum of Modern Art in New York City. (applause, laughter)

**Garrels**  I don't think we can come up with anything that can improve on that remark, so we can call it a day.

# ILLUSTRATIONS

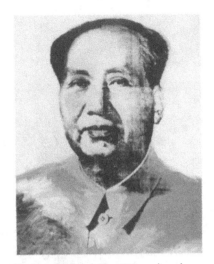

A PAINTING OF A
SOUP CAN USED
TO HANG HERE

fig. 1. William Anastasi, *Untitled*, 1977,
Bakelite plastic, 8 × 12".

fig. 2. Andy Warhol, *Mao*, 1973, acrylic and
silkscreen on canvas, 176½ × 136½". Collection
of the Art Institute of Chicago, Mr. and Mrs.
Frank G. Logan Purchase Prize Fund and Wilson
L. Mead Fund.

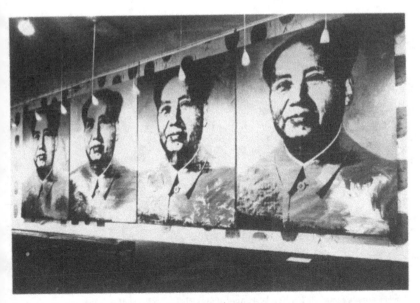

fig. 3. Installation, Musée Galliera, Paris, February-March 1974.

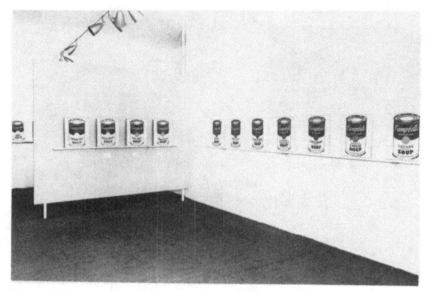

fig. 4. Installation, Ferus Gallery, Los Angeles, July-August 1962.

fig. 5. Window display, Bonwit Teller, New York, April 1961. Includes *Before and After I* (1960).

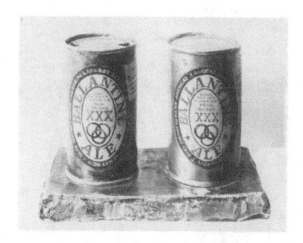

fig. 6. Jasper Johns, *Painted Bronze*, 1960, painted bronze, 5½ × 8 × 4¾".
Collection of Dr. Peter Ludwig, Aachen, Germany. Photo by
Rudolph Burckhardt.

fig. 8. Andy Warhol, *Oxidation Painting*,
1978, mixed media and copper metallic
paint on canvas, 40 × 30". Collection of
The Estate of Andy Warhol.

fig. 7. Andy Warhol, *Handle With Care–Glass–
Thank You*, 1962, acrylic on canvas, 82 × 67".
Collection Dr. Marx, West Berlin.

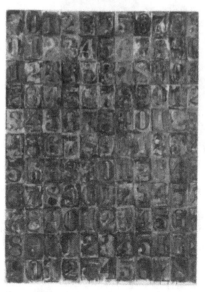

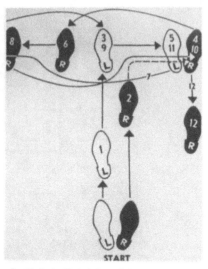

fig. 9. Jasper Johns, *Gray Numbers,* 1958, encaustic and collage on canvas, 67 × 49½". Private collection. Photo by Rudolph Burckhardt.

fig. 10. Andy Warhol, *Dance Diagram–Tango,* 1962, acrylic on canvas, 71¼ × 52". Collection of The Estate of Andy Warhol.

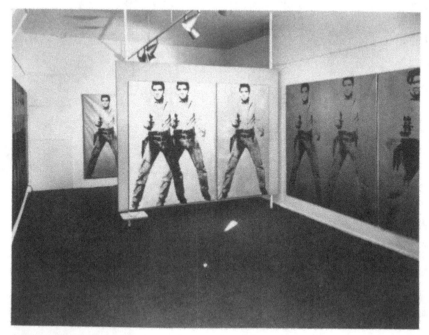

fig. 11. Installation, Ferus Gallery, Los Angeles, September 1963.

fig. 12. Andy Warhol, *The Kiss (Bela Lugosi)*, 1963, silkscreen ink on paper, 30 × 40″. Collection of Richard Weisman, Los Angeles.

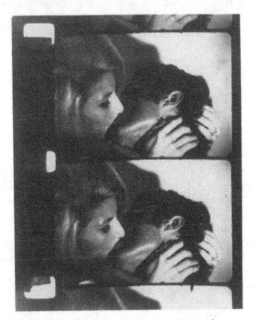

fig. 13. Andy Warhol, film still from *Kiss*, 1963, with Baby Jane Holzer and Gerard Malanga.

fig. 14. Andy Warhol, film still from *Sleep*, 1963, with John Giorno.

fig. 15. Andy Warhol, *The Week That Was I,* 1963, acrylic and silkscreen on canvas, 80 × 64″. Collection of Mrs. Raymond Goetz, Lawrence, Kansas.

fig. 16. Andy Warhol, *Tunafish Disaster,* 1963, acrylic and silkscreen ink on canvas, 112 × 82″. Private collection.

fig. 17. Andy Warhol, *Ambulance Disaster,* 1963, acrylic and silkscreen on canvas, 119 × 80″. Collection of the Dia Art Foundation, New York.

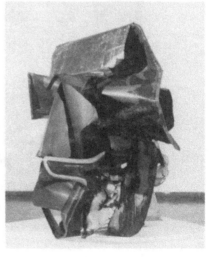

fig. 18. John Chamberlain, *Jackpot,* 1961, painted and chromium-plated steel with gilt, cardboard, 60 × 52 × 46″. Collection of the Whitney Museum of American Art, New York. Gift of Andy Warhol.

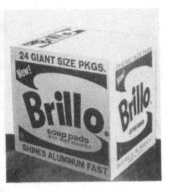

fig. 19. Andy Warhol, *Brillo,* 1964,
silkscreen ink on wood, 17 × 17 × 14″.

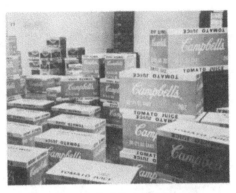

fig. 21. Installation, Stable Gallery, New York,
April-May 1964.

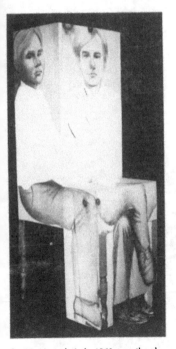

fig. 20. Marisol, *Andy,* 1963, pencil and
paint on wood construction and cast
plaster with Warhol's shoes, 56½ × 17¼
× 22½″. Collection of Mrs. Edwin A.
Bergman, Chicago.

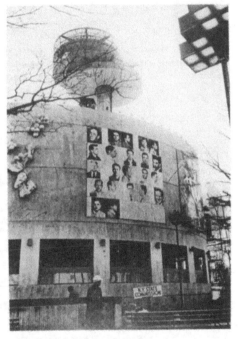

fig. 22. Andy Warhol, *Thirteen Most Wanted Men,* 1964,
mural on New York State Pavilion, New York World's Fair,
20 × 20′ (destroyed).

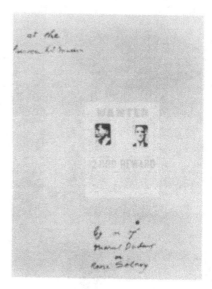

fig. 23. Andy Warhol, *Thirteen Most Wanted Men*, 1964, mural painted over with aluminum (destroyed).

fig. 24. Marcel Duchamp, *Poster within a Poster,* 1963, poster with reproduction of *WANTED/$2,000 REWARD,* 1923, rectified readymade. (Copyright © A.D.A.G.P. Paris/A.R.S., N.Y., 1989.)

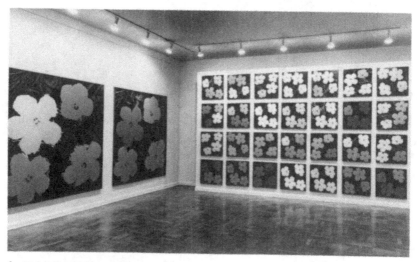

fig. 25. Installation, Leo Castelli Gallery, New York, November-December 1964.

fig. 28. Andy Warhol, *Self-Portrait,* 1966-67, acrylic and silkscreen on canvas, 22 × 22″.

fig. 26. Andy Warhol, wrapping paper design with Nathan Gluck for Tiffany & Co., 1959, stencil on paper.

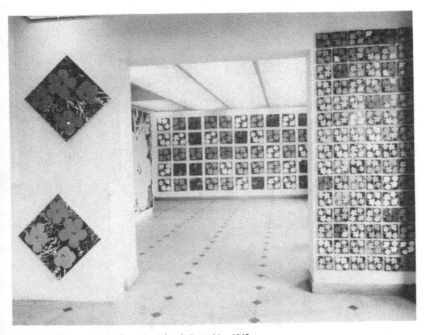

fig. 27. Installation, Galerie Ileana Sonnabend, Paris, May 1965.

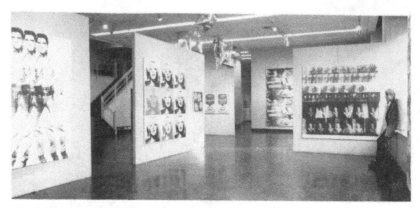

fig. 29. Installation, Institute of Contemporary Art, Boston, October 1-November 6, 1966. *Portrait of Holly Solomon* (center), 1966, acrylic and silkscreen ink on canvas, 90¼ × 90¼". Photo by Barry Burstein.

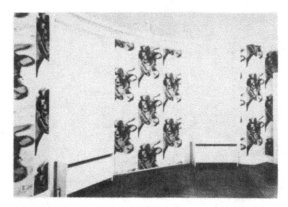

fig. 30. Installation, Leo Castelli Gallery, New York, April 1966.

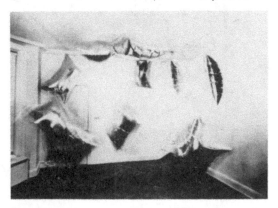

fig. 31. Installation, Leo Castelli Gallery, New York, April 1966.

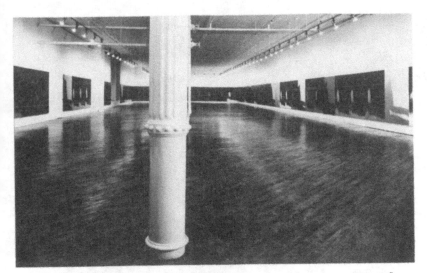

fig. 32. Andy Warhol, *Shadows,* 1979, acrylic silkscreened and hand-painted on canvas, each 76 × 52″. Installation, 393 West Broadway, New York, January 27-March 10, 1979. Collection of the Dia Art Foundation, New York. Photo by Jon Abbott.

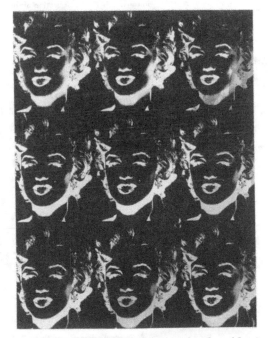

fig. 33. Andy Warhol, *Nine Multi-Colored Marilyns (Reversal Series),* 1979-80, acrylic and silkscreen on canvas, 54⅛ × 41¼″. Photo by Dorothy Zeidman.

fig. 34. Richard Hamilton, *Just What Is It That Makes Today's Homes So Different, So Appealing?*, 1956, collage on paper, 10¼ × 9¾". Private collection, West Germany.

fig. 35. Andy Warhol, *A Boy for Meg,* 1961, acrylic on canvas, 72 × 52". Collection of the National Gallery of Art, Washington, D.C. Gift of Mr. and Mrs. Burton G. Tremaine.

fig. 36. *New York Post,* front page, November 3, 1961. Collections of the Library of Congress.

fig. 37. Andy Warhol, *129 Die (Plane Crash),* 1962, acrylic on canvas, 100 × 72". Collection of Museum Ludwig, Cologne.

fig. 38. Yves Klein, front page of *Dimanche, le journal d'un seul jour,* November 27, 1960. Newsprint on paper, unnumbered large edition. The Menil Collection, Houston.

fig. 39. *New York Post,* front page, June 4, 1968. Collections of the Library of Congress.

fig. 40. Advertisement for Westinghouse Electric Home Appliances, c. 1943-44.

fig. 41. Laszlo Moholy-Nagy, *Two Nudes*, 1925, positive and negative prints. International Museum of Photography at the George Eastman House.

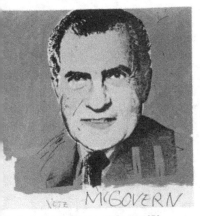

fig. 42. Andy Warhol, *Vote McGovern*, 1972,
serigraph on paper, edition of 250, 42 × 42″.

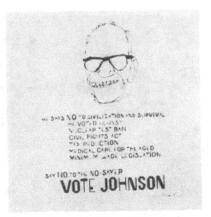

fig. 43. Ben Shahn, *Vote Johnson*, 1964, colored
offset, edition of 500, 28⅛ × 21⅝″.

fig. 45. Andy Warhol, *Do-It-Yourself*
*(Narcissus)*, 1962, pencil and colored pencil
on paper, 23 × 18″. Collection of
Oeffentliche Kunstsammlung Basel,
Kupferstichkabinett. Karl August
Burckhardt-Koechlin Fonds.

fig. 44. Andy Warhol, *Do-It-Yourself (Flowers)*, 1962,
acrylic on canvas, 69 × 59″.

fig. 46. Tony Palladino, *Paint By Numbers with Flowers,* 1959, poster for School of Visual Arts.

fig. 47. Andy Warhol, *Mona Lisa,* 1963, acrylic and silkscreen on canvas, 125¼ × 82⅛″.

fig. 48. Andy Warhol, *Ethel Scull Thirty-Six Times,* 1963, acrylic and silkscreen on canvas, 79¼ × 143″. Collection of the Whitney Museum of American Art, New York. Gift of Ethel Redner Scull.

**158**

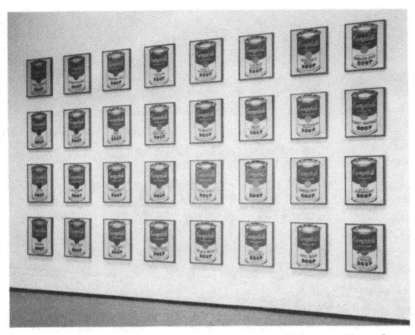

fig. 49. Andy Warhol, *32 Campbell's Soup Cans,* 1961-62, acrylic on canvas, 32 panels, each 20 × 16″.
Installed at the National Gallery of Art, Washington, D.C., 1987. Collection of Irving Blum, New York.

fig. 50. Walker Evans, *Photographer's
Window Display,* 1936. Collections of the
Library of Congress, Washington, D.C.

fig. 51. Robert Rauschenberg, *Gloria,* 1956, oil, paper, and
fabric on canvas, 66¼ × 63¼″. Collection of The Cleveland
Museum of Art. Gift of the Cleveland Society for
Contemporary Art.

**159**

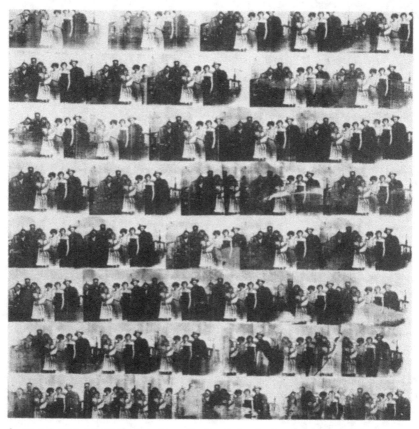

fig. 52. Andy Warhol, *Let Us Now Praise Famous Men (Rauschenberg Family)*, 1963, acrylic and silkscreen on canvas, 82 × 82″. Collection of the National Gallery of Art, Washington, D.C. Gift of Mr. and Mrs. William Howard Adams.

fig. 53. Walker Evans, *Sharecropper's Family, Hale County, Alabama* (Ivy, Ellen, Pearl, Thomas, and Bud Woods, and Miss Molly Gallatin), 1936. Collections of the Library of Congress, Washington, D.C.

fig. 54. Sepia-colored advertisement for Utica Club Beer as it appeared in *Life*, August 30, 1963.

...38,000,000 housewives did.

fig. 55. Sepia-colored advertisement for Morton Salt, from *Food Marketing in New England*, Spring 1966.

fig. 56. Andy Warhol, *210 Coca-Cola Bottles,* 1962, acrylic and silkscreen on canvas, 82½ × 105″. Collection of Martin and Janet Blinder. Courtesy of Martin Lawrence Limited Editions, Los Angeles.

fig. 57. Advertisement for Hunt's Catsup, 1956, as it appeared in *Vogue* and *Harper's Bazaar* magazines, August 1956.

fig. 58. Saul Steinberg, *Untitled (Rimbaud)*, 1946, ink and watercolor on paper, 11⅜ × 8⅝". Collection Galerie Claude Bernard, Paris.

fig. 59. Man Ray, *Imaginary Portrait of D. A. F. de Sade*, 1936, ink on paper, 25 × 19¼". (Copyright © A.D.A.G.P. Paris/A.R.S., N.Y., 1989.)

fig. 60. Andy Warhol, *Ginger Rogers*, 1962, pencil on paper, 23¼ × 18". Collection of the Whitney Museum of American Art, New York, purchase with funds from the Lauder Foundation Drawing Fund. Photo by Geoffrey Clements Inc., New York.

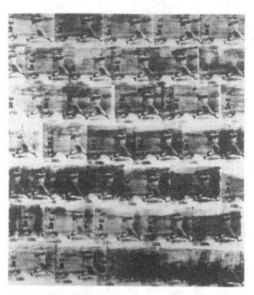

fig. 61. Andy Warhol, *Baseball,* 1962, silkscreen ink and oil on canvas, 91½ × 82". Collection of the Nelson-Atkins Museum of Art, Kansas City, Missouri. Gift of the Guild of the Friends of Art and a group of friends of the gallery.

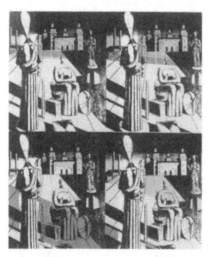

fig. 62. Andy Warhol, *The Disquieting Muses (After de Chirico),* 1982, acrylic and silkscreen ink on canvas, 50 × 45¼". Photo by Ellen Page Wilson.

fig. 63. Jacques Louis David, *The Death of Marat,* 1793. Collection of the Musées Royaux des Beaux Arts, Brussels.

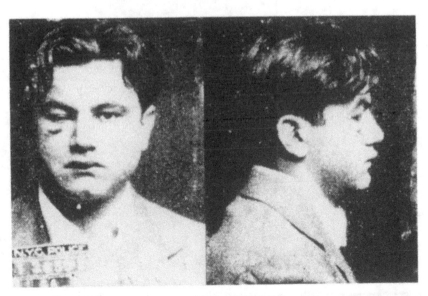

fig. 64. Andy Warhol, *Most Wanted Men No. 2, John Victor G.,* 1964, acrylic and silkscreen on canvas, 48½ × 75⅝". Collection of the Dia Art Foundation, New York.

fig. 65. Andy Warhol, *Huey Long,* 1948-49, ink on paper, 29⅛ × 23". Collection of the Museum of Art, Carnegie Institute, Pittsburgh.

fig. 66. Andy Warhol, *There Was Snow on the Street,* 1953. Collection Gotham Book Mart Gallery, New York.

fig. 67. Andy Warhol, *Birds and Bees,* ca. 1955, cut paper, ink, and watercolor on paper, 24 × 22". Collection of the Dia Art Foundation, New York.

fig. 68. Andy Warhol, *Judy Garland,* 1956, collage, ink, and gold leaf on paper, 20⅛ × 12". Collection of Michael Becher, Bremen.

fig. 69. Andy Warhol, *Superman,* 1960, ink, tempera, crayon, and oil on canvas, 67 × 52½". Collection of Gunter Sachs, Paris.

fig. 70. Andy Warhol, *Daily News,* 1962, acrylic on canvas, 72¼ × 88". Collection of Museum für Moderne Kunst, Frankfurt.

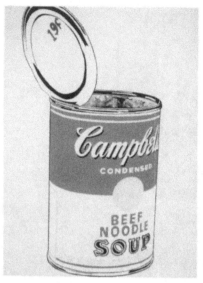

fig. 71. Andy Warhol, *Big Campbell's Soup Can,* 1962, acrylic and pencil on canvas, 72 × 54½". The Menil Collection, Houston.

fig. 72. Andy Warhol, *This Side Up,* 1962, oil and pencil on canvas, 81 × 50⅜". Collection of the Dia Art Foundation, New York.

fig. 73. Andy Warhol, *70 S&H Green Stamps,* 1962, rubber stamp and acrylic on canvas, with metal staples, 16⅛ × 20¼". Collection Martin and Janet Blinder. Courtesy of Martin Lawrence Limited Editions, Los Angeles.

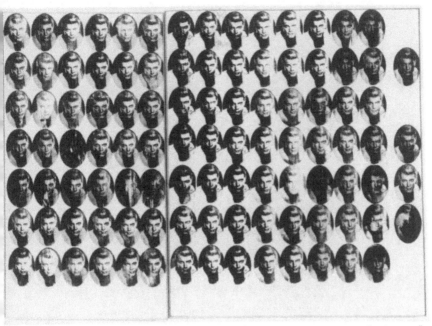

fig. 74. Andy Warhol, *Troy Diptych,* 1962, acrylic and silkscreen on canvas, two panels, 82 × 43″ and 82 × 68″.
Collection of the Museum of Contemporary Art, Chicago. Gift of Mrs. Robert B. Mayer.

fig. 75. Andy Warhol, film still from *Empire,* 1964.

fig. 76. Ben Shahn, *Reclining Boy,* c. 1943.

fig. 77. Andy Warhol, *Hand with Flowers,* 1956, hand-colored offset print, 14⅛ × 10″. Private collection, Hamburg.

fig. 78. Andy Warhol, *H. B. Mister Lisanby,* 1956, watercolor and ink on paper, 17⅞ × 12½″. Collection of Charles Lisanby, New York.

fig. 80. Henri Matisse, *Woman with Crossed Arms,* 1936, pencil on paper.

fig. 79. Andy Warhol, *The Moor of Venice,* 1953, offset on paper, from *Love is a Pink Cake.*

fig. 82. Andy Warhol, *Philippe Julien,* 1956, collage, gold leaf, and ink on paper, 13¾ × 10⅝". Collection of Michael Becher, Bremen.

fig. 81. Andy Warhol, *Happy Butterfly Day,* 1955, colored offset, 12⅝ × 9⅜".

fig. 83. Andy Warhol, *Wigs,* 1960, oil and wax crayon on canvas, 70⅛ × 40″. Collection of the Dia Art Foundation, New York.

fig. 84. Andy Warhol, *Before and After,* 1960, acrylic on canvas, 54 × 70″. Collection of The Estate of Andy Warhol. Photo by Kate Keller.

fig. 85. Andy Warhol, *Before and After III,* 1962, acrylic on canvas, 72 × 99⅝″. Collection of the Whitney Museum of American Art, New York, purchase with funds from Charles Simon. Photo by Geoffrey Clements Inc., New York.

fig. 86. Andy Warhol, *Close Cover Before Striking (Pepsi-Cola),* 1962, acrylic and sandpaper on canvas, 72 × 54". Collection of Museum Ludwig, Cologne.

fig. 87. Andy Warhol, *100 Campbell's Soup Cans,* 1962, oil on canvas, 72 × 52". Collection Museum für Moderne Kunst, Frankfurt.

fig. 88. Andy Warhol, *7¢ Airmail Stamp,* 1962, acrylic on canvas, 7⅞ × 5⅞". Collection of the Dia Art Foundation, New York.

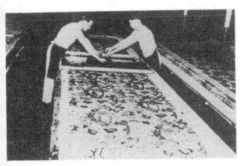

fig. 89. In a wallpaper factory, silkscreen printing of wallpaper.

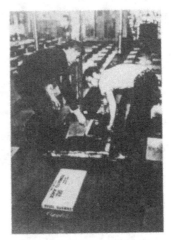

fig. 90. In the Factory: Warhol and friends producing *Campbell's Boxes*.

fig. 91. Photograph of the Factory, 860 Broadway, from *Andy Warhol's Exposures* (New York: Grosset & Dunlap, 1979). Collection of The Estate of Andy Warhol.

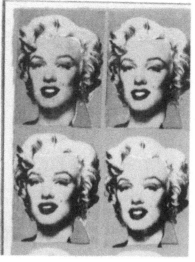

fig. 92. Andy Warhol, *How to tell you're having a heart attack,* c. 1982, acrylic on canvas, 14 × 11″. Collection of The Estate of Andy Warhol.

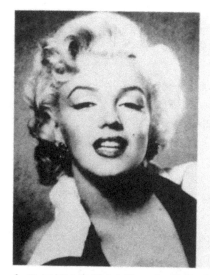

fig. 93. (right) Andy Warhol, *Marilyn Diptych* (detail), 1962, acrylic and silkscreen on canvas, 82 × 114″. Collection of the Tate Gallery, London. (left) Publicity photograph of Marilyn Monroe, reproduced in *Art in America* 75 (May 1987).

fig. 94. Andy Warhol, ten "Skull" drawings, 1976, graphite on paper, 27½ × 41″ and 20½ × 27½″. Installation at 77 Wooster Street, New York, Dia Art Foundation, October 14, 1987-June 18, 1988. Collection of the Dia Art Foundation, New York.

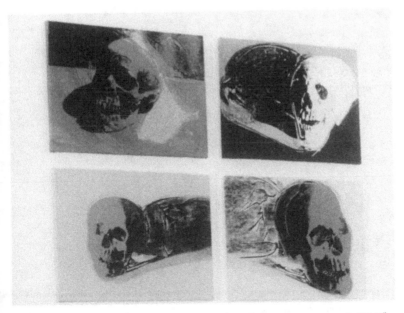

fig. 95. Andy Warhol, four "Skull" paintings, 1976, acrylic and silkscreen on canvas, each 15 × 19″. Collection of The Estate of Andy Warhol.

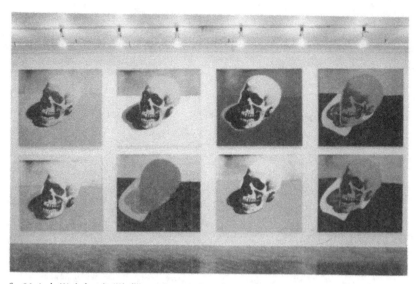

fig. 96. Andy Warhol, eight "Skull" paintings, 1976, acrylic and silkscreen on canvas, each 72 × 80″. Installation at 77 Wooster Street, New York, Dia Art Foundation, October 14, 1987-June 18, 1988. Collection of the Dia Art Foundation, New York.

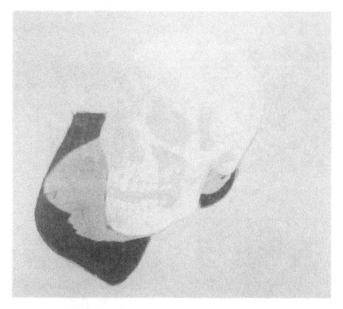

fig. 97. Andy Warhol, *Skull,* 1976, acrylic and silkscreen on canvas, 132 × 150″. Collection of the Dia Art Foundation, New York.

**178**

fig. 98. Andy Warhol, *Skull,* 1976, acrylic and silk-screen on canvas, 15 X 19″. Collection of The Estate of Andy Warhol.

fig. 99. Andy Warhol, *Skull,* 1976, acrylic and silk-screen on canvas, 15 X 19″. Collection of The Estate of Andy Warhol.

fig. 100. Andy Warhol, *Ladies and Gentlemen,* 1975, acrylic and silkscreen on canvas, 14 X 11″. Collection of The Estate of Andy Warhol. Photo by Phillips/Schwab.

179

fig. 101. Antonio and Giovanni Giusti, *Tomb of Louis XII and Anne de Bretagne,* Abbey Church, Saint-Denis, 1516-31. Photograph by Pierre Jahan of detail of central section of monument showing the royal corpses prior to embalming and burial.

fig. 102. Andy Warhol, *Blue Electric Chair,* 1963, acrylic and silkscreen on canvas, diptych, overall 105 × 160½". Saatchi Collection, London.

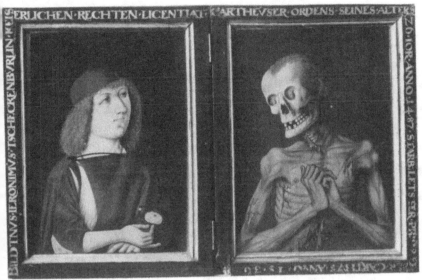

fig. 103. Basler Meister von 1487, *Portrait of Hieronymus Tschekkenburlin*, 1487, oil on wood, diptych, overall 16 × 22¾". Collection of Oeffentliche Kunstsammlung Basel Kunstmuseum.

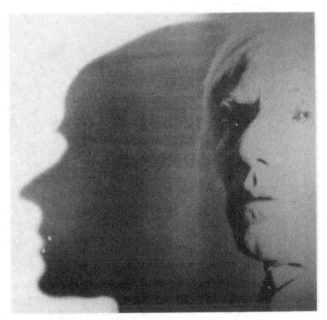

fig. 104. Andy Warhol, *The Shadow*, 1981, from "Myths," serigraph on paper, edition of 200, 38 × 38". Photo by eeva-inkeri.

fig. 105. Christopher Makos, *Christopher Makos and Friend, New York,* from *White Trash* (Stonehill Publishing, 1977).

fig. 106. Allan Tannenbaum, photograph of Andy Warhol and Victor Hugo at Leo Castelli Gallery opening for Warhol's "Still Lifes," January 11, 1977. (Copyright © 1988 Allan Tannenbaum.)

fig. 107. Andy Warhol, *Self-Portrait with Skull,* 1978, acrylic and silkscreen on canvas, 16 × 13". The Menil Collection, Houston.

fig. 108. Andy Warhol, *Self-Portrait with Hands Around Neck,* 1978, acrylic and silkscreen on canvas, 16 × 13". Collection of The Estate of Andy Warhol.

fig. 110. Italian fascist banner, ca. 1930, detail of a photograph by Mimmo Frassinetti, 1988.

fig. 109. Jacques de Gheyn the Elder (1565-1629), *Vanitas*, oil on wood, 32½ × 21¼". Collection of The Metropolitan Museum of Art, New York. Purchase from Charles B. Curtis, Marquand, Victor Wilbour Memorial, and Alfred N. Punnett Endowment Funds, 1974.

fig. 111. Andy Warhol, *Philip's CAT Scan,* 1985, acrylic and silkscreen on canvas, 40 × 40". Collection of The Estate of Andy Warhol.

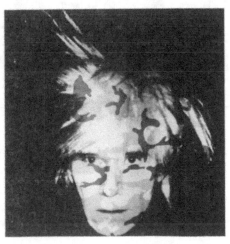

fig. 112. Andy Warhol, *Self-Portrait,* 1986, acrylic and silkscreen on canvas, 80 × 80".

fig. 113. Andy Warhol, *Untitled*, 1987, black and white photographs, machine-sewn, photo edition for *Parkett* (Zurich), edition of 120, 9¾ × 7¼". Collection of Karen Marta, New York.

## Photo Credits

Fig. 1 courtesy the artist; fig. 2 courtesy the Art Institute of Chicago; figs. 4, 7, 8, 10, 11, 15, 16, 25, 26, 27, 28, 30, 31, 37, 42, 48, 87, 91, 92, 95, 98, 99, 100, 108, and 111 courtesy The Estate and Foundation of Andy Warhol; figs. 6, 9, 19, and 33 courtesy Leo Castelli Gallery, New York; figs. 13, 14, 18, 60, and 85 courtesy the Whitney Museum of American Art, New York; figs. 17, 38, 64, 67, 71, 72, and 83 courtesy The Menil Collection, Houston; figs. 24 and 59 courtesy A.R.S., N.Y.; figs. 32, 88, 94, 96, and 97 courtesy the Dia Art Foundation, New York; figs. 35, 49, and 52 courtesy the National Gallery of Art, Washington, D.C.; figs. 36, 39, 50, and 53 courtesy the Library of Congress, Washington, D.C.; fig. 41 courtesy the International Museum of Photography at George Eastman House, Rochester, N.Y.; fig. 44 courtesy Thomas Ammann, Zurich; figs. 47 and 102 courtesy Blum Helman Gallery, New York; fig. 51 courtesy the Cleveland Museum of Art; fig. 55 courtesy the Morton Salt Division of Morton Thiokol, Inc.; figs. 56 and 73 courtesy Martin Lawrence Limited Editions, Los Angeles; fig. 57 courtesy the Art Directors Club Museum of Advertising and Communication Design, New York, and Young & Rubicam; fig. 58 courtesy Galerie Claude Bernard, Paris; fig. 61 courtesy the Nelson-Atkins Museum of Art, Kansas City; fig. 62 courtesy Marisa del Re Gallery, New York; fig. 63 courtesy Art Resource, New York; fig. 65 courtesy the Museum of Art, Carnegie Institute, Pittsburgh; figs. 69 and 84 courtesy the Museum of Modern Art, New York; fig. 70 courtesy Museum für Moderne Kunst, Frankfurt; fig. 74 courtesy the Museum of Contemporary Art, Chicago; fig. 75 courtesy Museum of Modern Art/Film Stills Archive, New York; fig. 103 courtesy Kunstmuseum Basel; fig. 104 courtesy Ronald Feldman Fine Arts, New York; fig. 105 courtesy Christopher Makos; fig. 106 courtesy Allan Tannenbaum; fig. 107 courtesy Sotheby's, New York; fig. 109 courtesy the Metropolitan Museum of Art, New York; fig. 110 courtesy *La Repubblica*; fig. 112 courtesy Anthony d'Offay Gallery, London; fig. 113 courtesy *Parkett,* Zurich, and Karen Marta, New York.

**Dia Art Foundation**
**77 Wooster Street, New York**

WARHOL EXHIBITIONS

ANDY WARHOL:

DISASTER PAINTINGS 1963

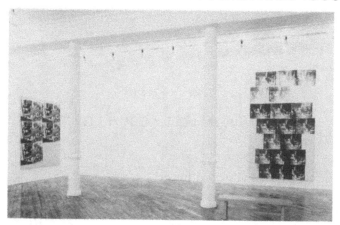

Curated by Donna M. De Salvo

**Gangster Funeral** 1963
Oil and silkscreen enamel
on canvas
105 × 75¾″ (266.7 × 192.3 cm.)
Dia Art Foundation, New York

**1947 White** 1963
Oil and silkscreen enamel
on canvas
121¼ × 77⅞″ (307.9 × 197.8 cm.)
Dia Art Foundation, New York

**Ambulance Disaster** 1963
Oil and silkscreen enamel
on canvas
119 × 80⅛″ (302.2 × 203.4 cm.)
Dia Art Foundation, New York

**Foot and Tire** 1963
Oil and silkscreen enamel
on canvas
80¼ × 144¾″ (204 × 368 cm.)
Dia Art Foundation, New York

**White Burning Car III** 1963
Oil and silkscreen enamel
on canvas
100 × 78¾″ (254 × 200 cm.)
Dia Art Foundation, New York

**White Car Crash Nineteen Times** 1963
Oil and silkscreen enamel
on canvas
145 × 83¼″ (368.3 × 211.5 cm.)
Dia Art Foundation, New York,
on extended loan from a private
collection

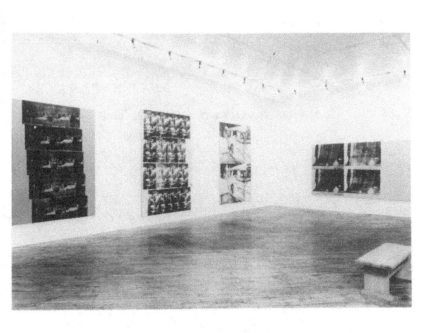

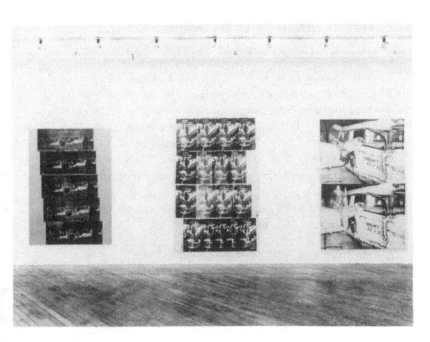

ANDY WARHOL:

HAND-PAINTED IMAGES 1960—62

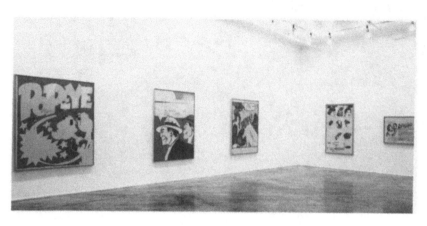

Curated by Donna M. De Salvo

**Bald?** 1960
Pencil and gouache on paper
28½ × 22½" (72.5 × 57 cm.)
Dia Art Foundation, New York

**Campbell's Soup Can
(Tomato Rice)** (1960)
Ink, tempera, crayon, and oil
on oil-primed canvas
36¾ × 34¾" (93.3 × 88.3 cm.)
Dia Art Foundation, New York

**Coca-Cola** (1960)
Ink, tempera, and crayon on
oil-primed canvas
72 × 54" (183 × 137 cm.)
Dia Art Foundation, New York

**Dick Tracy** (1960)
Oil on canvas
70½ × 52⅜" (179.1 × 133.7 cm.)
Collection of Mr. and Mrs. S.I.
Newhouse, Jr., New York

**Dr. Scholl's Corns** (1960)
Ink and tempera on oil-
primed linen
40 × 48" (101.6 × 121.9 cm.)
The Metropolitan Museum of
Art, New York, Gift of Halston,
1982

**Icebox** (1960)
Ink, tempera, oil, crayon, and
pencil on canvas
67 × 53⅛" (170.3 × 135 cm.)
The Menil Collection, Houston

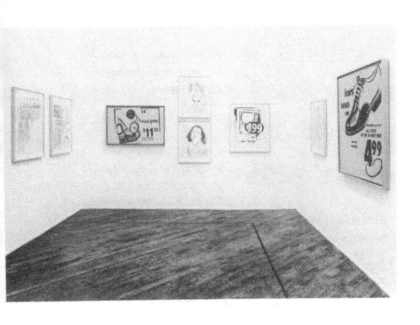

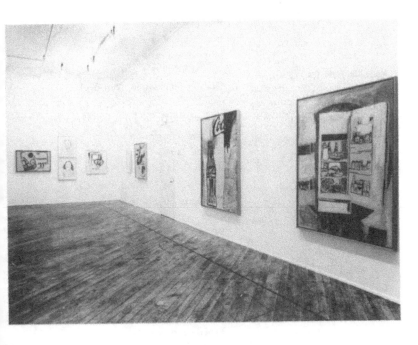

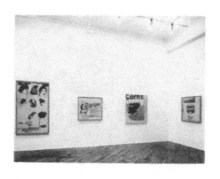

**Icer's Shoes** (1960)
Ink and tempera on oil-primed canvas
42½ × 39⅞" (107.9 × 101.3 cm.)
The Estate of Andy Warhol

**Journal American** 1960
Ball-point ink on paper
23¾ × 17⅞" (30 × 23 cm.)
Dia Art Foundation, New York

**Make Him Want You** (1960)
Ink, tempera, crayon, and oil on oil-primed linen
33 × 33¾" (84 × 91.9 cm.)
Dia Art Foundation, New York

**$199 Television** 1960
Ink and pencil on paper
29 × 23" (72.5 × 58.5 cm.)
Dia Art Foundation, New York

**Superman** (1960)
Ink, tempera, crayon, and oil on canvas
67 × 52½" (171 × 133.2 cm.)
Collection of Gunter Sachs, Paris

**3-D Vacuum Cleaner** (1960)
Ink and tempera on oil-primed canvas
25⅞ × 39⅝" (65.4 × 100.7 cm.)
The Estate of Andy Warhol

**U Spend $2 Your Hair** 1960
Pencil and gouache on paper
28⅝ × 22½" (72.6 × 57.1 cm.)
Dia Art Foundation, New York

**Water Heater** (1960)
Acrylic on canvas
44⅞ × 40¼" (114 × 102.2 cm.)
The Museum of Modern Art, New York, Gift of Roy Lichtenstein, 1971

**Wigs** (1960)
Ink, tempera, and crayon on oil-primed canvas
70⅛ × 40" (178.1 × 101.6 cm.)
Dia Art Foundation, New York

**Popeye** (1961)
Ink and tempera on oil-primed canvas
68 × 59" (149.6 × 129.8 cm.)
Collection of Mr. and Mrs. S.I. Newhouse, Jr., New York

**Hedy Lamarr** 1962
Pencil on paper
24⅛ × 18" (60.9 × 45.7 cm.)
Dia Art Foundation, New York

**Joan Crawford** 1962
Pencil on paper
24 × 18" (60.9 × 45.7 cm.)
Dia Art Foundation, New York

# ANDY WARHOL: SKULLS 1976

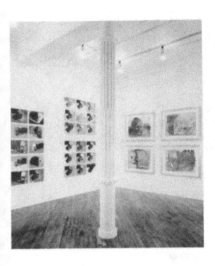

Curated by Gary Garrels. The exhibition had been conceived as an installation by Warhol that would include a wallpaper design based on one of the "Skull" drawings. Warhol was working on the project at the time of his death in February 1987.

**(Eight Paintings)** 1976
Acrylic and silkscreen on canvas
Each 72 × 80″ (182.9 × 203.2 cm.)
Dia Art Foundation, New York

**(Painting)** 1976
Acrylic and silkscreen on canvas
132 × 150″ (335.3 × 381 cm.)
Dia Art Foundation, New York

**(Ten paintings)** 1976
Acrylic and silkscreen on canvas
Each 15 × 19″ (38.1 × 48.2 cm.)
The Estate of Andy Warhol

**(Nine paintings)** 1976
Acrylic and silkscreen on canvas
Each 15 × 19″ (38.1 × 48.2 cm.)
Private collection, New York

**(Nine paintings)** 1976
Acrylic and silkscreen on canvas
Each 15 × 19″ (38.1 × 48.2 cm.)
The Estate of Andy Warhol

**(Collage)** 1976
Silkscreen, paper collage, and photo transfer on overlaid mylar sheets
30 × 41″ (76.2 × 104.2 cm.)
Collection of Massimo Valsecchi, Milan

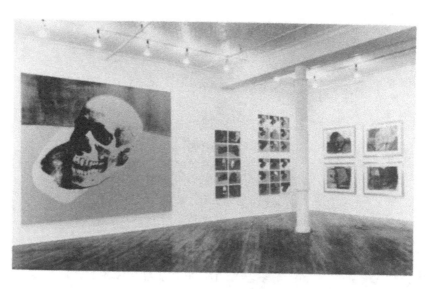

**(Collage)** 1976
Silkscreen, paper collage, and
photo transfer on overlaid
mylar sheets
30 × 41″ (76.2 × 104.2 cm.)
Collection of Massimo
Valsecchi, Milan

**(Collage)** 1976
Silkscreen, paper collage, and
photo transfer on overlaid
mylar sheets
30 × 41″ (76.2 × 104.2 cm.)
The Estate of Andy Warhol

**(Collage)** 1976
Silkscreen, paper collage, and
photo transfer on overlaid
mylar sheets
30 × 41″ (76.2 × 104.2 cm.)
Private collection, New York
Courtesy of Sonnabend Gallery,
New York

**(Painting)** 1976
Acrylic and silkscreen on canvas
132 × 150″ (335.3 × 381 cm.)
Dia Art Foundation, New York

**(Six drawings)** 1976
Graphite on paper
Each 27½ × 41″ (69.8 × 104.2 cm.)
Dia Art Foundation, New York

**(Four drawings)** 1976
Graphite on paper
20½ × 27½″ (52.1 × 69.8 cm.)
Dia Art Foundation, New York

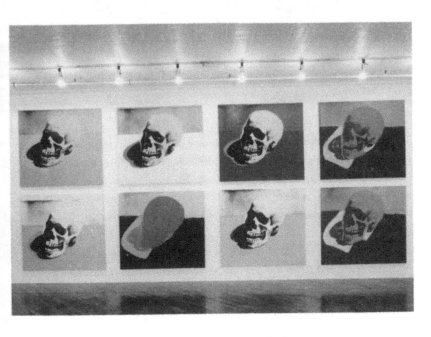

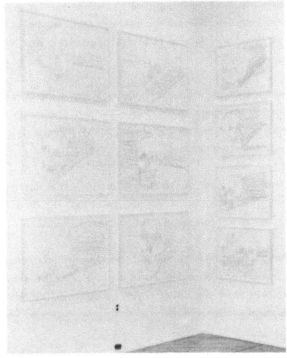

**Benjamin H. D. Buchloh** is Assistant Professor in the Department of History, Theory, and Criticism in the School of Architecture, Massachusetts Institute of Technology. He contributed an essay to *Andy Warhol: A Retrospective* (1989), and a collection of his essays is forthcoming from MIT Press in the fall of 1989.

**Rainer Crone** is Associate Professor of Art History at Columbia University and Chief Curator at the Kunsthalle, Düsseldorf. He is the author of *Andy Warhol* (1970) and *Andy Warhol: The Early Work, 1942-1962* (1987).

**Trevor Fairbrother** is Associate Curator of Contemporary Art at the Museum of Fine Arts, Boston. His interview with Warhol at the Whitney's John Singer Sargent exhibition appeared in *Arts Magazine* (February 1987).

**Nan Rosenthal** is Curator of Twentieth-Century Art at the National Gallery of Art, Washington, D.C. She is the author of monographs on Yves Klein and George Rickey and is completing a book on Robert Rauschenberg.

**Charles F. Stuckey** is Curator of Twentieth-Century Art at the Art Institute of Chicago and most recently co-curated *The Art of Paul Gauguin*. He has written on Warhol for *Art in America*.

**Simon Watney** is a cultural historian and theorist currently living in London and working as an AIDS educator. He is on the editorial board of *Screen* and is the author of *Policing Desire: AIDS, Pornography, and the Media* (1987).

Printed in the USA
CPSIA information can be obtained
at www.ICGtesting.com
LVHW010414090824
787694LV00001B/121